THE ART
OF CONTEMPORARY ENGLISH CULTURE

The Art
of Contemporary
English Culture

GEORGE H. GILPIN

St. Martin's Press New York

First published in the United States of America in 1991

Printed in Hong Kong

ISBN 0-312-04496-8

Library of Congress Cataloging-in-Publication Data
Gilpin, George H.
The art of contemporary English culture / George H. Gilpin
p. cm.
ISBN 0-312-04496-8
1. England – Civilization – 20th century. 2. English
literature – 20th century – History and criticism. 3. Art and
literature – England – History – 20th century. 4. Art, English.
I. Title.
DA589.4.G55 1991
941.085 – dc20 90–8369
 CIP

93-0750mc

For Hermione de Almeida

Contents

Acknowledgments

For permission to reprint quotations, I wish to thank the following sources: Little, Brown and Company (Boston) and Jonathan Cape (London) for excerpts from John Fowles, *Daniel Martin* Copyright © 1977 by J. R. Fowles Ltd.; Farrar, Straus, and Giroux, Inc. (Boston) and A. P. Watt Ltd. (London) on behalf of the Estate of Robert Graves for excerpts and the poem 'In Dedication' from Robert Graves, *The White Goddess: Amended and Enlarged Edition*, Copyright ©1948 by International Authors N. V. Copyright renewed ©1975 by Robert Graves; Simon and Schuster, Inc. (New York) and Michael Joseph Ltd. (London) for excerpts from Doris Lessing, *The Golden Notebook*, copyright ©1962 by Doris Lessing.

I wish to acknowledge the advice and assistance of colleagues and friends over the years: Alan Grob, Philip Herring, John Kings, Donald Reiman, Norman Sherry, and Carl Woodring for their critiques of work-in-progress; Cassandra Hancock, Mary Lowe-Evans, and B. J. Robinson for their assistance with research; Bill Lee and Luis Glazer for recognizing that a university administrator needs time for scholarship; Mary Hope Anderson, Nettie Hairston, and Patti McCulley for coordinating and processing the words; the staffs of the Richter Library at the University of Miami, the British Library, and the Royal Institute of British Architects for finding the books; Gene Man (on bicycle), Arthur Brown, Mihoko Suzuki, and Frank Palmeri for finding time to advise me; and Hecate, our Persian cat, for sharing her table by the lake. I thank my parents, Billie and George, and my children, Katherine and George III, for their patience. Hermione Jr. shares the dedication with her mother.

G.H.G
Coral Lake
Miami, Florida

List of Illustrations

1. Henry Moore, *Shelter Scene* (1941). © Henry Moore Foundation 1990. Reproduced by kind permission of the Henry Moore Foundation.

2. Henry Moore, *September 3rd 1939* (1939). © Henry Moore Foundation 1990. Reproduced by kind permission of the Henry Moore Foundation.

3. Laura Knight, *Nuremberg Courtroom* (1946). Trustees of the Imperial War Museum.

4. Francis Bacon, *Three Studies for Figures at the Base of a Crucifixion* (1944). The Tate Gallery, London.

5. Francis Bacon, *Figure Study II* (1945–46). © Kirklees Metropolitan Council, Huddersfield Art Gallery.

6. Francis Bacon, *Study After Velasquez's Portrait of Pope Innocent X* (1953). Coffin Fine Arts Trust Fund, 1980; Nathan Emory Coffin Collection of the Des Moines Art Center, Iowa.

7. Francis Bacon, *Triptych Inspired by T. S. Eliot's Poem 'Sweeney Agonistes'* (1967). Hirschhorn Museum and Sculpture Garden, Smithsonian Institution, Gift of Joseph H. Hirschhorn Foundation, 1972.

8. Eduardo Paolozzi, *I Was a Rich Man's Plaything* (1947). Published by kind permission of the Artist.

9. Richard Hamilton, *$he* (1958–61).

10. Peter Blake, *Self-Portrait with Badges* (1961).

11. James Stirling and James Gowan, *School Assembly Hall*, Camberwell (1958–61). Reproduced by permission of the Architects.

12. James Stirling and James Gowan, *Leicester University Engineering Building* (1959–63). Reproduced by permission of the Architects.

Foreword

> One is as much impressed by the disharmony of things as one
> is surprised by their occasional harmony.
>
> C. G. Jung, *Psyche and Symbol*

For this kind of study, Lytton Strachey set the tone: 'Ignorance is
the first requisite of the historian – ignorance, which simplifies
and clarifies, which selects and omits, with a placid perfection
unattainable by the highest art.' Any view of the art and culture
of a civilization is inevitably partial, especially one of an age which
is, I think, still evolving. Therefore, my purpose is neither to write
a history documenting what happened in England beginning with
the outbreak of the Second World War nor to evaluate the changes
in art and culture that I perceive. It is, rather, to suggest the shape of
the thinking about the state of England as a culture and its national
identity.

Moreover, I am an American, and in that sense my ignorance
goes beyond that of Strachey's 'historian': selectivity and omission
are exercised at a distance, emotionally and intellectually, from
the subject matter. However, looking at a civilization as an
outsider may be best for defining the emerging shape of its
finest thinking about itself. The perspective is reasonable for
describing the historical panorama while not getting lost in the
parade.

Also, I have tried to avoid the scholarly trap that defines the
contemporary by the most immediate and comprehensible past,
calling it 'post-Modern'.[1] Even if a paradigm of the diverse issues
of 'Modernism' could be firmly articulated (and perhaps it is better
to speak of the 'Moderns'), such an approach to contemporary
English culture is as inappropriate as defining the Moderns as
'post-Victorians'. The contemporary canon cannot be established
in terms of a scholarly understanding of the recent past – after
all, an event more historically climactic and psychologically
disturbing than merely the turn of a century or even the death
of a monarch occurs: for the first time England is attacked at home
and knows world war in its everyday life. The war makes all the

1

difference, even if there is in some of the survivors a clinging to the past, even to some of the issues of an increasingly vilified Modernism.

Most enlightening to me for this study are those writers and artists who recognize the difference the war makes, who define the intellectual crisis that this recognition brings, who break ground to rebuild culture on a new foundation. Their efforts do not occur chronologically, of course – as often as I find examples of the search for something new in works written during the war, I find examples in recent works of a longing for a culture that is gone. Sometimes my strategy of presentation is literary: incidents are presented that are for me epiphanies epitomising succinctly cultural issues, beginning with the victorious Kitchener at Khartoum in 1898 and ending with a glimpse of London today. Presented in between is a narrative concerning selected artists and their works that I identify as landmarks which define the terrain and mark the progress toward delineating the post-war culture, at least as it has been conceived creatively. My choices are necessarily eclectic. Therefore, my argument is structured in terms of issues posed by the new culture rather than by the history of culture, even though I hope that approaching the former will increase understanding of the latter.[2]

The initial issue, already articulated by the end of the nineteenth century, was a pessimistic questioning – by Joseph Conrad, for example – of the very nature of European civilization. This established the intellectual context for those in the 1930s like William Butler Yeats, W. H. Auden, T. S. Eliot, and Virginia Woolf who realized that Modernism was ending and looked forward, even at the expense of war and devastation, to a new basis for culture taking its place. With the Victorian sense of security and confidence finally destroyed once and for all (perhaps the assumption that permitted some of the less savory political conservatism of the Moderns), there was a sense of disillusionment in the feeling of writers like George Orwell, Graham Greene, Alan Sillitoe, John Osborne, Harold Pinter and of painters like Laura Knight and Francis Bacon that no real basis for a traditional literate culture could survive in the post-war and that civilization had become truly neurotic and philistine. Some of these psychological prisoners of war, and Cold War, were long after the fact still indulging imaginations of disaster and pessimism that, perhaps, could appropriately be termed 'post-Modern'.

In contrast, there are the pioneers of the new, Contemporary culture who, in spite of the intellectual devastation, continue to believe in the meaningfulness of English culture, even if its assumptions are unclear. While in the prosperity of post-war America artists and theorists could dabble in essentially Modernist notions of deconstructionism and the meaninglessness of cultural artifacts, the English, faced with the reality of rebuilding their nation, hardly have the luxury. If for no other reason than a historical sense of national dignity and hope, the most intellectually adventurous explore the idea of culture, finding it an ample subject for contemplation. They approach it theoretically from new points of view that defy the previous Modernist philosophy, some being liberal to the point of Marxist like Raymond Williams, others even being scientistic like C. P. Snow. They escape the nostalgia and insularity of those still looking to the past, coping for the first time with being English while being part of the European and American world, as, for example, through the 'pop' art of Richard Hamilton and Peter Blake and through the 'brutal' architecture of Alison and Peter Smithson and James Stirling. They resurrect the mythology of the English countryside, finding new sources of inspiration through the motif of the White Goddess, as in works by Robert Graves, Evelyn Waugh, Ted Hughes, and sculptor Henry Moore. They create feminist and traditional epics on the theme of being English and contemporary as do Doris Lessing in *The Golden Notebook* and John Fowles in *Daniel Martin*. While they are not always pleased with having become international and while they often cling to thoughts of a vaguely conceived paradise of the 'old England', these pathfinders deal with the future with its new psychologies, changed social order, and expanded vision of the world. In doing so, they conceive new and unique forms for their expression, blurring the usual distinctions among the genres of fiction, autobiography, literary and cultural criticism. An open door between art and life becomes their way to renewal and the image of their aesthetic. They chart the territory and create the canon of Contemporary English culture.

Exactly where this contemplation of culture is leading still remains unclear, but among the pathfinders there is the sense that they are going somewhere. That belief may be enough to define, at this point, a foundation for Contemporary English culture. By the end of my narrative, my hope is that the reader will feel, like

William Wordsworth contemplating the landscape above Tintern Abbey, that while 'something' of an earlier – Victorian – sense of civilization has been lost there is in the creative contemplation of English culture of the late twentieth century 'abundant recompense'.

1

Victorian Shades

They are the dark places of the earth, full of unimaginable cruelty, touching the Railway and the Telegraph on one side, and, on the other, the days of Harun-al-Raschid.

Rudyard Kipling, *The Man Who Would Be King* (1889)

I saw him open his mouth wide – it gave him a weirdly voracious aspect as though he had wanted to swallow all the air, all the earth, all the men before him.

Joseph Conrad, *Heart of Darkness* (1899)

But a cough like this – I didn't know there was such a cough! It isn't a human cough at all. It isn't dry and yet it isn't loose either – that is very far from being the right word for it. It is just as if one could look right into him when he coughs, and see what it looks like: all slime and mucous –

Thomas Mann, *The Magic Mountain* (1924)

Horatio Herbert Kitchener, standing amid the ruins of conquered Khartoum in September, 1898, considered sending the skull of his enemy to the Royal College of Surgeons for study and display.[1] He felt inspired both by a victor's sense of trophy and a Victorian's enthusiasm for measuring heads, and the Mahdi's skull, which had been brought to Kitchener after he had ordered the Muslim leader's tomb destroyed, was unusually large and well shaped. According to the fashionable views of the craniologists, study of it could well contribute to the distinguishing between the qualities of the civilized man and those of the barbarian. Indeed, Paul Broca, the French anthropologist (1824–1880), thought that the shape of a skull made all the difference in comparing the hero to the savage:

Frontal deformation produced blind passions, ferocious instincts, and animal courage, all of which I would willingly call occipital

courage. We must not confound it with true courage, frontal courage, which we may call Caucasian courage.[2]

Kitchener had good reason to feel heady: he had revenged the tragic death of his predecessor in Khartoum, General Gordon, whose head had been cut off and taken to the Mahdi,[3] and the savage dervishes of the Sudan finally had been subdued. Therefore, desecrating the tomb of the Mahdi in order to prove the warrior's mortality and end his worship as a prophet seemed like a good idea, an appropriate final act of the violent campaign for the control of the lower Nile valley.

Kitchener's critics at home disagreed. For them, desecrating the grave of the enemy – as well as accounts of inhumane treatment of the dervishes wounded during the campaign – sullied the English banner of civilization under which Kitchener marched. The hero of Omdurman was attacked in the press and in Parliament. George Bernard Shaw, in a letter to the *Morning Leader* of 6 October 1898, responds to an expression of willingness to accept the skull by the 'craniological secretary' of the Royal College of Surgeons by comparing its treatment to the mutilation of the body of Oliver Cromwell, an event which 'has hitherto been used to mark the Tartar-like savagery of English society 200 years ago'. Shaw continues in a Swiftian mode: 'I presume that if the next expedition of the Sirdar is undertaken against cannibals, public opinion of this sort will demand that he shall eat every chief whom he conquers, as otherwise the native population will not be persuaded that he is really stronger than they'.[4] Commenting in the *Contemporary Review*, January, 1899, Ernest W. Bennett says of the treatment of the Mahdi's body, 'The act is nothing more or less than a return to the barbarism of the Middle Ages'. He perceives in it a challenge to the very concept of imperialistic civilization:

> It is certainly high time that the conscience of civilised nations realised that some considerations of humanity are due even to a semi-civilised or barbarous enemy. The conduct of the Belgians in the Congo Free State, the French in Algeria, the Germans in the Camaroons, the Russians in Central Asia, ourselves in South Africa and the Soudan – the conduct of the various nations who are sharing in the partition of Africa and Asia, seems to be based on the assumption that the rights of the native in a state of war are practically *nil*.[5]

Winston Churchill, who had participated in the battle of Omdurman, described Bennett's account as 'absolutely correct'.[6] One member of Parliament rose to denounce the treatment of the Mahdi's corpse 'as a lamentable and revolting act which cast a blot upon our national renown.'[7] The controversy raged through the fall of 1898 and became so widespread by the spring of 1899 that a parliamentary white paper was issued in which the now *Lord* Kitchener categorically denied charges of inhumanity.

A young writer who had visited Africa and viewed there the effects of the progress of European civilization was immediately inspired by the controversy. On 31 December 1898, he wrote enthusiastically to his publisher about the contemporary relevance of the theme of his new novel:

> The title I am thinking of is *'The Heart of Darkness'* but the narrative is not gloomy. The criminality of inefficiency and pure selfishness when tackling the civilizing work in Africa is a justifiable idea. The subject is of our time distincly [sic] – though not topically treated.[8]

Merging personal observations of the ivory trade on the Congo made during a trip in 1890 with the issue of 'the civilizing work in Africa' recently raised by Kitchener's campaign on the Nile, Joseph Conrad, keeping his promise to his publisher to avoid being obviously topical, never names the river which is his setting, leaving it mysterious but provocative. Yet, in a novel composed and published serially at the very time of the Parliamentary debate on the Sudan (February, March, April, 1899), the author cannot resist titillating his reader with veiled allusions to the cloud on Kitchener's reputation and, specifically, to the incident of the skull. Conrad's very choice of the name 'Kurtz' would have seemed almost a pun at the time,[9] and the link between fact and fiction was forged by characterizing Kurtz in terms of the legendary Kitchener portrayed by journalists as an overly ambitious leader representing the finest of European civilization. Specifically, when Kitchener returned to London from the Sudan in October 1898, his special train was greeted at Charing Cross Station by European royalty as well as the Queen's minister,[10] and Kurtz is described as a man who 'desired to have kings meet him at railway stations on his return from some ghastly Nowhere, where he intended to accomplish great things' (69).

There is an emphasis throughout the novel on skulls and taking measure of them, beginning with the company physician's interest in the narrator Marlow's head: '"I always ask leave, in the interests of science, to measure the crania of those going out there . . . the changes take place inside, you know"' (11). Subsequently, the clearest picture in the narrative of the evil Kurtz occurs when Marlow expresses a similar interest in craniology: 'And the lofty frontal bone of Mr. Kurtz! They say the hair goes on growing sometimes, but this – ah – specimen was impressively bald. The wilderness had patted him on the head, and, behold, it was like a ball – an ivory ball; it had caressed him, and – lo! – he had withered; it had taken him, loved him, embraced him, got into his veins, consumed his flesh, and sealed his soul to its own by the inconceivable ceremonies of some devilish initiation' (49). And, reminiscent of George Bernard Shaw's satiric portrait of Kitchener, is the collection of skulls surrounding mad Kurtz. They hint at the savage rites to which he has descended by being carried away in the 'pure selfishness' and perverse 'efficiency', as Conrad described it to his publisher, of the 'civilizing work' in Africa:

> These round knobs were not ornamental but symbolic; they were expressive and puzzling, striking and disturbing – food for thought and also for vultures if there had been any looking down from the sky; but at all events for such ants as were industrious enough to ascend the pole. They would have been even more impressive, those heads on the stakes, if their faces had not been turned to the house. Only one, the first I had made out, was facing my way. I was not so shocked as you may think. The start back I had given was really nothing but a movement of surprise. I had expected to see a knob of wood there, you know. I returned deliberately to the first I had seen – and there it was, black, dried, sunken, with closed eyelids – a head that seemed to sleep at the top of that pole, and, with the shrunken dry lips showing a narrow white line of the teeth, was smiling too, smiling continuously at some endless and jocose dream of that eternal slumber. (58)[11]

Even after returning to Europe, Marlow's own head echoes with Kurtz's dying words of recognition of the depravity of which he had become a part in the wilderness, 'The horror! The horror!', but he cannot bring himself to tell them to Kurtz's Intended. Instead,

Marlow lies, telling her that Kurtz's last words were her name. In doing so, he upholds Kurtz's reputation and preserves the Intended's faith in European decency and courage. Indeed, Marlow lies for the sake of the very idea of civilization, to sustain it, because otherwise, as he says finally, 'It would have been too dark – too dark altogether' (79). In this way, *Heart of Darkness* presents a pessimism about the nature of civilization which is part of an intellectual movement beginning to stir in Europe at the end of the nineteenth century, and Conrad may have been the first English novelist to express it. Certainly his notions of the 'darkness' and the civilized 'lie' echo the thoughts and even the words of one of the earliest European pessimists proclaiming cultural degeneration, the Hungarian Max Nordau, whose famous work, *Degeneration*, appeared in English in 1895. Nordau titles an earlier book *The Conventional Lies of Our Civilization* (1883) and begins it by stating what he finds to be the paradox of his times:

> Culture and civilization are spreading and conquering even the most benighted regions of the globe. Those countries where darkness reigned but yesterday, are to-day basking in a glorious sunshine. . . . But yet, . . . the world of civilization is an immense hospital-ward, the air is filled with groans and lamentations, and every form of suffering is to be seen twisting and turning on the beds. . . . Pause and listen at the borders, and the breeze will bring to your ears from each one, the same confused echoes of contention and tumult, of revolt and of oppression.[12]

While telling his lie, Conrad's Marlow is hearing the same echoes as Nordau, and the sense of doom for civilization anticipates Oswald Spengler's *Decline of the West* (1918), the vision of all of Europe as a hospital ward in Thomas Mann's *Magic Mountain* (1924),[13] and Sigmund Freud's speculation in *Civilization and Its Discontents* (1930) that 'if the development of civilization has such a far-reaching similarity to the development of the individual and if it employs the same methods, may we not be justified in reaching the diagnosis that, under the influence of cultural urges, some civilizations, or some epochs of civilization – possibly the whole of mankind – have become "neurotic"?'[14]

Marlow – and Conrad – are not alone in hearing these disturbing echoes in 1899. Struggling to put an end to the irritating business of the Mahdi's skull which was besmirching his reputation, Kitchener

writes to Queen Victoria in March to try to bury the matter: 'Lord
Kitchener is much distressed that Your Majesty should think that
the destruction of the Mahdi's tomb, and the disposal of his bones
was improperly carried out. The Mahdi's skull, in a box,
was brought to me, and I did not know what to do with it. I
had thought of sending it to the College of Surgeons where, I
believe, such things are kept. It has now been buried in a Moslem
cemetery.'[15] The true fate of the skull remains unclear since one
witness suggests that it was, in fact, actually sent to the Royal
College of Surgeons,[16] even though Kitchener claimed to have had
it buried. However, the Queen accepted Kitchener's explanation
and ended the matter by replying that she was 'quite satisfied
now, as the skull has been buried', but her letter also suggests that
even she had caught a glimpse from the public controversy of the
threatening 'darkness' lurking at the borders of her empire. Queen
Victoria tells Lord Kitchener that 'the destruction of the poor body
of a man who, whether he was very bad and cruel, after all was a
man of a *certain* importance . . . savours in the Queen's opinion, too
much of the Middle Ages.'[17]

Lord Kitchener, contemplating the skull of the Mahdi, stands at
the threshold of the twentieth century.

* * *

But it is not until 1939 when war overran Europe that Victorian
confidence in the glory and security of English civilization finally
dissipates. Origins of this inevitable recognition lay in the intel-
lectual shock experienced in Europe at the violence of the first
world war in the Teens, the mania of its decadent aftermath in the
Twenties, and the despair of the depressed economy and the rise of
Fascism of the Thirties. By the time war again engulfs Europe, think-
ers and artists were finding in the historical chaos frightening, dark
forces signifying the passing of the old order of civilization. There is
a loss of the belief which had existed since the Enlightenment in the
rationality of man and society, and a growing feeling that the indi-
vidual person is irrelevant and helpless amid uncontrollable forces.
Neither art nor philosophy nor, indeed, even language itself any
longer seems adequate to maintain a sense of understanding and
civilized values amid the wasteland. Artistic icons of expectation
and anticipation of the coming of a new age prevail.

One prophet of change between the wars had been W. B. Yeats.
Again and again he describes the old order disintegrating and

giving way to an unknown future one. Yet, even as Yeats witnesses
the moral chaos of his time, he epitomizes a lingering commitment
to belief in the power of the mind to order experience, if not
rationally then by the creation of personal myth. Yeats proclaims
this confidence in 'All Souls' Night' (1921), the poem that serves
as an epilogue to the presentation of his metaphoric system in
A Vision (1925) and that is placed at the end of his volume of
poems celebrating the 'unageing intellect', *The Tower* (1929). Echo-
ing William Wordsworth's tribute to 'the philosophic mind' in *Ode:
Intimations of Immortality*, Yeats writes:

> Such thought – such thought have I that hold it tight
> Till meditation master all its parts,
> Nothing can stay my glance
> Until that glance run in the world's despite
> To where the damned have howled away their hearts,
> And where the blessed dance;
> Such thought, that in it bound
> I need no other thing,
> Wound in mind's wandering
> As mummies in the mummy-cloth are wound.[18]

But even Yeats's poetic 'thought' begins to unwind amid the his-
torical nightmare at the end of the 1930s, and he comes to question
his vision. His last plays, *Purgatory* (1939) and *The Death of Cuchulain*
(1939), anticipate the stark post-war plays of Samuel Beckett and
Harold Pinter in expressing anxiety, pessimism and fear. While in
earlier works Yeats had celebrated the 'sensual music' of the procre-
ation of generations, in *Purgatory* he presents an Old Man who after
viewing the cursed state of civilization exemplified by a 'ruined
house' stabs to death a Boy 'because had he grown up/He would
have struck a woman's fancy,/ Begot, and passed pollution on,'[19]
words anticipating Hamm's fear of procreation in Beckett's *Endgame*
(1958).[20] At the end of *Purgatory*, the Old Man prays hopelessly:

> O God,
> Release my mother's soul from its dream!
> Mankind can do no more. Appease
> The misery of the living and the remorse of the dead.

Similarly, in *The Death of Cuchulain* Yeats, in the mode of a Prospero
lamenting the limits of his magic, presents an Old Man who

expresses a sense of inadequacy and irrelevancy in 'producing' the play:

> I have been asked to produce a play called *The Death of Cuchulain*. It is the last of a series of plays which has for theme his life and death: I have been selected because I am out of fashion and out of date like the antiquated romantic stuff the thing is made of.

Even 'words' themselves – in an age of propaganda – no longer can be trusted by the Old Man,

> I promise a dance. I wanted a dance
> because where there are no words there is
> less to spoil,

and, indeed, the play concludes in an abstract and expressionistic style with a dance around a circle of six black parallelograms 'the size of a man's head' representing Cuchulain and other 'dead'. The black forms evoke the mythology of an ancient Celtic stone-ring, the lingering relic of a lost civilization. They commemorate the end of an age along with the death of Cuchulain, and they present a transformed image of the emerging cycle of history. Its form is very different from Yeats's earlier vision of a terrifying but vigorous 'rough beast' which 'Slouches towards Bethlehem to be born' in 'The Second Coming' (1920). As the dying Cuchulain describes his reincarnation,

> There floats out there
> The shape that I shall take when I am dead,
> My soul's first shape, a soft feathery shape,
> And is not that a strange shape for the soul
> Of a great fighting-man?

This bird-like shape represents a more vulnerable and tentative form of release than Yeats had earlier foreseen.

When Yeats dies in January, 1939, with England on the brink of another war, it is a time for mourning not only the passing of genius but the passing of an age. The 'darkness' anticipated by Conrad has descended, and the human condition is nightmarish. 'The day of his death was a dark cold day' is the refrain of W. H. Auden's

'In Memory of W. B. Yeats'.[21] Auden views Yeats's belief in the power of the artistic mind as inadequate for affecting change in the human condition: 'Now Ireland has her madness and her weather still,/For poetry makes nothing happen'. Indeed, in Auden's ironic view, Yeats's death will be barely noticed, 'As one thinks of a day when one did something slightly unusual'. Yet, Auden commemorates Yeats because at a time when 'In the nightmare of the dark/All the dogs of Europe bark', he brought understanding and illumination through his acceptance of transition in what Auden terms his 'rapture of distress'. Yeats, too, found comfort in the 'terrible beauty' of his time because he accepted the inadequacy of humanity in the face of historical change.

Freud, in probing the discontents of civilization, tries like Yeats to explain the 'darkness', and, when he dies in September, 1939, he too, with his times, is elegized by Auden. The poet celebrates Freud for his attempt to explain the twentieth-century mind, yet, as in the poem on Yeats, Auden is ironic in portraying the insignificance of genius in troubling times. Most people will notice only briefly the passing of 'an important Jew who died in exile'; yet, for the poet, 'One rational voice is dumb'. Freud's teachings offer solace because

> he would have us remember most of all
> to be enthusiastic over the night,
> not only for a sense of wonder
> it alone has to offer, but also

> because it needs our love.

As Auden views the passing of genius, history seems to be in Satanic hands; nevertheless, Freud made 'darkness' and its 'fauna of the night' the object of his study. Therefore, Auden compares Freud's psychoanalytic method to a traditional descent to the Underworld:

> but he went his way,
> down among the lost people like Dante, down
> to the stinking fosse where the injured
> lead the ugly life of the rejected.

Ultimately, Freud, like Yeats, has made some difference, 'in a world he changed/simply by looking back with no false regrets'. He

sought to extend the rationality of scientific inquiry to the 'darkness', an act of intellect contrary to the pessimism of an age in which

> sad is Eros, builder of cities,
> and weeping anarchic Aphrodite.

Auden celebrates Yeats for trying to explain modern history and Freud for trying to plumb its darkness, but the poet as modern elegist could understand the limits of creativity and intellect better than they could. Yeats and Freud are children of the nineteenth century with its confidence in the power of the individual mind to effect change, while Auden, a child of the twentieth century, can only view their 'achievement' with sad irony.

Auden's world of 1939 is a disillusioning one where, as he describes it in the elegy on Freud,

> Only Hate was happy, hoping to augment
> his practice now, and his dingy clientele
> who think they can be cured by killing
> and covering the gardens with ashes.

The imagery of the spoiled garden complements that of another observor of the century, T. S. Eliot. His *Waste Land* (1922) and *Ash Wednesday* (1930) express the sense of social and personal paralysis that follows the first world war, and his *Four Quartets* (1935–42) anticipate and define the violence of the second. The first of the *Quartets*, 'Burnt Norton' (1935), begins by presenting the depressed world of the 1930s as a fading rose garden in which there is a 'drained pool'.[22] The imagery continues the sense of sterility expressed in Eliot's earlier poems: 'Dry the pool, dry concrete, brown edged'. But, conditions now have worsened: winter threatens and there is a quality of the fragile and ominous to the autumnal garden scene:

> Go, go, go, said the bird: human kind
> Cannot bear very much reality.

In the final poem of the *Quartets*, 'Little Gidding' (1941), Eliot elegizes Yeats and the end of civilization as he had known it. Written during the 'blitz' of London, the poem describes an early

morning walk after a bombing raid during which Eliot encoun-
ters the 'shade' of Yeats. The hallucinatory experience merges the
imagery of Dante's *Inferno* with, appropriately and evocatively, that
of Yeats's 'Byzantium'. Yeats's poem of 1930 describes civilization
in disarray, its artistry shattered and broken; amid the chaos the
poet confronts a figure who embodies the terror and mystery of a
time of human and cultural transition:

> Before me floats an image, man or shade,
> Shade more than man, more image than a shade;
> For Hades' bobbin bound in mummy-cloth
> May unwind the winding path;
> A mouth that has no moisture and no breath
> Breathless mouths may summon;
> I hail the superhuman;
> I call it death-in-life and life-in-death.

In 'Little Gidding', Eliot evokes this sense of a dying civilization
to describe London after the bombing, and the mysterious shade
he meets is Yeats himself who had sought through art to span the
cycles of history.

Eliot introduces the encounter by conveying a sense of the
uniqueness of the moment: it is one when understanding, usually
denied to the mortal, can come only from beyond the natural world.
Hence, only the 'dead' can assist poetic vision amid the 'fire' of the
pentacostal violence of the 'blitz':

> And what the dead had no speech for, when living,
> They can tell you, being dead: the communication
> Of the dead is tongued with fire beyond the language of the
> living.
> Here, the intersection of the timeless moment
> Is England and nowhere. Never and always.

At this moment in history, then, and in the dawn after an attack,
Eliot meets a purgatorial Yeats, who, like the troubled ghost of
Hamlet's father, wanders about in search of peace. It is as if Eliot,
viewing himself as Yeats's inheritor, suddenly understood what his
predecessor was trying to say. Yeats's message and its imagery
recalls that of his 'Byzantium' and 'Second Coming', the inadequacy
of any person's philosophical ideas or poetic myth amid the turmoil
of history:

> 'I am not eager to rehearse
> My thought and theory which you have forgotten.
> These things have served their purpose: let them be.
> So with your own, and pray they be forgiven
> By others, as I pray you to forgive
> Both bad and good. Last season's fruit is eaten
> And the fullfed beast shall kick the empty pail.
> For last year's words belong to last year's language
> And next year's words await another voice.'

The shade of Yeats continues to warn of the frustration and rage of trying to cling to outmoded beliefs, and he concludes with a vindication of violent change as regenerative and necessary:

> 'From wrong to wrong the exasperated spirit
> Proceeds, unless restored by that refining fire
> Where you must move in measure, like a dancer.'

The lines echo the conclusion of 'Byzantium' which celebrates the vitality of artistic expression in surviving generations and inspiring future ones:

> Marbles of the dancing floor
> Break bitter furies of complexity,
> Those images that yet
> Fresh images beget,
> That dolphin-torn, that gong-tormented sea.

Eliot's understanding of his time merges with Yeats's. At the conclusion of 'Little Gidding' and the *Four Quartets*, then, Eliot, evoking the Logos of John's Gospel, focuses on words as the agent of the new 'beginning':

> What we call the beginning is often the end
> And to make an end is to make a beginning.
> The end is where we start from. And every phrase
> And sentence that is right . . .
> Every phrase and every sentence is an end and a beginning.
> Every poem an epitaph.

Virginia Woolf, too, acknowledges the ambiguity of the moment. In *Between the Acts*, virtually complete at the time of her suicide and

published posthumously in 1941, she acknowledges the prevailing sense of interregnum, beginning with the title.[23] It refers specifically to the major action of the novel, the presentation of a pageant of English history from the beginning to June 1939, the very eve of war. The play, like the cycle of history it presents, must end enigmatically, after being interrupted, as it is, by a thunderstorm; so, too, the lives of the central characters: Isa Oliver who is 39, 'the age of the century' (19), her husband Giles, a guest, Mrs. Manresa, who is pursuing him, and Mr. Haines, a gentleman farmer, with whom Isa is in love. Their quadrangle of affection and disaffection remains unresolved, anticipating the sort of domestic paralysis presented in the post-war plays of Harold Pinter. Their lives consist of waiting for both the next stage of their lives and the next act of the pageant of their own times:

> They were all caught and caged; prisoners; watching a spectacle. Nothing happened. The tick of the machine was maddening. (176)

The ticking is that of a grammophone used to accompany the pageant, but its rhythm is, of course, clocklike. Hence, the characters await their fate in time, seeking identity and resolution, conscious of their Victorian confidence dissipating amid the ambivalence of the historical moment:

> They were neither one thing nor the other; neither Victorians nor themselves. They were suspended, without being, in limbo. Tick, tick, tick went the machine. (178)

The last act of the pageant is 'the present', that being the time of war represented by 'aeroplanes' flying in formation overhead. For Virginia Woolf, the horror of the moment is not in the unseen violence elsewhere, but in the terror of not knowing what it all means and where it is leading. Indeed, in Woolf's village, as in Eliot's garden, 'present reality' is untenable, as the author and director of the pageant, Miss LaTrobe, acknowledges:

> She wanted to expose them, as it were, to douche them, with present-time reality. But something was going wrong with the experiment. 'Reality too strong', she muttered. 'Curse 'em!' (179–80)

Indeed, reality was 'too strong' for the novel's author as well, on the brink of self-destruction as she was, but a sense of it is finally revealed in her novel. The present is 'ourselves', the audience mirrored in myriad reflectors held up by the actors, creating, like Yeats's broken marble and Eliot's 'last year's words', a shattered vision of 'present reality' to be sure. The novel ends with history and with those 'caught and caged' by it who wait for the next, unknowable act of their lives to commence.

Like Yeats and Eliot, Woolf, too, looks forward desperately to the answers for civilization which will come out of the violence. Her style bristles with metaphor – cloyingly so; and the wretched suspense of the present and the need to act violently for relief are finally brilliantly summed up in symbol. Giles, leaving the pageant during one of its interruptions, encounters a most allegorical scene:

> There, couched in the grass, curled in an olive green ring, was a snake. Dead? No, choked with a toad in its mouth. The snake was unable to swallow; the toad was unable to die. A spasm made the ribs contract; blood oozed. It was birth the wrong way round – a monstrous inversion. So, raising his foot, he stamped on them. The mass crushed and slithered. The white canvas on his tennis shoes was bloodstained and sticky. But it was action. Action relieved him. He strode to the Barn, with blood on his shoes. (99)

This is the 'reality too strong' of England, June 1939, on the brink of a declaration of war. Woolf's 'blood' is like Yeats's anticipatory shade of 'death-in-life and life-in-death' and Eliot's cleansing pentacostal 'fire'. All accept the violence of the 'present reality' as a way to get on with history; all wander about in the Underworld seeking direction to what lies beyond.

After war was declared 3 September 1939, the sculptor, Henry Moore, chose his own way to respond. He abandoned sculpture altogether and devoted himself to a series of drawings of the wartime Underworld which evoke a stifling atmosphere similar to Woolf's *Between the Acts*. Some of the drawings portray the air raid shelters in the 'Underground' with people being wrapped like mummies in their blankets and sheets, images suggesting the realisation in London of Yeats's decaying 'Byzantium' [Plate 1]. As one critic describes the experience of these drawings, 'It is a descent into hell, a sort of underground migration to seek safety and salvation.

At the end of these tunnels crowded with bodies lined up along the wall, the little light of day and hope appears. These creatures seized while waiting or asleep are a presentiment of waking and the resurrection.'[24] Moore himself recognized the pervading theme of the shelter drawings to be 'the group sense of communion in apprehension'.[25] In addition to these scenes of the domestic world underground, Moore sketched the industry of what was known as the 'British Underground Army', miners at work. While the dwellers of the Underworld are mostly women and children, the miners are male. Hence, the wartime sketches of the Underworld note the suffering of separation in the human family – the family being a frequent motif of Moore's sculpture – while celebrating the heroism both of those who labor for the nation and those who suffer its trials resolutely. All in this propagandistic allegory of the enduring family at war display the fortitude and hope that remain alive beneath the violent surface of life.

Two allegorical drawings mark the advent and close of this period of Moore's effort. The first, 'September 3rd, 1939', shows the cliffs of Dover, dark but massive in strength and enduring, while eight mis-shapen and apparently anguished classical human forms – Moore sculptures, perhaps – sink into the sea in the foreground: a presentation of British strength and resolution in the face of the European disaster [Plate 2]. The very classicism of the drowning forms suggests the sculptor's sense of tradition becoming lost with nothing new identified to take its place. They are the equivalent of Yeats's dramatic image of the ring of black parallelograms in *The Death of Cuchulain*.[26] The second drawing of 1942 is described adequately by its title, 'Crowd Looking at a Tied-Up Object'. The 'object' at which the crowd stares expectantly from a littered wasteland – a battlefield perhaps – is a tall and somewhat phallic shaped form wrapped in a white curtain and bound with rope. Its irregular shape suggests one of the unhewn shafts of stone which Moore kept for his work,[27] and it is wrapped in a net of lines like the waiting mummified figures in the shelter drawings. Yet, in contrast to the sombre image of the drawing from 1939, this drawing suggests hope for the unveiling of a new, vital cultural icon once the restraints of war are removed. The unformed sculpture embodies the unrevealed potential of Yeats's 'soft feathery shape', Eliot's 'epitaph', Woolf's unwritten next 'act'. It captures the expectation of all that out of the shattered relics of their civilization will be born a new culture with different forms of expression.

2
Orwell's War

History . . . is the Devil's scripture.

<div align="right">Lord Byron, Cain (1821)</div>

The cinema sheet stares us in the face. The sheet is the actual fabric of Being. Our loves, our hates, our wars and battles, are no more than a phantasmagoria dancing on that fabric, themselves as unsubstantial as a dream. We may rage in our dreaming.

<div align="right">H. G. Wells, Mind at the End of Its Tether (1946)</div>

In Bedlam, or, rather, the building that previously housed the London asylum, now the Imperial War Museum, hangs the last official historical painting. (After the Second World War photography took over the visual documentation of history.) Its remarkable subject is the Nazi war crimes trial held at Nuremberg; its remarkable painter, sent by the War Office to provide an official record, a seventy year old woman named Laura Knight, who had first exhibited her work during the reign of Queen Victoria. Born in 1877, she acquired her reputation by creating skilful figure studies, especially of circus, ballet, and theatre performers, and she was elected to the Royal Academy in 1927 (only the second woman in this century). She published her autobiography in 1936; she published a second autobiography in 1965.[1] Knight became well-known during the war for posters from her paintings portraying scenes of people engaged in military activities – an air raid warden, a women's barrage balloon crew, a bomber flight crew, but her response in 1946 to seeing war-ravaged Germany and hearing testimony at the warcrimes trial produced a result quite different from her previous work.

Knight conscientiously recorded her reactions to Nuremberg in her diary. About the trial, she comments: 'Again and again, the theatre comes to mind: "good lines", "bad lines", "good diction",

"bad diction"' (290). In addition, living in a bomb-damaged hotel and driving about in a war-torn city leads her to exclaim, 'every corner of that city told its own poignant and terrible story' (297). The enormity of the mortal loss is inescapable: 'We sit side by side with death – and death by the million – wherever we are' (289). Hence, the totality of the destruction and the pervasiveness of all that the trial embodies and represents for the condition of humankind permeates her psyche: 'No matter whether asleep in bed at night – no matter whether at the breakfast or the dinner table, wherever you are and whatever your attitude of mind – everything reverts to the trial' (291). Months after returning home to England, she finds 'haunting still is the nightmare of Nuremberg' (309). These elements of Knight's immersion in the world of Nuremberg coalesce for her composition: the theatricality of the courtroom with its testimony and showing of horrifying films, the daily encounter with the bombed city, and an overall feeling of being involved in nightmare; the result is a painting of enormous ambition.

Knight paints a theatre of horrors in which the defendants and their counsels from the real trial are shown as spectators witnessing the nightmare of the disasters of war [Plate 3]. From the theatre of the courthouse, they witness a scene of burning and devastated buildings amid a sea of dead, dying, and wounded victims, the very picture of the collapse of civilized order prophesied in Yeats's imagery of 'broken wall, the burning roof and tower/And Agamemnon dead' ('Leda and the Swan', 1928). For this painting, Knight breaks away from the conventions of design of her usual realistic and figurative work to paint surrealistically in order to convey the psychological as well as the literal nightmare of Nuremberg and what it means, and her composition presents a shocking tension between order and civilization and chaos and barbarism. She questions through her design the very idea of confidence in human rationality that had endured since the Enlightenment, confronting the viewer with the best and the worst of what human beings can make of themselves. In looking at the painting, initially one perceives the civilized order of the brightly lit courtroom with its rigid rows of prisoners, ten to a bench, guarded by a carefully spaced company of white-helmeted, uniformed military guards. Then, in contrast, one perceives in the dimly lit nightscene of the background the horrors of war, chaos encroaching on the order of the courtroom as the arms of victims reach out into the setting of the trial. And, in the midst of the composition, one encounters

the defendants, each given individuality by being presented in his typical courtroom pose yet each faceless and almost anonymous in the ignominy of his shame, portrayed not from the straightforward attitude of conventional portraiture but as if viewed from a curious vantage point above the head. By her strategy, Knight captures in the physical presence of each defendant the pathos and weakness of all of them: 'Goering's soignée coiffure' and 'ominous bald patch on the crown of his head', the 'unbending figure Keitel who, always stiffly upright, had no crease in his uniform', or, in contrast, 'poor little Funk, the pianist, . . . sits all in a huddle – aloof, clothed in the crumpled folds of a smart black suit, his linen collar and cuffs a spotless white' (288–89). Knight's painting is clearly about a 'Reality too strong' in which the very ability of frail humanity to uphold the responsibility of civilization is under severe scrutiny.

The disorienting strategy of presentation conveys a sense of the presence of another engaged participant at this trial of civilization, the artist herself. When Knight was first shown the courtroom, she pointedly rejected a place with other reporters over the prosecutors' table from which the defendants' faces could be directly seen, stating, 'I find the view of the court from there to be utterly uninteresting'; she chose, instead, to sketch from a gallery immediately above the dock, looking down almost on the backs of the prisoners' heads. At the same time, apparently in order to keep her viewer's attention focused on the human issue, she excluded from her final composition – though not from preliminary sketches done in the courtroom[2] – the most interesting and symbolic feature of the courtroom setting, described in her diary as 'an elaborate malachite-green bronze and carved wooden emblem of Justice – a well-fed Justice' (286–87); perhaps, she finally thought it too ironic and out of place for her conception. The choice of perspective is significant because, like the overall surrealistic design for the composition, Knight in her perspective breaks with her own strongly pictorial and representational style. She is not just depicting a scene or painting a portrait; she is personally commenting through her art on the significance – the idea – of the Nuremberg moment, and her view of the state of civilization corresponds to that anticipated at the turn of the century by Conrad. Like Marlow in *Heart of Darkness*, Knight is ultimately fascinated by the skulls of the defendants, especially as they are set off against the white helmets of their guards, and she seeks to suggest through the awful phantasmagoria surrounding them something of the 'darkness' of the human psyche

that is being tried and examined. The 'Big Lie', which these Nazis on trial at Nuremberg had told, had evolved from Marlow's 'lie' for civilization.

*　　　　　*　　　　　*

George Orwell understood the 'lie' in civilization and its threat to traditional English culture. Beginning with *Inside the Whale*, a collection of three essays published in 1939, he commenced a campaign against the 'lie' from the point of view of a psyche under historical stress and with a Marxist's obsession with social artifacts. *Inside the Whale*, therefore, progresses from an assessment of why in the present reality the Victorian writer Charles Dickens still seems so quintessentially 'English', through an analysis of disturbing social values implicit in the adolescent literature of the Edwardian boys' weeklies, to a definition and acceptance of the passive political and aesthetic position assumed by an almost unknown American contemporary novelist, Henry Miller. These essays represent Orwell's effort to survive and to cope intellectually amid the general darkness of economic hardship and the onslaught of war; they express his struggle to find and cling to English values amid what he thinks is an increasingly hopeless situation. In responding to his times as a working journalist and without consciously intending to make an artistic declaration, it is Orwell who establishes the agenda for concerned questioning of the nature of English culture at midcentury. Observing in Germany the emergence of a well-conceived theory of propaganda and realizing how through mass communication language can be used politically to manipulate and to instigate human thought and action, Orwell's fundamental insight into what is happening to his civilization in *Inside the Whale* is his recognition that English culture essentially derives its values from literature and that this heritage is threatened intellectually by the historical demise of respect for the integrity of words.

Orwell approaches his first topic, Dickens, with the intention of irritating his reader into confronting the issue. After summarizing Dickens' themes, Orwell stops midway through the essay to admit to his strategy and to state his basic assumption:

> By this time anyone who is a lover of Dickens, and who has read as far as this, will probably be angry with me.
> I have been discussing Dickens simply in terms of his 'message', and almost ignoring his literary qualities. But every writer,

especially every novelist, *has* a 'message', whether he admits it or not, and the minutest details of his work are influenced by it. All art is propaganda.

'All art is propaganda' – Orwell's disturbing premise is stated like one of the political slogans of his time that he despised, but then he goes on to explain that the basis of Dickens' continuing popularity is the very fact that he cannot be claimed by any single ideology. While Dickens 'has been stolen by Marxists, by Catholics and, above all, by Conservatives' (I, 448–49),[3] the fact is, according to Orwell, the novelist essentially lacks a political vision: 'His radicalism is of the vaguest kind, and yet one always knows that it is there. . . . He has no constructive suggestions, not even a clear grasp of the nature of the society he is attacking, only an emotional perception that something is wrong. All he can finally say is, 'behave decently', which . . . is not necessarily so shallow as it sounds' (I, 457–58). Consequently, in concluding the essay, Orwell contemplates a photograph of Dickens as a way to sum up the Victorian's relevance:

> It is the face of a man who is always fighting against something, but who fights in the open and is not frightened, the face of a man who is *generously angry* – in other words, of a nineteenth-century liberal, a free intelligence, a type hated with equal hatred by all the smelly little orthodoxies which are now contending for our souls. (I, 460)

Dickens still stands for an ideal of being 'English' in the world of conflict and hate that is 1939.

While Dickens' novels are praised for avoiding ideology and orthodoxy, stories published in the boys' weeklies are condemned for fostering them, however naively. Orwell chooses the topic because of his initial premise that the attitude of an individual is shaped by all of the artifacts, especially written and visual ones, that surround him in his environment; he has been appropriately praised for initiating in this essay serious consideration of 'popular culture' as a subject for scrutiny.[4] Consequently, recognizing the manipulative and shaping power on the reader of even the most unsophisticated fiction, Orwell selects his unlikely topic. He finds the values in the stories from some of the older weeklies to be essentially 'Conservative, but in a completely pre-1914 style, with no

Fascist tinge' (I, 471). In newer publications, however, he finds more frightening modern attitudes: 'The other thing that has emerged in the post-war boys' papers, though not to anything like the extent one would expect, is bully-worship and the cult of violence' (I, 476). Most importantly, Orwell finds that the social outlook of all of the stories is arrested in Edwardian snobbishness and that working-class characters and their life are ignored or treated stereotypically:

> Where working-class characters appear, it is usually either as comics (jokes about tramps, convicts, etc) or as prize-fighters, acrobats, cowboys, professional footballers and Foreign Legionaries – in other words, as adventurers. There is no facing of the facts about working-class life, or, indeed, about *working* life of any description. (I, 480)

Orwell concludes that the fiction of the boys' weeklies is a manipulative expression of Conservatism which ill-prepares adolescent readers to cope with the facts of life in 1939:

> I am merely pointing to the fact that, in England, popular imaginative literature is a field that left-wing thought has never begun to enter. *All* fiction from the novels in the mushroom libraries downwards is censored in the interests of the ruling class. And boys' fiction above all, the blood-and-thunder stuff which nearly every boy devours at some time or other, is sodden in the worst illusions of 1910. (I, 484)

In Orwell's view here, England is not yet the explicitly controlled world of Big Brother that he will later describe, but in light of the Fascist threat it is viewed rhetorically in some bitterness as dominated by a conservative political hegemony that manipulates innocent minds for its own purposes.

Having explored the popularity of Dickens and the implicit propaganda in boys' weeklies, Orwell, in the long title essay 'Inside the Whale', becomes more introspective. He had expressed his admiration for Henry Miller as early as 1936 in a review of *Black Spring* in which he also praised *Tropic of Cancer*, published the previous year, because 'it cast a kind of bridge across the frightful gulf which exists, in fiction, between the intellectual and the man-in-the-street. . . . Books about ordinary people behaving in an ordinary manner are extremely rare' (I, 230). Orwell's novels

of the Depression, *Keep the Aspidistra Flying* (1936) and *Coming Up for Air* (1939), are attempts kindred to those of Miller to present the plight of the common man; consequently, the Englishman is well-prepared to understand the American's attitudes in an age contemplating disaster. Since at that time Miller's novels were obtainable only in Paris from the Obelisk Press and the English public would have had little opportunity to read them, the focus of the essay for the reader inevitably had to be more on Orwell's opinions than on Miller's fiction. This is appropriate to Orwell's intention of using a discussion of Miller as a means of shaping the articulation of his own view of the kind of writing that is required for dealing artistically with the historical moment. Orwell praises Miller for writing with prescience as if 'our civilisation was destined to be swept away and replaced by something so different that we should scarcely regard it as human' (I, 519). He understands that Miller, to cope, declares a position of 'irresponsibility' and succeeds in posing as a kind of Jonah:

> Miller himself is inside the whale. All his best and most characteristic passages are written from the angle of Jonah, a willing Jonah . . . he feels no impulse to alter or control the process that he is undergoing. He has performed the essential Jonah act of allowing himself to be swallowed, remaining passive, accepting. (I, 520–21)

This attitude is necessary for the writer during the historical interregnum, for, as Orwell sees it,

> What is quite obviously happening, war or no war, is the break-up of *laissez-faire* capitalism and of the liberal-Christian culture. . . . Almost certainly we are moving into an age of totalitarian dictatorships – an age in which freedom of thought will be at first a deadly sin and later on a meaningless abstraction. (I, 525)

For Orwell, then, the coming war is only a symptom of a larger cultural crisis.

From *Inside the Whale* to *Nineteen Eighty-Four* distinctions among the forms of writing used by Orwell become increasingly blurred; the content of one genre tends to merge with that of another and differences between fiction and essay, commentary and

autobiography, creatively break down under the pressure of his perception of the intellectual crisis. Orwell's obsession with the plight of language in a nation under threat of losing its literary culture inspires a cluster of fictional and nonfictional works that should be viewed as variations on the theme. Consequently, in discussing these works and using Orwell's statement in one mode – for example, the essay – to explicate his meaning in another – the novel, one must recognize that the author intellectually and artistically cannot and does not maintain the usual distinctions between genres. His works are integrated so closely in theme and metaphor that they must be seen as simultaneous and continuous in their vision of the danger of cultural breakdown. This loss of discrimination among genres – which happens instinctively in Orwell's writings – anticipates a significant characteristic of late twentieth-century artistic expression.[5]

Orwell's works of 1939 exemplify this attribute. He writes *Coming Up For Air* simultaneous to composing 'Inside the Whale', and the novel is a fictional treatment of life in the historical interregnum written in the comic style of Miller described in the essay. Orwell's protaganist is a kind of disgruntled John Bull figure named George Bowling, nicknamed, appropriate to his shape, 'Fatty', who sells insurance, and, who, as we watch him during the summer of 1938, personifies the predicament specified by the epigraph to the novel, 'He's dead, but he won't lie down'. He seems like the bloated toad about to be crushed under Giles's foot in *Between the Acts*; but, actually, all that happens to Fatty by the end of the novel is that, after a disillusioning trip to the place that was his childhood home, he returns to face the anger of his shrewish wife who wants to know where he has been and what he has been doing. Therefore, while the plot of the novel can be described as comic, the reader cannot ignore the tragedy of Fatty's discovery of the absurdity of the human condition in his time. In limbo in 1938, waiting for war, Fatty learns that the civilization in which he grew up is gone and that he is the victim of social and historical forces beyond his control.

Fearful of the future, Fatty views his world with the alienated cynicism of Miller's protagonists.[6] His suburban neighborhood, Ellesmere Road, 'is part of a huge racket called the Hesperides Estate, the property of the Cheerful Credit Building Society' (15).[7] To him, it is a 'line of semi-detached torture chambers' (14) ruled by the commercial 'god of building societies' (15) in a city of 'skeletons

walking' (29). Fatty believes himself to be the 'only person awake in a city of sleepwalkers' (28), and, while a totalitarian society may still be only a future threat, he finds the world of which he is a part to be as imprisoning as if the inescapable future had already come:

> Fear! We swim in it. It's our element. Everyone that isn't scared stiff of losing his job is scared stiff of war, or Fascism, or Communism, or something. Jews sweating when they think of Hitler. (19)

Like Miller's protagonists, Fatty finds the political voices of his time irrelevant; neither spokesmen for progress nor for tradition – no ideology, Left or Right – can relieve his anxiety. He hears a lecture on the menace of Fascism at a Left Book Club meeting and finds it to be a foreshadowing of the horror of society after the expected war. He watches the anti-Fascist speaker stir up the crowd to 'Hate, hate, hate . . . have a good hate' and realizes that

> it isn't the war that matters, it's the after-war. The world we're going down into, the kind of hate-world, slogan-world. . . . And the processions and the posters with enormous faces, and the crowds of a million people all cheering for the Leader till they deafen themselves into thinking that they really worship him. (148–49)

For Orwell's Fatty, then, the 'hate' of the book club meeting with its reminder of Hitler's mass gatherings foreshadows the England of the future, whether politically an England of the Left or of the Right. Subsequently, Fatty visits a retired school master, Porteous, thinking that 'if the local Left Book Club branch represents Progress, old Porteous stands for Culture' (153), but tradition and literature also turn out to be irrelevant under the circumstances. Porteous, so old-fashioned that he even objects to listening to what he calls the 'wireless', considers Hitler to be 'a mere adventurer' whose effect on history will be 'ephemeral' (157). This view hardly satisfies Fatty who even while listening to the old man cannot avoid thinking about the war and especially the 'after-war, the food-queues and the secret police and the loudspeakers telling you what to think' (158). Fatty concludes that Porteous, with his 'whole life revolving

round the old school and . . . bits of Latin and Greek and poetry', is *'dead* . . . a ghost' (159) and that neither Progress nor Culture really matter anymore, 'neither of them cuts much ice in West Bletchley' (153). 1948 – or 1984 – is already present in Orwell's interpretation of 1938 through Fatty's eyes, and there is no escaping the consequences.

Nevertheless, Fatty tries desperately to recover a golden age of his youth. Anticipating the nostalgic structure of Evelyn Waugh's *Brideshead Revisited* (1945), more than half of Fatty's autobiography (Part II) consists of his long reminiscence of his turn-of-the-century childhood in the pastoral village of Lower Binfield in Oxfordshire. Fatty remembers it as 'a good place to live in' (34), an orderly place of home and church life close to nature, one that appears to him, looking back at it from 1938, to have been part of a different civilization, one that he defines by associating it with the major pastime of his youth, fishing:

I *am* sentimental about my childhood – not my own particular childhood, but the civilization which I grew up in and which is now, I suppose, just about at its last kick. And fishing is somehow typical of that civilization. As soon as you think of fishing you think of things that don't belong to the modern world. The very idea of sitting all day under a willow tree beside a quiet pool – and being able to find a quiet pool to sit beside – belongs to the time before the war, before the radio, before aeroplanes, before Hitler. (74)

Indeed, Fatty becomes obsessed by his recollection of a discovery when he was sixteen of a secret pool full of large fish:

The great fish were gliding round in the pool behind Binfield House. Nobody knew about them except me. They were stored away in my mind; some day, some bank holiday perhaps, I'd go back and catch them. But I never went back. (81)

Discovery of the teeming pool marked both the fulfilment of youthful innocence and its end, for Fatty never returned to fish in the secret pool because experiences of work and of the First World War that altered his civilization had intervened. He never fished again 'because in this life we lead – I don't mean human life in general, I mean life in this particular age and this particular country – we

don't do the things we want to do' (80). But the obsession remains, and, one day in 1938 while on a business trip, Fatty stops by the road to pick some primroses and resolves to return to Lower Binfield in search of the peace and tranquility – and the secret pool – he remembers from his youth. Fatty's flight from his ordinary routine and return to Lower Binfield is his equivalent of trying to achieve the attitude that Orwell attributes to Miller in 'Inside the Whale':

> For the fact is that being inside a whale is a very comfortable, cosy, homelike thought. . . . The whale's belly is simply a womb big enough for an adult. . . . Short of being dead, it is the final, unsurpassable stage of irresponsibility. (I, 521)

However, in the novel Orwell's English vision diverges from Miller's American one for Fatty discovers that he cannot find 'home' again, that attaining the condition of being 'inside the whale' is, for him, impossible. When he returns, he finds that the Lower Binfield of memory and nostalgia is lost; it has been industrialized and developed and signs of the coming war are everywhere. Seeking his secret pool, Fatty meets an estate agent, who noting the 'dark satanic mills' of the factory town which Lower Binfield has become, explains that the property around the old mansion has become the 'Upper Binfield Estate', Fatty's world of nature has been transformed into a suburbia that the agent terms a 'Woodland City'. The secret pond of great fish has been drained to become a rubbish dump, and its loss becomes for Fatty an emblem of the times in which he and all humanity are drowning:

> I'm finished with this notion of getting back into the past. What's the good of trying to revisit the scenes of your boyhood? They don't exist. Coming up for air! But there isn't any air. The dustbin that we're in reaches up to the stratosphere. (215–16)

After witnessing destruction in the town caused by a bomb that was made at a local factory and accidentally dropped during a practice run, Fatty defines his predicament in the very terms Orwell uses for Miller:

> The old life's finished, and to go about looking for it is just waste of time. There's no way back to Lower Binfield, you can't put Jonah back in the whale. (223)

Fatty's nostalgia for the way of life, the 'civilization', in Lower Binfield before the First World War is his version of playing Jonah and finding a safe womb in which he as an adult can hide. He has been longing to get back to catch the big fish from the secret pool ever since, but, like Jonah – and Western Civilization on the brink of war, he learns that he cannot return to innocence or recover the civilization now lost. Time is running out and, while Fatty can imaginatively revisit the past in sentimental reminiscence, he cannot relive it. Having gone to fat in eight or nine years in trying to become his own whale in which to hide, 'Fatty' Bowling literally embodies the loathing, frustration, and fear of his time as well as the ludicrousness of all who are part of the tragic pageant:

> He can't ever be present at a tragic scene, because a scene where there's a fat man present isn't tragic, it's comic. Just imagine a fat Hamlet, for instance! Or Oliver Hardy acting Romeo. (21–22)

The comedy of Miller's novels has become tragicomedy in Orwell's; the figure of Fatty, in his final frustration, anticipates Samuel Beckett's clownish Vladimir and Estragon imprisoned in the absurd world of *Waiting for Godot* (1954).

In novels and essays written after *Inside the Whale* and *Coming Up for Air*, Orwell refines and amplifies his interconnected themes: the suppression of individualism by various ideologies and the threat of propaganda to traditional literary culture. Works like *Animal Farm* (1945), 'The Prevention of Literature' (1946), 'Politics and the English Language' (1946), *James Burnham and the Managerial Revolution* (1946), 'Politics vs. Literature: an Examination of *Gulliver's Travels*' (1946), and *Nineteen Eighty-Four* (1949) express Orwell's belief that the threat to civilization in the future will come from neither Fascism nor Marxism but from a new kind of tyranny that partakes of both. He finds in the business theories of the American, James Burnham, indication of the 'managerial' form that the new totalitarianism will take:

> Capitalism is disappearing, but Socialism is not replacing it. What is now arising is a new kind of planned, centralised society which will be neither capitalist nor, in any accepted sense of the word, democratic. The rulers of this new society will be the people who effectively control the means of production: that is, business executives, technicians, bureaucrats and soldiers,

lumped together by Burnham under the name of 'managers'.
(IV, 160)

Orwell's understanding of this new bureaucratic totalitarianism is
clarified by his rereading of *Gulliver's Travels* and finding in Part III
a description of the totalitarian 'spy-haunted "police State"', with
its endless heresy-hunts and treason trials, all really designed to
neutralise popular discontent by changing it into war hysteria' (IV,
213). From Swift, Orwell also learns the satirist's technique of exag-
geration which leads him to treat 1948 as *Nineteen Eighty-Four*, and
his disturbing vision of the future becomes only an extreme version
of Fatty Bowling's view of 1938. The plot of *Nineteen Eighty-Four*
could be viewed as Winston Smith's rebellious 'coming up for air' in
the 'after-war'. Like Fatty, Winston is nostalgic for the past and the
peace and tranquility of nature. In courting Julia and reviving with
her old-fashioned emotions of love and passion, he seeks escape to
the pastoral world of the countryside and into the nostalgia of what
he believes is the safety of a quaint room over an antique shop.
Because the orthodoxy of the world of 1984 is far more extreme
than that of 1938, the consequences for Winston are far worse than
for Fatty. Nevertheless, for both protagonists the outcome of their
experiences is the same in the end, a hopeless return to acceptance
of the inevitability of things as they are – 'he's dead, but he won't
lie down'. However, in the 'after-war', tragicomedy gives way fully
to tragedy.

The difference between Fatty's absurdity and Winston's tragedy
is Orwell's refined conception of the 'after-war', his understand-
ing of the pervasiveness of the kind of experience felt by George
Bowling at the anti-Fascist rally. Therefore, suppression of personal
thought and the propagandistic threat to the literate word becomes
the theme Orwell expresses in later essays and novels. Orwell's
sense of a threat to the word, literally, is announced in his concept of
'Newspeak', the official and bureaucratic language of Big Brother's
managerial regime, a 'grammar' for which is appended to the novel.
Newspeak represents the efforts of the state to control thought
by limiting communication and by distorting history to the point
of a lie. Reality in 1984, as organized by the state, has become
a fiction. Newspeak gives managerial tyranny a language of its
own with which to stifle the creativity, the passion, and, finally,
the rationality in human beings. Winston Smith is denied the right to
express himself, to feel love, and, eventually, even to think logically.

The reader is shown the nadir of human existence – what William Blake called 'Ulro' – in which all that can be known and felt by a person is mental and social conformity, and in Orwell's vision of the managerial state of Oceania the politics of the Left and the Right in pre-war England have merged. Neither Fascism nor Marxism has won, but elements of both have contributed to the common tyranny.

The language of totalitarianism, Newspeak, exterminates hope for a literate culture of thoughtful citizens. In presenting this illogical, debased language that accomplishes the supression of free thought in *Nineteen Eighty-Four*, Orwell is reacting to the political use and abuse of language that he witnessed in propaganda ministries during the war. As he says in 'The Prevention of Literature':

> In our age, the idea of intellectual liberty is under attack from two directions. On the one side are its theoretical enemies, the apologists of totalitarianism, and on the other its immediate, practical enemies, monopoly and bureacracy. (IV, 59–60)

Both directions converge in the figure of the State, personified in the image of Big Brother, which, like the German government before the war and the British government during it, employs writers like George Orwell and 'Winston Smith' to create propaganda. As Orwell says in his essay, 'From the totalitarian point of view history is something to be created rather than learned' (IV, 63).

The world of Big Brother represents the ultimate denial of a literate culture for, as O'Brien, the torturer from the bureaucracy of the Ministry of Love, tells Winston, 'Reality exists in the human mind, and nowhere else' (252).[8] Winston Smith in his 'rebellion' experiences real thinking and creativity through his love for Julia, and their passion is literate and vital in its expression through letters and diaries. However, the State cannot tolerate the reality of true feelings and creativity between the sexes; through brainwashing and torture the corporate regime of Big Brother, through its representative O'Brien, supplants Julia as Winston Smith's lover. The goal of the interrogation of Winston Smith is for him to learn to love Big Brother and, by giving up passion, creativity, and reason, conform. In Orwell's view of things to come, an unthinking philistine world of totalitarianism, in which the vital muse of the literate word and individualism is renounced, is in ascendence. The 'big lie' for Civilization, which Marlow felt compelled to tell at the

end of *Heart of Darkness*, has become not just the means to an end but its own end.

Denied vitality, passion and creativity, the world of 1984 is an expansion of the urban wasteland of T. S. Eliot, the words of Eliot's poem echoing into Orwell's introductory description:

> It was a bright cold day in April, and the clocks were striking thirteen. Winston Smith, his chin nuzzled into his breast in an effort to escape the vile wind, slipped quickly through the glass door of Victory Mansions, but not quickly enough to prevent a swirl of gritty dust from entering along with him. (5)

Orwell originally wanted to call his book 'Nineteen Forty-Eight', and the novel is certainly less a Wellsian prophecy of things to come than a Swiftian fiction of things as they are in the age of post-war austerity on which the author comments in his journalism. Writing in the aftermath of the Conservative defeat of 1945, Orwell ironically names his protagonist – who will also be defeated – 'Winston', and his protagonist's experiences are set in places that are realistic enough: the Ministry of Truth is Broadcasting House where Orwell worked, and Room 101 was the place in the basement from which Orwell made propaganda broadcasts to India; television, with its screens, was an emerging technology; the British Army conducted 'Hate School' in the manner of 'Hate Week'; and ubiquitous posters advertising a correspondence school inspired the images of Big Brother. Indeed, as Anthony Burgess remembers it, the world of Winston Smith accurately represents the post-war scene:

> we had worse privations than during the war, and they seemed to get worse every week. The meat ration was down to a couple of slices of fatty corned beef. One egg a month, and the egg was usually bad. I seem to remember you could get cabbages easily enough. Boiled cabbage was a redolent staple of the British diet. You couldn't get cigarettes. Razor blades had disappeared from the market. . . . You saw the effects of German bombing everywhere, with London Pride and loosestrife growing brilliantly in the craters. It's all in Orwell.[9]

Amid such austerity, rational and literate culture perishes. Orwell in his novel shows its loss to an indifferent, managerial tyranny

which seeks to suppress not only individual thinking but language itself.

Psychologically, Winston Smith's situation is that of any wartime Londoner living with the fear and the lies. His work, the correcting and revising of historical records for the Ministry of Truth, parallels Orwell's own involvement in broadcasting propaganda. Orwell fears the politics of tyranny, but his novel shows that he feared as greatly the psychological conditioning created by fear and austerity. The torture and brainwashing that Winston Smith undergoes at the hands of O'Brien in the Ministry of Love only epitomizes the real conditioning of Londoners in the environment of war and post-war austerity. It is appropriate that Winston's ultimate conversion to unthinking love for Big Brother is accomplished by his being confronted by that which he most fears in his everyday environment: rats. 'The worst thing in the world' (232) turns out to be some horror with which one must cope day to day, and for Winston Smith in 1984, as for George Orwell in 1948, rats epitomize an environment that devours human vitality, passion, and thought.[10] To love Big Brother is a living death, but what is the political end of *Nineteen Eighty-Four* is, for Orwell, the satiric present reality of 1948.

In the process of observing the power of political manipulation by the media of communication, which culminates in the description of Big Brother's use of telecommunications to condition a whole society, Orwell notices as well the ways in which the psyche can be affected by the appearance of the commonplace artifacts of the society in which the human being is immersed. Indeed, the reason why the essays collected in *Inside the Whale* were considered pioneering studies in the field of popular culture in the years following their appearance is that in them Orwell illuminates the psychological importance of everyday objects that comprise the environment of the common man. This awareness appears in his appreciation of the rich descriptive style of Dickens, where he identifies the 'outstanding, unmistakable mark' of the Victorian author to be 'the *unnecessary detail*', the 'picturesque details' which are 'too good to be left out' (I, 450, 454); the awareness grows in sophistication in his analysis of the conservative political values implicit in the popular imaginative literature of boys' weeklies. Orwell later expands his interest to postcards in 'The Art of Donald Gill' (1941) and thrillers in 'Raffles and Miss Blandish' (1944). This is the literature and art of the common man that both shapes his thinking and becomes a repository of values at the subliminal level.

Armed with his new awareness, Orwell begins in his fiction to select and present everyday objects that acquire special meaning for the protagonists. These objects, which evoke somehow an element of nostalgia for a better time, a vanished golden age, will soon become the focus of Pop artists.[11]

Orwell's novels identify nostalgically charged objects and depend on them to motivate character and to shape plot. *Coming Up For Air* offers almost an inventory of common artifacts from English life. Most significant for its plot is the newspaper poster headlining 'King Zog's Wedding' that haunts Fatty and triggers the reminiscing that causes him to return to Lower Binfield. It is not the meaning of the headline that affects the protagonist; indeed, Fatty has no interest in the marriage of the King of Albania, the newspaper headline writer's 'Zog'.[12] Rather, the pervasive appearance of the headline evokes an emotional response in Fatty, feelings of nostalgia and dislocation, by reminding him of Psalm 136 about Og, King of Bashan, that he sang at church as a child in Lower Binfield: 'The world I momentarily remembered when I saw King Zog's name on the poster was so different from the world I live in now that you might have a bit of difficulty believing I ever belonged to it' (35). There are other objects of nostalgia identified in Fatty's past such as his own reading of boys' weeklies and his mother's copy of *Hilda's Home Companion*, but the sense of nostalgia and desire to return to the innocence of his childhood home before the First World War motivates the remainder of his effort to 'come up for air' in a world on the brink of war. The image, 'King Zog's Wedding', subliminally unleashes in Fatty's psyche recollection and nostalgia as well as the desire for the insularity of village life, and its effect contrasts with the intrusive mental manipulation of the media that Orwell foresees and Fatty fears in the 'after-war', the 'slogan world' of 'posters with enormous faces'.

In this awful world in the making that Orwell describes in place in *Nineteen Eighty-Four*, sources inspiring recollection and nostalgia, which are the means by which Fatty Bowling clings to his humanity, are being eliminated as quickly as possible. Winston Smith's job is to rewrite history, and he and Julia are betrayed in a room furnished with antiques: an old-fashioned clock with a twelve hour face, a gateleg table, a glass paper-weight and a huge mahogany bed. In a world held together by lies and propaganda, there is no place for things that are appealing simply because they are authentic in evoking recollection of a more peaceful, simpler, freer

time. Orwell initiates the appreciation of commonplace objects, the content of Pop art, by reacting, like his protagonists Fatty and Winston, to the lack of authenticity and overwhelming complexity of his mid-century world of propaganda and austerity; the author's interest in unappreciated simple things arises to complement his fear of modern technology.[13] His novels as well as his essays on popular culture attest to the appropriateness of Cyril Connolly's judgement that 'Mr. Orwell is a revolutionary who is in love with 1910'.[14] Orwell himself acknowledges the value of reminders of a simpler, earlier style of life when he writes: 'For man only stays human by preserving large patches of simplicity in his life, while the tendency of many modern inventions – in particular the film, the radio and aeroplane – is to weaken his consciousness, dull his curiosity, and, in general, drive him nearer to the animals'. For Orwell, 'outside my work the thing I care about most is gardening, specially vegetable gardening',[15] hence, underlying the sense of nostalgia are associations with not only the simple life but also the Romantic pastoral ideal. Ultimately, Orwell is most concerned for the plight of the English common man, not just for his political and economic environment, but, most importantly, for his intellectual state of being. In describing the novels of Dickens, Orwell says, 'The common man is still living in the mental world of Dickens, but nearly every modern intellectual has gone over to some or other form of totalitarianism'. Orwell admires the 'certain cultural unity' created by the 'native decency of the common man' who is innately dedicated to the 'idea of freedom and equality' (I, 459). Orwell's protagonists are such decent common men who seek to find and retain such a cultural unity, but their kind of language and thought is at war with their times.

3

Prisoners of War

Madame Sosostris, famous clairvoyante,
Had a bad cold, nevertheless
Is known to be the wisest woman in Europe,
With a wicked pack of cards. Here, said she,
Is your card, the drowned Phoenician Sailor,

. Fear death by water.

T. S. Eliot, *The Waste Land* (1922)

'Sam, I'm sorry to sound so gloomy.'
'My dear Harold, you couldn't be gloomier than I am.'

Harold Pinter to Samuel Beckett,
New York Times Magazine (1984)

'The History of Europe in My Lifetime'[1] – that is the great theme
of paintings which since World War II have brought fame and
controversy to Francis Bacon. Indeed, Bacon's paintings as they
confront the viewer with the 'bestial floor', as W. B. Yeats termed
it, of our time, offer a Freudian understanding of the psychic forces
which have shaped that 'History'. Like Daumier's portraits of post-
Napoleonic France or Goya's *Disasters of War* or Picasso's scenes
of the Spanish Civil War, Bacon captures the horror of an age of
instincts unleashed. As he says, 'So I could say, perhaps, I have been
accustomed to always living through forms of violence – which
may or may not have an effect upon one, but I think probably
does'.[2] Born of British parents in Dublin in 1909, the self-taught
artist left revolutionary Ireland in 1925 to become an interior deco-
rator in London. He first exhibited paintings there in 1930, but, after
receiving little recognition, he virtually ceased painting in 1934. As a
member of the Civil Defence Corps during the war, Bacon witnessed
first-hand the destruction in London, and he began to paint again in
a frenzied style that immediately brought him attention and fame
when three of the paintings were exhibited in 1945.[3] While the

success of Bacon as a painter occurred after the war, he usually cites as influences on his work the Moderns who scrutinized the wasteland of civilization during his formative years. Of T. S. Eliot, he writes, 'I always feel I've been influenced by Eliot. *The Waste Land* especially and the poems before it have always affected me very much. And I often read the *Four Quartets*, and I think perhaps they're even greater poetry than *The Waste Land*, though they don't move me in the same way'.[4] Bacon also found a point of reference for his work in Conrad's *Heart of Darkness*, having 'always been possessed by the notion of Africa as a place where people do irremediable things to one another and death stalks in the long dry spikes of the rustling grass'.[5]

As a post-Modern, then, Bacon paints the 'History' of a primal world in which faith has been lost. He uses religious iconography, in works called 'Crucifixions' and in portraits of popes, to express suffering and terror at the loss. Much like Graham Sutherland who was moved by the war to paint terrifying cruciforms and briar-ridden landscapes instead of tranquil pastoral scenes, Bacon depicted the destruction in London as scenes related to a crucifix-ion. His 1944 triptych, 'Three Studies for Figures at the Base of a Crucifixion', reveals his interpretation [Plate 4]. Three misshapen, tortured, half-bestial and half-human creatures convey his response to the suffering. Bacon has referred to these forms as figures for the 'Eumenides' who in Greek culture were thought to haunt and torture mankind,[6] but the figures could as well represent victims of the violence of world war, who, like those who witnessed the punishment of Christ, have lost all hope and are reduced to noth-ing but downtrodden meekness, blind voraciousness, and howling despair. Salvation is out of the question in the face of such depravity. In the parallel triptych of 1962, 'Three Studies for a Crucifixion', human figures devolve from the civilized to the bestial: in the first painting, the figures are dressed; in the second, they have become a naked couple writhing on a bed; in the third, nothing remains of their humanity but a still life of a carcass. As John Rothenstein notices, 'for Bacon, who is a non-believer, the Crucifixion has no religious significance and is just an extreme and most celebrated instance of man's behavior to man' and that for the artist carcasses of meat 'have about them the smell of death which he associates with the Crucifixion'.[7] Another wartime painting, 'Figure Study Two' (1945–46), is known also as 'the Magdalene'[8] and depicts a kneeling, half-naked, screaming human form caught in the orange

glow of violence – probably flames from an air-raid, trying inef-
fectually to find shelter under an umbrella and a wool overcoat,
the mangled, nearly severed skull crushing palm fronds on a
table [Plate 5]. Bacon's original title suggests the figure of Mary
Magdalene witnessing the Crucifixion without hope of redemption,
and the kneeling pose of the figure as well the presence of the palms
create an image that is a parody of worship and the promise of
redemption. Certainly in the painting innocence in the face of ines-
capable violence finds no refuge, either physically or spiritually, and
the inclusion in the design of commonplace objects of English life
like the umbrella and the overcoat that would offer protection from
the elements in ordinary times add the force of topical relevance to
the war-time composition.

Bacon's portraits of papal figures show conventional and ordinary
faith confronted by the astonishing horror of modern history. The
screaming figure in Bacon's imitation of Velasquez's 'Pope Innocent
X' (1953) dramatizes the paralysis of established faith in facing
the times; we see the pope, still enthroned and garbed in regal
gown, confined within bars and curtains [Plate 6]. The reference
to Velasquez as well as the trappings of authority contrast to the
horror of the face with its cavernous and vicious mouth and the
impotence to act suggested by the composition as a whole; Bacon's
painting is a grotesque parody of its predecessor. Indeed, in some
of Bacon's versions of screaming popes, the figures are encased by
a transparent cube that gives the impression of the scream being
silenced within the vacuum of a glass cell. The scenes suggest
torture, or even execution. (E. I. Zamyatin's Russian novel of 1923,
We, first translated and published in English in 1945, describes
torture in a glass vacuum chamber.)[9] Bacon claims that these trans-
parent cubes, so often used in his paintings, have no meaning other
than as a 'frame' to help him 'to see the image'.[10] Certainly the
geometrical shape creates distance between the subject and the
viewer as does displaying Bacon's paintings under glass, a practice
which the artist prefers.[11] The paintings of popes are reminders
of a lost world of authority and faith in which leadership was
possible, and from which is retained only an instinctive recoil to
its present insignificance. Hence, crucifixions and popes in Bacon's
work appear as mere relics of the past in place of true icons of belief.
It is as if the symbols of Christianity had been transformed into a
nearly faceless form distorted in its utterance at the sight of 'the
horror' of the twentieth century.

In the absence of faith and in the face of violence, human passion and beauty remain, but in Bacon's paintings love and ecstasy are reduced to lust and bestiality, human forms to carcasses. Sex, rather than affirming the life of the body, exposes mortality in the world of Bacon, and, like his mockery of papal authority, it usually occurs in a setting of restraint that ultimately suggests impotence. Lovers in their coupling are found to be encased on their beds or confined in transparent cubes, and they are usually watched over by indifferent, bored voyeurs who appear to be their imprisoners or torturers.

The composition entitled 'Triptych Inspired by T. S. Eliot's Poem "Sweeney Agonistes"' (1967) is typical [Plate 7]. There are three large paintings, each 5 by 6 feet, and the first and third paintings reveal the blurred forms of a copulating couple writhing on a platform bed. Like an Eadweard Muybridge photographic study of human movement,[12] the figures in the first painting appear in animated motion in the fury of their coupling. Amid the violence of their energy, only the teeth are distinct. There is a sense of seeing snakes writhing together, of frenzied bestiality, and it is not clear whether the figures are of different sexes or of the same: they seem to be two women with long hair. The third painting implies time has passed: the lighting is darker and a cigarette pack visible in the first painting is missing. However, a third figure who is clothed now observes the writhing couple while talking on the telephone. This person, whose form is reflected in a mirror, is a voyeur who casually contemplates the violent encounter on the bed – the figure implies the perspective of the viewer of the painting. But, is the scene the same as the first except for the lapse of time? The figures now seem to be male rather than female with short rather than long hair.

Completing the triptych, which is modeled more on Eastern erotica than on Western religious expression, is the central scene, remote from the others and, upon immediate apprehension, more puzzling. In it, another room is shown, perhaps in a hotel, with a towel hung on a door knob and a suitcase in the foreground. As in the other paintings, the centre of attention is the bed, but in this instance, amid the commonplace objects in the room, the viewer confronts the raw meat of a still bloody carcass. This violent, terrible painting comments on the other two by linking in a surreal manner the butcher shop, with its reminder of death, to the violence of sheer, undifferentiated sexuality. As Bacon has said, 'Well, of course, we are meat, we are potential carcasses. If I go into a butcher's shop I always think it's surprising that I wasn't there instead of the

animal.'[13] In 'Triptych', the mortality of the human beast is revealed in the deadly sexual struggle. Instead of revealing the life-force of passionate lovers, as D. H. Lawrence would, the composition shows its contrary, the compulsion of mortality and death. For Bacon, neither vitality nor regeneration comes from sexuality; it is merely an instinct, a need of the beast fulfilled amid an awful void of social indifference where the only links are those of perverse voyeurism.

Man, then, in Bacon's view is isolated, alienated, ugly, and insignificant. Paintings of single figures usually surround the human form with a background of flat planes of color and dark lines of imprisoning hues. Even when posed at rest, apart from either violence or sexuality, the human being shows a loss of dignity and nobility. Forms are distorted, shrivelled up, sometimes languishing in unflattering postures as in the case of Bacon's evocation of the traditional nude in two life studies of Henrietta Moraes (1963, 1966). As painted by Bacon, the model's body is ugly, even ridiculous, as she assumes the classical poses prescribed for the female nude, the idyllic innocence of artistic conventionality becoming distorted by the terror implicit in the artist's brush.

If Bacon's artistic subject is not sexual or hinting of the sexual, it is often a commonplace act: shaving, talking, sitting passively, smoking a cigarette. Sometimes, as in the full length self-portraits of 1972–73 or 'Study for a Portrait of Lucian Freud' (1971), the figures are alone in stiflingly empty rooms. Or, as in 'Study for Portrait of Seated Figure' (1977), they seem incarcerated in chairs of excruciating design as if doomed to execution in a gas chamber. These images convey Bacon's understanding of the human condition: 'I think that man now realizes that he is an accident, that he is a completely futile being, that he has to play out the game without reason.'[14]

People, then, are a scream. The screaming mouth, Bacon's most pervasive motif, is derived from several sources, including a close-up of the nurse shot through the glasses and eye from the film, *The Battleship Potemkin*, and a book on diseases of the mouth.[15] Even in his portraits of people, including friends, the distortion centers around the gaping mouth. Bacon's portraits carry on his understanding of post-war life. 'Who can I tear to pieces, if not my friends?' is said to be a favorite comment by the painter',[16] and there they are, Lucian Freud, Isabel Rawsthorne, Henrietta Moraes, and the artist himself in his frequent self-portraits, stripped to their

flesh, almost carcasses, captured in the artistic dissection of their mortality. Bacon's 'heart of darkness', like Conrad's, is ultimately the beast with vacuous mouth within us all, and no one is beyond being examined as if he or she were Eliot's 'patient etherized upon a table'. As John Russell says of viewing the portraits:

> We feel . . . that we have penetrated to the inmost nature of human behaviour, and that these people are betraying in the everyday traffic of life something of that instinctual violence which marked the great warrior Cuchulain in the height of battle. . . . Cuchulain in the heat of the fray was said to twist round in his own skin to such an extent that at moments he was literally 'back to front'; and something of that sort happens to Bacon's subjects when he commits them to canvas.[17]

Whether in portraits or in groups or in multiple scenes, Bacon's prisoners of modern history – often shown confined in real rooms or illusionary chambers with newspapers strewn on the floors – have no true faces. The sense of distortion, usually to the point of the macabre, produces in the viewer a perception of a compound, superimposed state which the artist is attempting to unravel. This is the vitality of the aesthetic effort: a dissection of the human image to reveal its awful essence. Bacon says 'fact leaves its ghost',[18] and, indeed, we meet shades in the underworld of his paintings. What appears to be a vague, almost obliterated, image becomes, upon contemplation, vision into a deeper, more terrifying level of the inferno of the modern psyche. Cancelled images overlap newer ones with the effect of X-ray vision until Bacon's dissection reveals the morbidity beneath the skin.[19]

And the understanding is deadly. Bacon's figures are ghosts because, for him, beyond the living lurks death. 'I have a feeling', he says, 'of mortality all the time. Because, if life excites you, its opposite, like a shadow, death, must excite you'.[20] The portraits, then, are of the opposites – the shadows or shades – of people who are encaged by the history of the twentieth century. As John Rothenstein says of Bacon and his work, 'he does, however, believe in Hell – Hell is here and now'.[21] Hence those who are dissected in portraits and life studies as well as the laconic voyeurs who keep and restrain the living in the more complex compositions are all inhabitants of the same post-Modern underworld. The naked essence of things, then, Bacon's unravelling of modernist truth,

is terrifying. Each painting is like Marlow's trip upriver to find Kurtz in *Heart of Darkness*, a journey inward toward the primitive and the mortal. Finally, the fact of every man portrayed is the fact of violence and death in our time. Neither authority nor philosophy can intervene, and the images of that condition can only be ghastly. As Rothenstein concludes, 'It is precisely because these apprehensions are presented to us in terms so entirely appropriate to our own time that they continue to haunt us so persistently. Bacon's contemporaries belong to generations that have seen the destruction of cities by bombs, the flight of whole peoples under the lash of fear, the concentration camps, the death camps and the rest.'[22] Indeed, Bacon's vision is finally one of history; he shows us on canvas a real hell from which we may never escape.

* * *

'He's dead, but he won't lie down' – Orwell's epigraph to *Coming Up For Air* could be taken as the theme of those post-Modern artists like Bacon who continue after the war to express pessimism about the human condition. For them, the condition of the post-war is a continuation of the condition of the war and their expression is a continuation of what preceded it. They find in contemporary English culture either nothing new or an emerging shape which confirms their worst fears about the rise of totalitarianism and the increasing alienation of the individual amid the philistinism of a socialist state. In a sense, the artistic attention of these artists is arrested by the imagery of the breakdown of civilization, and they continue to express 'the horror' even after – sometimes long after – the war itself. Their models remain those Moderns who prophesied the coming collapse, Conrad, Eliot, and Yeats. For them, the culture of the 'after-war' in England remains enwrapped in historical disaster.

While post-war life seemed to many people to be as meaningless and austere as Orwell had feared, it is the actual collapse of traditional culture and its language and the loss of an historical sense of place – not the imposition of a malevolent political state like Oceania – that define the prevailing cultural neurosis. Under the stress of what Jeff Nuttall termed the 'bomb culture' of the 1950s – hydrogen bombs were exploded by the United States in 1952 and the Soviet Union in 1953 – an underground of youth appeared: 'Teddy suits with their frock-coats, fancy waistcoats, moleskin collars and drainpipe trousers, and, for the girls, hobble

skirts, black-seam nylons and coolie hats, were the first public showing, in England at any rate, of radical social divergence on the part of young people'.[23] Nigel Dennis in his novel of 1955, *Cards of Identity*, precisely defines the feeling of historical dislocation. After members of a group called the 'Identity Club' reopen an abandoned 'great house', their leader, Captain Mallet, explains the need for the club in an age in which 'established identities' have been lost:

> 'This sort of house was once a heart and centre of the national identity. A whole world lived in relation to it. Millions knew who they were by reference to it. ... Today, when it is rare to find any man who can be said to know his self, it is clubs such as ours which tell these sufferers who they are . . . we give our patients the identities they can use best. We can make all sorts of identities, from Freudian and Teddy Boy to Marxist and Christian. We are thus the idea behind the idea, the theory at the root of theory.'[24]

Simultaneous to Dennis' fictional analysis of the cultural break-down, the psychiatrist R. D. Laing at the Tavistock Clinic in London was studying schizophrenics and concluding that their madness was commonplace. As Laing explains in *The Divided Self* (1960), the substantiality of age age is one of 'ontological insecurity' in which traditional assurances for a person's identity – 'the permanency of things', 'the reliability of natural processes', 'the substantiality of others' – are lacking.[25] Without such security for the self, a person becomes schizoid:

> The individual in the ordinary circumstances of living may feel more unreal than real; in a literal sense, more dead than alive; precariously differentiated from the rest of the world, so that his identity and autonomy are always in question. He may lack the experience of his own temporal continuity. He may not possess an over-riding sense of personal consistency or cohesiveness. He may feel more insubstantial than substantial, and unable to assume that the stuff he is made of is genuine, good, valuable. And he may feel his self as partially divorced from his body.[26]

In defining 'ontological insecurity', Laing cites artistic equivalents of the condition: 'With Samuel Beckett, for instance, one enters a

world in which there is no contradictory sense of the self in its 'health and validity' to mitigate the despair, terror, and boredom of existence . . . In painting, Francis Bacon, among others, seems to be dealing with similar issues'.[27] Laing could also have cited Orwell's *Coming Up for Air* and *Nineteen Eighty-Four.* According to Laing, to find a way to survive in such a world, a schizoid may adopt – like the patients initiated by the 'Identity Club' – a 'fictitious' or 'false-self', impersonating either a real or an imagined personality as a means of achieving an identity in a social setting. Considering the uncertainties and anxieties of his age, Laing believes:

> 'A man without a mask' is indeed very rare. One even doubts the possibility of such a man. Everyone in some measure wears a mask, and there are many things we do not put ourselves into fully. In 'ordinary' life it seems hardly possible for it to be otherwise.[28]

With the myth of the England fostered by the Victorian ideal finally dissipated by war and austerity, contemporary protagonists of its post-Modern culture are, indeed, all too often human beings with masks because civilization has become, as Freud speculated it would, 'neurotic'.

E. M. Forster described the condition long before Laing diagnosed it. In the essay, 'What I Believe', published in 1939, Forster, from the stated perspective of a disbeliever in faiths of any kind, religious or political, reacts to the worship of the Reich in Germany and to nationalistic zeal in England by responding in a fashion similar to that of Orwell:

> So Two Cheers for Democracy: one because it admits variety and two because it permits criticism. Two cheers are quite enough: there is no occasion to give three. Only Love the Beloved Republic deserves that.[29]

Forster reaches his conclusion based on assumptions that anticipate Laing. From the same basis in Freud, Forster thinks that 'psychology has split and shattered the idea of a "Person" and has shown that there is something incalculable in each of us, which may at any moment rise to the surface and destroy our normal balance'. Consequently, amid psychological as well as political confusion at the time – the breakdown of traditional assurances for the self,

Forster puts his faith in personal relationships: 'Starting from them, I get a little order into the contemporary chaos. One must be fond of people and trust them if one is not to make a mess of life, and it is therefore essential that they should not let one down. They often do.' Therefore, in the context of an exceptional historical moment, England and Germany on the brink of world war, Forster states a proposition that will haunt post-war society:

> I hate the idea of causes, and if I had to choose between betraying my country and betraying my friend, I hope that I should have the guts to betray my country. . . . Love and loyalty to an individual can run counter to the claims of the State. When they do – down with the State, say I, which means that the State would down me.[30]

Forster's belief helps define both Winston Smith's rebellion against Big Brother and the true horror of his capitulation to O'Brien's ultimate demand, the betrayal of Julia; at the same time, the statement becomes an explanation and a defence (quite unfair to Forster and his intention) of the acts of treason that have become a symptom of the breakdown of personal identity in post-war England.

Indeed, the British spy scandals of our period epitomize historically a significant concern of contemporary literature: the theme of betrayal – of friends, of lovers, of country. In 'What I Believe', Forster, reacting against the kind of hero-worship that leads to the cult of a 'Great Man' and the popular support for a Hitler, calls for a new aristocracy:

> Not an aristocracy of power, based upon rank and influence, but an aristocracy of the sensitive, the considerate and the plucky. Its members are to be found in all nations and classes, and all through the ages, and there is a secret understanding between them when they meet.[31]

However, amid the disillusionment of the Cold War, a perverted version of Forster's 'aristocracy' emerged. Guy Burgess, Donald Maclean, 'Kim' Philby, and Anthony Blunt were among the best and brightest in England, but their sense of elitism combined with an ideal of secret friendship to create what has been termed the 'Cambridge Conspiracy'. The knot of their personal and political relationships has been untangling for years in fact and fiction: all

were educated at Cambridge in the 1930s where they were initially attracted to Marxist socialism as the only apparent alternative to Fascist capitalism and all were subsequently recruited to be Soviet spies. Rebecca West has suggested that the modern spy sought 'in politics what in other ages he would have found in religion',[32] however, as much as politics, it was the feeling of elitism combined with a cult of secrecy arising out of a daisy-chain of private relationships, some homosexual, that explains the conspiracy. The 'Cambridge Conspiracy' could be understood to be just a real-life version of the 'Identity Club',[33] and the treasonable acts of its members frequently have been retold in fiction, the most popular of which has been John le Carré's espionage novels, especially *Tinker, Tailor, Soldier Spy* (1974) and *An Honorable Schoolboy* (1977) which are based on Philby's career. Le Carré, however, goes beyond creating adventure plots from history; as John Halperin argues, 'le Carré's novels provide a sort of critical analysis of modern life and values that Matthew Arnold and Camus and T. S. Eliot undoubtedly would have found congenial and embody a pathology of contemporary existence instantly recognizable to, say, the scholar-gypsy, Sisyphus, or Prufrock. The absurdist, wasteland quality of modern international politics is le Carré's subject.'[34] Halperin goes on to cite the belief of the 'mole' in *Tinker, Tailor, Soldier, Spy* that 'the British secret services . . . are . . . microcosms of the British condition, of our social attitudes and vanities.'[35]

But, if le Carré conceives of the national neurosis in Modernist terms of the wasteland and absurdity, it is the old master, Graham Greene, who provides an analysis of the personal neurosis and the betrayals to which it leads in the face of the contemporary breakdown of traditional, literate culture. Based on the experience of 'Kim' Philby, a friend of his, Greene in *The Human Factor* (1978) allegorically anatomizes the political and personal emptiness of British life at the moment of sunset of the Empire. Politically, he focuses on British support for the government of South Africa, stating in his autobiography, *Ways of Escape*, that 'perhaps the hypocrisy of our relations with South Africa nagged me on to work too. It was so obvious that, however much opposed the governments of the Western Alliance might pretend to be to apartheid, however much our leaders talked of its immorality, they simply could not let South Africa succumb to Black Power and Communism'.[36] The emptiness of this policy translates to the 'human factor' as Greene portrays a man, who, betrayed by the ideals of his country, betrays it and,

finally, himself. As Greene, echoing Forster, cynically stated in an introduction that he wrote for Philby's memoirs: '"He betrayed his country" – yes, perhaps he did, but who among us has not committed treason to something or someone more important than a country?'[37]

Greene's fictional 'Philby' is called Castle, and his name confirms him to be a gentleman of the establishment who, like his counterpart in real life, works for British Intelligence. Like Philby, Castle has the right credentials, a cousin who proceeded him in the 'firm' as well as a degree in history from Cambridge. Being part of the 'old boy' network as he is, Castle initially escapes suspicion of treason while his colleague with the common name of 'Davis', who has no aristocratic connections and graduated from 'red brick' Reading University, becomes the focus of the security investigation. Indeed, it is Davis's very lack of a 'name', his lack of class and place in the establishment, that leads to his being mistakenly 'eliminated' by the 'firm'. But Castle's name is apt for another reason: he is a pawn in the game of international politics, a rook to impersonal forces of history that hold no brief for humanity. In that role his name hints at the Kafkaesque existence that he will finally have to accept. As Conor Cruise O'Brien noticed in reviewing the novel, 'More than in any other of Greene's novels there is a feeling here of Kafka's world and, in particular, of *The Castle*'.[38]

Indeed, the name 'Castle', bristling as it is with literary associations, suggests both how the novel should be read and the importance of reading in it. Literature serves as a touchstone throughout the plot of the novel against which we measure the nature of the characters. Castle's relationship to books is basic to his treason for he communicates with his Russian 'control' using codes involving literary classics. When he is questioned initially, he has a copy of Richardson's *Clarissa* in his briefcase; and, later, as his situation grows desperate, he tries to acquire Trollope's *The Way We Live Now* but does not get it until he is fleeing the country.

Castle purchases the books by which he communicates in code from the bookstore of Halliday and Son, located in the seedy environs of Soho and owned by a somewhat Dickensian proprietor:

> It was an unusually respectable bookshop for this area of Soho, quite unlike the bookshop which faced it across the street and bore the simple sign 'Books' in scarlet letters. The window below the scarlet sign displayed girlie magazines which nobody was

ever seen to buy – they were like a signal in an easy code long
broken; they indicated the nature of private wares and interests
inside. But the shop of Halliday & Son confronted the scarlet
'Books' with a window full of Penguins and Everyman and
second-hand copies of World's Classics. The son was never seen
there, only old Mr. Halliday himself, bent and white haired,
wearing an air of courtesy like an old suit in which he would
probably like to be buried. He wrote all his business letters in
longhand: he was busy on one of them now. (56)[39]

It is from Mr. Halliday's bookshop, not his son's, that the espio-
nage code based on literature originates, and Mr. Halliday himself
eventually turns out to be the Russian agent sent to assist Castle in
his escape. The association of Castle and Mr. Halliday's espionage
with the English literary heritage suggests the idea that Marxism
represents an intellectual commitment which has since become
distorted, and even quixotic, amid the cultural degeneration of
Britain in the Cold War.

Indeed, the real philistines of the novel, those who abuse litera-
ture, are the members of Castle's 'firm' who pursue him. For them,
a book can become an object of suspicion. When Davis dies, a
copy of Robert Browning's poems is found in his room, and for
a moment – ironic, considering Castle's use of book codes – it is
considered proof of treason. Even though the old book is clearly
inscribed as a gift from Davis's father, who won it as a school prize,
Dr. Percival, pursuing the stupidity which has caused him to kill
Davis, struggles to ascribe 'significance' to the presence of the book.
The reading of a passage marked with a 'C' causes Percival's even
more foolish assistant to comment, 'It sounds to me like poetry, sir.'
(186) The effort to rationalize Davis's death by the book evaporates
when the 'C' is revealed to stand for 'Cynthia,' a secretary with
whom the dead man was in love.

Satire of the philistinism of the establishment is extended by
Greene through his portrait of Sir John Hargreaves, himself known
as 'C', who as the person in charge of the firm carelessly and,
perhaps, unwittingly allows the execution of Davis. The execution
is planned at Hargreaves' country estate with its rooms known for
their lithographs ('The Ben Nicholson Room,' 'The Miro Room'), but
the decoration was suggested by Dr. Percival to Lady Hargreaves
who had wanted sporting prints 'to go with the pheasants' (52).
Hargreaves is a weak man, a dilettante at leadership as well as art,

who is easily manipulated by the perverse Dr. Percival. Naturally, his reading reflects his character. While Castle cannot find a copy of Trollope's *The Way We Live Now*, Hargreaves acquires one, having wanted it because 'somebody, he couldn't remember who it was, had told him the novel had been turned into a good television series' (249). In his reading, Hargreaves appropriately feels sympathetic to the character of the old swindler Melmotte and shares a sense of isolation with him.

Such philistinism dominates Castle's England. Castle is unable to get a copy of *The Way We Live Now* because of the popularity of the televised version, and he is constantly comparing his tedious, anxious life as a spy to the romantic adventures enjoyed by his counterpart in pulp fiction, James Bond.[40] As Castle remarks about the lack of excitement at the 'firm', 'We've never been very James Bond minded here. I wasn't allowed to carry a gun, and my only car was a secondhand Morris Minor' (60). Castle's son is obsessed with finding out if there are real spies, 'spies like 007', to which his father sardonically replies, 'Well, not exactly' (75).

Castle's ultimate fate is defined by books as well. He is directed from England by old Mr. Halliday, about whom Castle had been deceived because he thought that the son who ran the pornographic bookshop was the Russian contact; it is as if Castle's trust in literary culture has begun to erode. Yet at the end of the novel Castle seems to take his own place in fiction. Just as the real spy, 'Kim' Philby, spent his life playing a role that seemed almost dictated by his having the nickname of Kipling's spy, Castle, too, becomes his own legend. The Star Flight Hotel in which Castle hides prior to escaping from England has a grill room called 'The Dickens' and a self-service restaurant called 'The Oliver Twist'. In this hotel, Castle is able finally to begin to read *The Way We Live Now*, which has been given to him by Mr. Halliday, and he receives a passport with a name, 'Partridge', that links him to another literary classic, Fielding's *Tom Jones*. But Castle must escape disguised as a blind man, leaving his Trollope and his English heritage behind.

Safe in Moscow, Castle discovers other British spies who have defected before him in the Lenin Library 'reading the English papers'. (324) Castle, too, comforts himself with reading his native literature: 'He had even found school editions in English of Shakespeare's plays, two novels of Dickens, *Oliver Twist* and *Hard Times*, *Tom Jones* and *Robinson Crusoe*'.[41] Furthermore, Castle comes to understand his role of exile in terms of this literary heritage:

In the evening he would warm some soup and sit huddled near the stove, with the dusty disconnected telephone at his elbow, and read *Robinson Crusoe*. Sometimes he could hear Crusoe speaking, as though on a tape recorder, with his own voice: 'I drew up the state of my affairs in writing; not so much to leave them to any that were to come after me, for I was like to have but few heirs, as to deliver my thoughts from daily poring upon them, and afflicting my mind'. (325–26)

Like the fictional Crusoe with his reminiscences of his island and like the real Philby who published his memoirs from exile, Castle finds himself trapped in a state of isolation, and the ironic – and literary – significance of his condition, living alone in Eastern Europe, is suggested finally by the literary association of his name. The castle in Kafka's novel is a place of confused and interrupted communication; at the end of *The Human Factor*, Castle, too, is confined in the same kind of world in which contact with loved ones depends upon a faulty, usually useless, telephone. After waiting weeks for the telephone to be connected, Castle learns that it is working at the very moment when he is reading about his fictional counterpart Crusoe's escape from his island to return home:

At nine thirty-two one evening he came to the end of Robinson Crusoe's ordeal – in noting the time he was behaving a little like Crusoe. 'And thus I left the island, the nineteenth of December, and I found by the ship's account, in the year 1686, after I had been upon it eight and twenty years, two months and nineteen days. . . .' He went to the window: the snow for the moment was not falling and he could see clearly the red star over the University, He turned and stared at the telephone with amazement. It was the telephone which was ringing. (335)

Castle learns that there are 'difficulties'; he is told that his wife and his son cannot join him in Moscow. Castle will have to remain there isolated and alone, living with his books. When his wife finally telephones, he desperately tries to comfort her, and reassure himself, before the telephone once again goes dead:

'Oh yes, I'm not alone, don't worry, Sarah. There's an Englishman who used to be in the British Council. He's invited me to his *dacha* in the country when the spring comes. When the spring comes,'

he repeated in a voice which she hardly recognized – it was the voice of an old man who couldn't count with certainty on any spring to come. (347)

The pathos of Castle's state at the end of *The Human Factor* recalls that of Gabriel Conroy, at the end of James Joyce's *The Dead*, who also stands at the window in isolation from his country and his wife, alone with the fragments of his ideals, and watches the snow fall. Greene's novel, by means of its literary references, moves from England to Europe and from the Victorian assurance of Trollope to the Modernist frustration of Joyce and Kafka. Castle may be a traitor, but in Greene's view 'the way we live now' in our civilization, east or west, is even more treasonable.

Moreover, literature of the 1950s and 1960s in England expresses the cultural neurosis of its time by combining the theme of betrayal with the other manifestation of post-war disillusionment with society, philistinism. This anti-intellectualism is not the same as that recognized by Matthew Arnold among the hardworking middle classes at the height of Victorian capitalism. Rather, it is something that emerges from the indifference of the post-war working classes to traditional, literate English culture and from their hostility to what they perceive to be a domain of the upper classes. Lacking education but enjoying the leisure provided by the full employment and welfare policies of the government, the new philistines represent a very different outcome of the 'after-war' than Orwell foresaw. Indeed, the 'proles' in *Nineteen Eighty-Four* escape the worst of totalitarianism through ignorance; in reality their economic liberation poses a serious issue. As Anthony Burgess describes it, 'the proletariat exists in a world that is merely a place where dull work is done and dull pleasures dully savored. The horror is that the proletariat is free, but does not understand freedom'.[42] Consequently, while in Orwell's novels a Gordon Comstock struggles against the personal and creative limits imposed by a Depression or a Fatty Bowling fights the fear and loathing of a nation on the brink of war or a Winston Smith rebels against political repression, the protagonists imagined by the Angry Young Men in the 1950s have abandoned the conflict with society so as to cope with the psychological consequences of the new England. Their predicament is that the old, literate culture is disappearing and nothing new has emerged to take its place and give significance to their lives. At best, they wail and squirm about the loss, clinging to remnants of

the old way of life; at worst, they acquiesce to the world around them or engage in senseless violence. Their condition seems to be one of inescapable imprisonment within class, a creative paralysis, whether they realize it or not. There is good reason for anger, even if they do not always know or express it.

Arthur Seaton in Alan Sillitoe's *Saturday Night and Sunday Morning* is an example. He is more bored than frustrated with his style of life, flailing out at the society around him in drunkenness or unthinking folly, and in his acquiescence and weakness he is a pathetic human being in comparison to his antecedents in Orwell who struggle against the limits of their situation. While Gordon Comstock in *Keep the Aspidistra Flying* struggles to maintain his intellectual integrity as a poet in spite of his poverty and rails at the aspidistra plant in his garret room that seems to him to flourish whenever he experiences personal disappointments, Arthur Seaton, in contrast, is quite sanguine in being found under an aspidistra in a drunken stupor, having just fallen down the steps in the pub where he spends his time enjoying the new leisure of his class:

> It seemed to Arthur that the man was endeavouring to tell him something as well, so he tried very hard, but unsuccessfully, to make an answer, though he did not yet know what the man was saying. Even had he been able to make his lips move the man would not have understood him, because Arthur's face was pulled down into his stomach, so that for all the world he looked like a fully-dressed and giant foetus curled up at the bottom of the stairs on a plush-red carpet, hiding in the shadow of two aspidistras that curved out over him like arms of jungle foliage. (9–10)[43]

Arthur's routine in life is one of lust and rage, but his behavior is pointless. His anti-social acts are protests against the boredom of routine: what is truly frightening about him is his lazy contentment with his condition.

Arthur uses his wits only enough to pace his work at a lathe in the bicycle factory where he works so that the production quota for his piecework rate will not increase and to avoid romantic entanglement in his love affairs. He most of all seeks to escape responsibility in his personal life, dating married women to avoid the possibility of marriage. The sterility of Arthur's style of life is poignantly portrayed in the gruesome scene in which he tries to

assist his girlfriend Brenda abort her pregnancy by drinking a bottle of gin while immersed in a scalding bath. His personal life is a fabric of lies and betrayals, as he deceives both the women with whom he sleeps and their husbands who are his friends. Finally, Arthur is unable even to maintain these deceptions, finding himself exposed in his adultery and promiscuity, beaten up for it, and even engaged to be married. Arthur gripes about his fate, but merely conventionally: he is ultimately unthinkingly contented with his plight. Under the circumstances, then, Arthur Seaton's indifference is a parody of the passive role of an accepting Jonah that Fatty Bowling desires to achieve and cannot in *Coming Up for Air*. Indeed, Arthur is in a sense arrested in the adolescent world of self-indulgence and physical pleasure that Orwell's protagonists never have a chance to enjoy, and he is portrayed at the end of *Saturday Night and Sunday Morning* calmly fishing in his favorite spot, the very pleasure that Fatty Bowling had so much longed to know again. As Arthur fishes, his thoughts reveal that his 'rebellion' has only been bluster and that, conditioned by post-war society, he is content to accept life as it comes in a way that Orwell's protagonists never could:

> And trouble for me it'll be, fighting every day until I die. Why do they make soldiers out of us when we're fighting up to the hilt as it is? Fighting with mothers and wives, landlords and gaffers, coppers, army, government. If it's not one thing it's another, apart from the work we have to do and the way we spend our wages. There's bound to be trouble in store for me every day of my life, because trouble it's always been and always will be. Born drunk and married blind, misbegotten into a strange and crazy world, dragged-up through the dole and into the war with a gas-mask on your clock, and the sirens rattling into you every night while you rot with scabies in an air-raid shelter. Slung into khaki at eighteen, and when they let you out, you sweat again in a factory, grabbing for an extra pint, doing women at the weekend and getting to know whose husbands are on the night-shift, working with rotten guts and an aching spine, and nothing for it but money to drag you back there every Monday morning.
>
> Well, it's a good life and a good world, all said and done, if you don't weaken, and if you know that the big wide world hasn't heard from you yet, no, not by a long way, though it won't be long now. (189–930)

Of course, Arthur's life is hardly a real 'fight'. He is a type of the new philistine in accepting the unthinking routine of his life, and it is his very benignity that is finally most frightening about him: he is free, but does not understand freedom.

Though better educated and more articulate about life than Arthur Seaton, Jimmy Porter in John Osborne's play, *Look Back in Anger* (1956), represents another version of post-war philistinism. Richard Wollheim, writing a Fabian tract in 1961, called the paradox of the welfare society 'the Present Compromise', describing how

> on the one hand, we have the old genteel or middle-class culture, preserved within certain traditional institutions, though now offered – on highly competitive terms – to many to whom it was traditionally denied. And below this we have a literate self-conscious mass culture, very assertive and very dynamic, which provides the sustenance for those who are unwilling or unable to partake of the higher culture.[44]

Jimmy intuitively perceives this 'Cultural Compromise', recognizes his own imprisonment within it, and feels truly angry at his society, in his alienation ranting like a contemporary King Lear. His life – and its plot – is one of repetition, as Jimmy constantly berates his good-natured, uneducated friend, Cliff Lewis, and abuses first his wife, Alison, then the aristocratic mistress who succeeds her in the flat, Helena Charles. The vitality of the play is in the energy manifested by Jimmy's loathing, and the plot is conceived to present and reflect the protagonist's feelings about and understanding of a society that is losing the coherency provided by both its historic class structure and its spiritual values.

The scenes of the play occur on Sunday with the occasional forlorn tolling of church bells outside the 'prison' that Jimmy has made for himself in his flat. For him, Sunday has only its mundane and boring routine:

> God, how I hate Sundays! It's always so depressing, always the same. We never seem to get any further, do we? Always the same ritual. Reading the papers, drinking tea, ironing. A few more hours, and another week gone. Our youth is slipping away. (14–15)[45]

He protests when Alison wants to accompany Helena to church, and he is smart enough to sum up the spiritual emptiness of his time for himself: 'Nobody thinks, nobody cares. No beliefs, no con- victions and no enthusiasm. Just another Sunday evening' (17). Nor does Jimmy's lonely playing of his trumpet, like some mad Gabriel, summon forth a response from the cosmos.

Jimmy is put in his place – or out of it – by the lingering Victorian social system in disarray. As one reviewer, John Raymond, describes it, 'Fundamentally, *Look Back* is a play about class and this fact goes a long way to explain its popularity. Snobbery is the English pox, the great national disease from which we all suffer and in which we all take a more or less veiled but passionate interest'.[46] Young Jimmy, armed with his university degree, had 'declared war' on the social order, inviting himself to parties and gate crashing. He met Alison, the daughter of a retired army officer, and married her in spite of the opposition of her mother who went to the extreme of setting private detectives onto the ineligible suitor. Consequently, it is Jimmy's class bitterness that jeopardizes his marriage and causes him to take out his frustration on Alison. At the same time, Jimmy, in defiance of his own lower middle-class upbringing, seeks the friendship of good natured but uneducated Cliff with whom he plans to set up a sweet shop. Jimmy, unable to escape the conditioning of his own background, dominates Cliff, claiming to be educating him but in reality ordering him around and abusing him for his stupidity. Finally, Jimmy asks Helena Charles to stay on in the flat when Alison leaves him because he is attracted by her aristocratic style and determined to put her, too, in her place. He succeeds; the audience – to its shock – finds Helena at the beginning of Act III ironing Jimmy's clothes on a Sunday evening just as Alison had been doing at the beginning of Act I. Hence, Jimmy's paralysis and frustration arise from the social order that he defies and despises but cannot escape even through the expression of his anger.

Jimmy exclaims and lives amid the shambles that remain in England of what was once the grandeur of Victorian culture. He is, in the words of his wife, an 'Eminent Victorian. Slightly comic – in a way' (90). The room in which he lives, psychologically imprisoned, is that of a converted attic 'at the top of a large Victorian house'. He is presented at the beginnings of Acts I and III surrounded by a 'jungle of newspapers and weeklies' (9), the remaining artifacts of a literate culture, and Jimmy has not been educated at Oxford or Cambridge, but has a degree from one of the new 'white tile' – 'not even red

brick' – universities (42). He clings, barely, to the remnants of the declining cultural literacy, no longer reading books but only reviews which are beginning to bore him: 'Different books – same reviews', as he complains (10). Nevertheless, Jimmy's rhetoric reflects a decent education, being permeated with historical and literary references and frequent allusions and puns. As his wife suggests, that to which Jimmy 'looks back' is Victorian and Edwardian England, the myth of national history that, in spite of himself, he cannot escape, living literally as he does in an architectural remnant of it. He mocks an article by J. B. Priestley that he has read in the newspapers as 'well-fed glances back to the Edwardian twilight from his comfortable, disenfranchized wilderness' (15–16), and the thought of listening to a Vaughan Williams concert prompts this tirade:

> The old Edwardian brigade do make their brief little world look pretty tempting. All homemade cakes and croquet, bright ideas, bright uniforms. Always the same picture: high summer, the long days in the sun, slim volumes of verse, crisp linen, the smell of starch. What a romantic picture. Phoney too, of course. It must have rained sometimes. Still, even I regret it somehow, phoney or not. If you've no world of your own, it's rather pleasant to regret the passing of someone else's. (17)

Alison's father, Colonel Redfern, when he comes to take her home, even accepts Jimmy's assessment of him as 'just one of those sturdy old plants left over from the Edwardian Wilderness that can't understand why the sun isn't shining any more' (66–67). Colonel Redfern, who witnessed the end of the Raj in India, admits that he knew that 'It was all over then. Everything' (68). Alison recognizes that her father's lament for the national glory of the past is simply the other side of her husband's anger about the present:

> You're hurt because everything is changed. Jimmy is hurt because everything is the same. And neither of you can face it. Something's gone wrong somewhere, hasn't it? (68)

Both the Colonel and Jimmy as representatives of two generations are victims of the same sense of historical dislocation in expressing a feeling of inauthenticity. Not only are they entrapped by class consciousness and national myths of the glorious past, but they

live in a world beyond even English control, 'the American age' (17) Jimmy calls it with its everpresent threat of nuclear destruction.

Out of this sense of inauthenticity and, in Laing's phrase, 'ontological insecurity' arises the most existentially revealing absurdity of the play. To break the Sunday boredom, Jimmy and Cliff slide into the roles of music hall comedians, and their skit turns out to be, in fact, a parody of Samuel Beckett's *Waiting for Godot*, which had first been performed in 1955. Jimmy and Cliff in looking for 'nobody' in the skit mimic the nonsensical dialogue of the clownish Estragon and Vladmir:

Cliff: Are you quite sure you haven't seen nobody?
Jimmy: Are you still here?
Cliff: I'm looking for nobody!
Jimmy: *Will* you kindly go away! 'She said she was called little Gidding – '
Cliff: Well, I can't find nobody anywhere, and I'm supposed to give him this case!
Jimmy: Will you kindly stop interfering per *lease*! Can't you see I'm trying to entertain these ladies and gentlemen? Who is this nobody you're talking about?
Cliff: I was told to come here and give this case to nobody.
Jimmy: You were told to come here and give this case to nobody.
Cliff: That's right. And when I gave it to him, nobody would give me a shilling.
Jimmy: And when you gave it to him, nobody would give you a shilling.
Cliff: That's right. (80)

The dialogue, with its irritating circularity of logic of a Beckett play, continues until Helena interrupts to reveal that she is, indeed, 'Nobody' and gets the case, which is, in fact, a cushion, hurled at her. The comparison to Odysseus' heroic adventure with the Cyclops, evoked by the references to 'nobody' and the action of throwing the cushion, mocks the weakness of Jimmy and his friends, and the skit concludes with a song that summarizes their condition:

Now there's a certain little lady, and you all know who I mean,
She may have been a Roedean, but to me she's still a queen.
Someday I'm goin' to marry her,

When times are not so bad,
Her mother doesn't care for me
So I'll 'ave to ask 'er dad.
We'll build a little home for two,
And have some quiet menage,
We'll send our kids to public school
And live on bread and marge.
Don't be afraid to sleep with your sweetheart,
Just because she's better than you.
Those forgotten middle-classes may have fallen on their noses,
But a girl who's true blue,
Will still have something left for you,
The angels up above, will know that you're in love
So don't be afraid to sleep with your sweetheart,
Just because she's better than you. . . .
 They call me Sydney,
Just because she's better than you. (81–82)

With the song, the analogy between the absurd world of Beckett's play and 'the Present Compromise' of Osborne's England is complete.

While the world of Beckett in its waiting for relief or salvation is distinguished by paralysis, the world of Osborne is distinguished by sterility and inauthenticity. Jimmy finds an identity to assume by living up to being named for 'Mrs. Porter' in T. S. Eliot's 'Sweeney Among the Nightingales'; he talks like a kind of latter-day version of the writer. As he comments sardonically on the wasteland of the 1950s, Jimmy echoes not only the style but the tone of Eliot's verse of the 1920s. Eliot is Jimmy's persona for venting anger, and when in Act III he with Cliff and Helena break into their music hall routine he titles it 'T. S. Eliot and Pam' (79) and refers to the *Four Quartets* in calling their recitation, 'She said she was called a little Gidding, but she was more like a gelding iron!' (80).

Rootless Jimmy, in assuming his persona, is like a member of the 'Identity Club' described in Dennis's *Cards of Identity*, the novel being almost contemporary with Osborne's play. None of Osborne's characters are complete human beings; none are able to conceive new identities mentally or physically. Rather, like the schizophrenics being studied by Laing, each is a divided self, keeping his or her real 'self' hidden while developing a 'false self' or personality with which to cope with the world. Jimmy, Cliff, and Alison are presented living

together in a kind of Lawrencian *ménage à trois* because uneducated Cliff possesses the physicality and sexuality that the disaffected intellectual Jimmy lacks – Lord Chatterley, Lady Chatterley, and the gamekeeper Mellors. Cliff takes off his pants for ironing in Act I and his shirt in Act III, posed partially undressed, in Jimmy's words, like 'Marlon Brando or something' (83). In their sexual rivalry, they wrestle like adolescent school boys, Jimmy seeking integration with the physical side he lacks, the two behaving like Gerald and Birkin in Lawrence's *Women in Love*. Correspondingly, the two sides of the feminine principle are represented by the wife and the mistress; as Alison recognizes, Jimmy is incapable of being satisfied by either her or Helena:

> He wants something quite different from us. What it is exactly I don't know – a kind of cross between a mother and a Greek courtesan, a henchwoman, a mixture of Cleopatra and Boswell. (91)

This world of divided selves finds its ultimate symbol in the baby that Alison loses. Unable to tell Jimmy of her pregnancy before she leaves him, Alison lets Helena tell him, and upon learning about the pregnancy, he responds in feigned indifference with an image appropriate to the theme of the divided self: 'I don't care if she's going to have a baby. I don't care if it has two heads!' (73).

Jimmy's personality may be inauthentic and divided, but, ultimately, Osborne reveals him to be a human being desperately desiring integration. Reunited with Alison and alone with her at the end of the play, Jimmy puts aside the mocking and ranting of the persona with which he confronts the world and shows the fear and vulnerability of his true self. In a wasted and sterile world, all that is left is love, and out of their affection Jimmy and Alison create roles into which to retreat in charming tenderness. From the beginning of the play, a 'tattered toy teddy bear and soft, woolly squirrel' (9) have been part of the scene, and at the end, acknowledging the fulfilment and promise they have lost with the baby, Jimmy and Alison take their most endearing and authentic roles from these children's toys. Previously in the play the Victorian flat has been a prison; in the end it becomes a retreat for the vulnerable human animal in recognition of the dangers of an indifferent universe. Jimmy and Alison are like Lear and Cordelia reunited and alone:

Jimmy: We'll be together in our bear's cave, and our squirrel's

drey, and we'll live on honey, and nuts – lots and lots of nuts. And we'll sing songs about ourselves – about warm trees and snug caves, and lying in the sun. And you'll keep those big eyes on my fur, and help me keep my claws in order, because I'm a bit of soppy, scruffy sort of a bear. And I'll see that you keep that sleek, bushy tail glistening as it should, because you're a very beautiful squirrel, but you're none too bright either, so we've got to be careful. There are cruel steel traps lying about everywhere, just waiting for rather mad, slightly satanic, and very timid little animals. Right?

Alison nods.
(*pathetically*). Poor squirrels
Alison: (with the same comic emphasis). Poor bears! *She laughs a little. Then looks at him very tenderly, and adds very softly.* Oh, poor, poor bears!
Slides her arms around him. (96)

Together Jimmy and Alison seek to create a new world for themselves out of nostalgia and tender fantasy. This child's world of Beatrix Potter, with its touch of Edwardian fancy, is not absurd, like Beckett's, but hopeful in the spirit of English perseverance. In it, decent people admit their true feelings and seek authenticity in and for England again. But, retreat to the past, to the English insularity of the Edwardian twilight that Jimmy himself so despises, is finally only an ending for a play, not the beginning of a new foundation for culture.

Nor is there any more articulation or any fewer betrayals among the characters, upper class and lower, portrayed in the plays of Harold Pinter. Indeed, his plays dramatize the situation of Francis Bacon's paintings. People are trapped in a sterile setting; they are nearly unmoving and most undramatic in their paralysis. Their emotions hidden by the languor of the scene, build quickly to intensity, leading to surprising revelations of violence and sexuality like that expressed in Bacon's paintings. Bacon has spoken of the 'story' of his triptych paintings, any sense of narrative being a concern for the artist since he wants to avoid amplification. Also, the usual similarity of the right and left paintings in the triptych tends to suggest temporal paralysis and spatial entrapment. Nevertheless, if one considers the visual compositions not as apprehended simultaneously, but as viewed, or read, sequentially, then a narrative could be said to unfold, though it is very limited. Like Bacon's

paintings, Pinter's scenes barely come alive, since his characters, too, are trapped in uninteresting rooms amid alienating silence. Pinter, amid the fragile civilization of the late twentieth century, does not trust words, stating that 'language under these conditions, is a highly ambiguous business'.[47] He and his characters have not yet found 'another voice' for 'next year's words', as Eliot's shade of Yeats had prophesied. When Pinter's characters do speak, it is usually to confront, to attack, and to lacerate their companions, a sense of the bestial emerging from a facade of the trivial. And in both Bacon's paintings and Pinter's plays, the focus is ultimately painful and Freudian as acts of sexuality and violence define and elucidate the mortality and the pathos of the characters. While Bacon in a triptych may use the central image of a bleeding carcass to comment on the writhing couples on each side of it, Pinter, through an almost static encounter of extremely limited dialogue, works – whether forward in time as in *The Homecoming* or backwards as in *Old Times* and *Betrayal* – toward a climax that exposes the hidden beast within the facade of civility as one of the characters is 'sacrificed' by the others to become a carcass left over from a tribal rite.

As watched by the audience, such moments of revelation are presented like a Bacon composition: two men locked in a struggle for territory in *The Caretaker*; a man and a woman struggling for sexual accommodation engaged psychologically in conflict and watched by another person who, like a Bacon voyeur, merely observes in *Betrayal*. The dramatic scene, like the painted one, in a moment of silence achieves the crucial revelation of the horror of the 'bestial floor'. Men and women are trapped together to confront each other as human beings, and Pinter, like Bacon, exposes their instinctual and fallen selves. As the director Peter Hall says of one example, *The Homecoming*, 'this play looks unblinkingly at life in the human jungle'.[48] Pinter as playwright adds to the visual scene the verbal context, creating a language of the ambiguous, the not-quite-said, and the silent – his own form of social 'Newspeak' – which puzzles the audience about relationships as much as the blurred, over-lapping, and multiple images of Bacon trouble his viewers. Like Bacon's lines, Pinter's words in their ambiguity express the superficiality and banality of a time in which the literary culture is inadequate and exhausted. As the playwright says,

I have another strong feeling about words which amounts to nothing less than nausea. Such a weight of words confronts

us day in, day out, words spoken in a context such as this, words written by me and by others, the bulk of it a stale dead terminology; ideas endlessly repeated and permutated become platitudinous, trite, meaningless. Given this nausea, it's very easy to be overcome by it and step back into paralysis.[49]

History in the late twentieth century has left little hope and nothing to say. Therefore, both Pinter and Bacon explore the lack of definition and meaning in the modern social order, the difficulties of human intercourse save on a physical level of sex and violence, and in the ambiguities of their presentation a similar suspense is created for the spectator that attracts one's attention and haunts one far beyond the opportunity to see the work. Time will not clarify the matter for it is unimportant, and no resolution is possible. Like Miss LaTrobe's grammaphone in *Between the Acts*, time is an indifferent machine, and history itself, according to Pinter, undependable: 'We are faced with the immense difficulty, if not impossibility, of verifying the past. I don't mean merely years ago, but yesterday, this morning. What took place, what was the nature of what took place, what happened?'[50] Hence, in works by both playwright and painter, the problem for the viewer is not even in the development of characters or their role in history but in understanding the depths of the absurd, static situation that is their present human tragedy.

Certainly Pinter's characters are as ontologically insecure as Bacon's, and they bare their fangs just as often. A Pinter character 'is there to defend his room', and this territorial struggle can produce, as in *The Homecoming*, 'a family of predators.'[51] And, as in a Bacon painting in which commonplace objects of British life like an umbrella or a pack of cigarettes appear in an ordinary setting against which some image of human coupling with teeth bared is staged, Pinter, too, confounds his audience with the juxtaposition of a sense of ordinary life, usually in leisurely repose, suddenly disrupted by the emergence of the incipient predatory natures of the characters. Indeed, even Bacon's figures that are posed reclining like conventional static figure studies are echoed in Pinter's play, *Old Times*, in which two characters spend much of the time resting on chaise lounges, barely moving and, indeed, hardly speaking as the ominous tension between them builds from the sparse dialogue. And, they are overheard from the beginning of the play by a third party, a silent listener standing at a window with her back to them, who enters the action midway through the first act by suddenly

turning and disturbing the near-silence with a rather lively, and, in the context of the previous strained dialogue, long speech which seems like a soliloquy performed in the presence of the unmoving pair on the couches.

Both Pinter and Bacon could be described as distorting the human figure toward the grotesque. Pinter does it with lines of dialogue or their lack; Bacon does it with the bending of lines. Both succeed in distorting to reveal and to mock. They are showing us the gruesome comedy of contemporary life, and both are satirists in their effort. (Samuel Beckett's relationship to Bacon in the matter of misshaping the human form to expose its frailty and ugliness is more direct: characters like Hamm and Clov in *Endgame* are physically as well as emotionally crippled.) Indeed, like the obscure figures of Bacon's triptych paintings, it is often hard to tell the characters apart because all suffer from the blight of missing meanings. In Pinter's *Old Times*, two women, Kate and Anna, seem at times indistinguishable, except in appearance, as they echo and repeat each other's lines and tend to merge into one personality in the audience's perception. Similarly, in *The Homecoming* a sense of difference among the male members of the family is difficult to maintain in watching the play. At the level of dialogue, the identities of such characters are just as ill-defined and blurred as the reworked and overlapping figures of Bacon's paintings.

The appearance of doubles, like the nearly indistinguishable Kate and Anna, creates a sense of violence. Indeed, twins have been interpreted by ethnologists as inspiring terror:

> Wherever differences are lacking, violence threatens. Between the biological twins and the sociological twins there arises a confusion that grows more troubled as the question of differences reaches a crisis. It is only natural that twins should awaken fear, for they are harbingers of indiscriminate violence, the greatest menace to primitive societies. . . . Twins are impure in the same way that a warrior steeped in carnage is impure, or an incestuous couple, or a menstruating woman. All forms of violence lead back to violence.[52]

Lack of purity, the inability to discriminate between and among human figures, indeed, the blurring of even sexual identities, is the condition presented by Bacon and Pinter that leads in their 'stories' to confrontation by the viewer with an imprecise and

flawed universe. When it becomes increasingly difficult to tell human beings apart, they seem at some level of understanding to be monstrous. In this way, the viewer, losing grip on the values of analysis that depend on clarity, confronts 'the horror' because the madness which has set in is inescapably real; along with the blurring and the doubles, both Pinter and Bacon enclose the viewer in insanity. Their world, like ours, is inescapable; their set is the 'bestial floor', and we are part of it. Anyone who tries to leave, as in *Old Times* and *The Homecoming*, cannot; they must stay, as must the viewer, to the end.

Pinter's *Old Times* begins with the same atmosphere and, indeed, setting of a Bacon painting. Visually, the set is appropriately contemporary and sterile, being 'a converted farm-house' with 'spare modern furniture'(6)[53] appropriate for the configuration of silent characters in the opening tableau that immediately conveys paralysis and alienation as well as ambiguity in the relationships:

> *DEELEY slumped in armchair, still.*
> *KATE curled on a sofa, still.*
> *ANNA standing at the window, looking out.* (7)

The lethargic opening dialogue between the lounging Deeley and Kate identifies Anna to be her roommate from younger days. As Deeley and Kate talk, Anna remains standing still and silent at the window, uninvolved in the scene. It is as if she were the personification of the couple's psychological focus as they anticipate her coming, a kind of ghost amid their near silence. Suddenly just as the tedium has grown nearly intolerable, Anna turns and joins the couple, speaking at length of her youthful experiences with Kate in London. As she does, the mood of Baconian languor ends, and the scene is transformed immediately into its alternative, a group of old friends amicably reminiscing about old times. However, Kate remains quiet, distracted as if daydreaming, while Deeley questions the lively Anna about her life, noticing as he does that there is something quaint about her. He comments at one point, 'The word gaze. Don't hear it very often' (26). Reminiscing leads Deeley and Anna to sing the songs of their youth and recollect past experiences; like so many post-war works, vitality can only be found in trivia from the past.

Amid the reminiscing, Anna recalls one experience which could be the 'story' for a Bacon composition:

This man crying in our room. One night late I returned and found him sobbing, his hand over his face, sitting in the armchair, all crumpled in the armchair and Katey sitting on the bed with a mug of coffee and no one spoke to me, no one spoke, no one looked up. There was nothing I could do. I undressed and switched out the light and got into my bed, the curtains were thin, the light from the street came in, Katey still, on her bed, the man sobbed, the light came in, it flicked the wall, there was a slight breeze, the curtains occasionally shook, there was nothing but sobbing, suddenly it stopped. The man came over to me, quickly, looked down at me, but I would have absolutely nothing to do with him, nothing.

Pause

No, no, I'm quite wrong . . . he didn't move quickly . . . that's quite wrong . . . he moved . . . very slowly, the light was bad, and stopped. He stood in the centre of the room. He looked at us both, at our beds. Then he turned towards me. He approached my bed. He bent down over me. But I would have nothing to do with him, absolutely nothing. (32)

After more accounts of Anna's life, there is a 'silence', and Anna and Kate are suddenly talking as if they were again roommates and Deeley were not present. Time in the play has become blurred, and the two middle-aged women have turned into happy young women excitedly sharing their anticipations of love and romance. It is Kate's only lively moment in the first act of the play, and Deeley sits displaced – 'odd man out' – while the dialogue between the roommates continues.

The second act is a mirror image of the first; indeed, it is like Bacon's use of a complementary image. Even the set is reversed: *'The divans and armchair are disposed in precisely the same relation to each other as the furniture in the first act, but in reversed positions'* (47). This act begins, as almost a continuation of the end of the first, in lively dialogue about old times except that it is between Anna and Deeley and Kate is not seen since she is taking the bath in the present which at the end of act one she had been about to take in the two women's reenactment of the past. In this act, instead of Anna suddenly entering the dialogue, Kate returns from the bath and goes to look out the window as Anna had done at the beginning of the play. Anna and Deeley reprise their singing of old lyrics before Kate turns – as Anna had – to begin a spritely

narrative about her bath. She still talks as if she were in the past, and Anna answers her in the same fashion. The disoriented Deeley tries 'to play along' with what appears to him to be a game while still attempting to question Anna about her present life. He grows increasingly threatened by Anna who in her visitation from the past seems literally to possess Kate. There is a connotation of lesbianism in the relationship of the roommates, and Deeley protests, saying, 'I mean I'd like to ask a question. Am I alone in beginning to find all this distasteful?' (66), and he goes on to describe how he first met Anna. Suddenly, the quiescent Kate interrupts to proclaim to Anna, 'But I remember you. I remember you dead', and she continues with a lengthy description of the event, which begins:

> I remember you lying dead. You didn't know I was watching you. I leaned over you. Your face was dirty. You lay dead, your face scrawled with dirt, all kinds of earnest inscriptions, but unblotted, so that they had run, all over your face, down to your throat. (71–72)

Kate explains how after Anna's death she became Deeley's lover and married him. The play concludes with an enactment of the scene of Deeley sobbing already described by Anna in act one, followed by a final tableau out of a Bacon painting that blazes into the viewer's sight:

> *Lights up full sharply. Very bright.*
> *DEELEY in armchair.*
> *ANNA lying on divan.*
> *KATE sitting on divan.* (75)

Clearly, Pinter's play with its unspoken quality and its ambiguities is about ghosts. Fact *has* left its ghost in Bacon's sense: Anna may be dead, but she is very much alive psychologically to Kate, whose somnambulance, almost catatonia, results in her being lost in the old times of memory. It may be that Anna with her tales of the past, songs, and romantic life in Italy embodies Kate's youthful dreams of womanhood which have been unfulfilled during twenty years of marriage. Deeley is, indeed, 'odd man out', like Joyce's Gabriel Conroy unable to intrude upon his wife's inner world. Like a Baconian composition, the first and second acts mirror one

another in appearance and action, and there is even, in a sense, the description of 'dead' Anna to confront us with the 'carcass' of human mortality. Bacon, like Pinter, usually plays with time, both artists hinting at a stasis in the human condition, a nightmarish state of limbo from which there is no escape. The sexuality described by both cannot, finally, overcome the tedium and boredom in life. And in both play and painting, there is the third party watching, the indifferent or bored presence of someone else, the figure on the phone in Bacon's 'Triptych' of 1967 and, interchangeably, first Anna, then Kate, and, finally Deeley, in *Old Times*. Anna and Kate, too, are frightening twins whose impurity in their hinted lesbianism terrifies the onlooking male. And Kate, whose play this really is, represents the schizoid modern self, unable to integrate youth and desire with age and reality. At the same time, like the character of Ruth in *The Homecoming*, a female visitor who succeeds in dominating a household of males, Kate has greater psychic force than her husband who, in time, becomes her victim – at least psychologically. Both Kate in *Old Times* and Ruth in *The Homecoming* begin their plays as alienated victims of an imprisoning culture – represented by the institution of marriage – which has denied them fulfilment; by the end of their plays they have become transformed into terrifying psychological predators.

In *Betrayal*, all of the characters are victims of one another.[54] Indeed, the play is a kind of mirror image of *Old Times* with the disruption of 'home' and personal relationships displayed in an adulterous triangle consisting of two men and a woman instead of two women and a man. Like *Old Times*, the chronology of presentation is reversed, except that in *Betrayal*, instead of the ambiguity of shifting from present to past to present without apparent transitions or scenes, the retrospective experience is clear to the audience because a date is affixed to each scene: the plot is similar to psychoanalysis during which the patient at each session is taken a little further back in time until a crucial starting point is finally reached. But, in *Betrayal*, there is no 'odd man out'; rather, an awareness created in the audience through the strategy of presentation that 'betrayal' pervades all of the relationships. The play presents an anatomy of the idea of betrayal, for, as the retrospective review of the major events of the affair reveals, not only has there been adultery in marriage but also disloyalty in friendship and deception between lovers. The ironies of these interrelated betrayals is made clear to the audience by the

reversal of the order of presentation: we begin after the affair and then reel backwards to its beginning, leaving a sense of disruption of the social order and decorum to reverberate in the audience's mind. Reversing the telling of events also calls attention to time itself which betrays the characters by taking its toll in spent passion and forgetfulness.

By ending, literally, with an act initiating and affirming love, the grasping of an arm, the plot of the play is classically comic. Yet, in actuality, the play is the tragic presentation of separation and violation. Scene after scene – enjoyed in dramatic irony by the audience – reveals each of the characters preying on the others – cheating, lying, deceiving while upholding the appearance of civility. The result for the audience is an overwhelming sense of cynicism about the fabric of loyalties in marriage and friendship and passion. And, overall, there is a sense that all of the emotion and lying is somehow irrelevant amid the indifferent stream of passing time.

Each scene is a Baconian composition: usually two figures in a room paralyzed by ennui and hiding their true selves; only the audience through dramatic irony understands the violence of their mutual betrayals. The first two scenes, both set in Spring 1977, reveal the alienation between lovers and friends. The first shows the deadness of feeling between the lovers, Emma and Jerry, two years after the end of their affair. They meet for a drink in a pub, and Emma tells Jerry that she has been quarrelling with her husband, Robert, because she has confessed to the affair. It becomes clear that the two lovers have become separated not only by choice but by circumstances and time: Emma has taken another lover, and the two cannot even agree about where an amusing event in their lives occurred years before. The mood is bittersweet for there is nothing left between them and even their nostalgic effort to recall 'old times' is mocked by their forgetfulness. In the second scene, Jerry meets Robert to apologize and learns that he had been told by Anna of the adultery not the previous night but four years before. Hence, an image of disorder is established at the outset of the play as deceptions amid the relationships of love and friendship are revealed, and the mutual dishonesty among Emma, Jerry, and Robert evolves in the ensuing scenes.

Continuing backward in time, we are shown Jerry and Emma in Winter 1975, in their hideaway flat meeting as bitter lovers for the last time and deciding to end their relationship. Then, we

see Jerry with Anna and Robert at their house in Autumn 1974, sharing a drink together in the midst of the affair and coping civilly, even though – as the audience is about to learn – Robert already knows of the illicit relationship. The next three scenes take place in Summer 1973, the period when Emma actually confessed her adultery to Robert. The first takes place in a Venice hotel room when the confession occurs; the second shows Emma and Robert meeting in their flat upon her return in which she fails to disclose her confession to her husband in Venice; and the third shows Jerry meeting Robert for lunch upon his return and implicit sexual rivalry emerging within the facade of their friendship. The final two scenes show moments of initial disloyalties in the relations of lovers and friends. The first occurs in the flat, Summer 1971, when Emma tells Jerry that she is pregnant by Robert, and the last scene is one of Jerry, Emma, and Robert together in Winter 1968, when Jerry first proclaims his love for Emma and, in a sense, the affair and the betrayals begin. Hence, Pinter's theme is fulfilled, in a play which takes the form of comedy but becomes, in fact, a statement on the tragedy of the human condition amid the cruel indifference of time.

In the world of Pinter's characters, all that is left finally is instinct: revitalizing passion is impossible. In *The Homecoming*, the audience sees a family of males contending for Ruth, the visiting American wife of one of them. They humiliate, even fight with one another, over her, while her husband, Teddy, essentially looks on as a passive voyeur. His role is like that of Deeley in *Old Times*, except that at the end Teddy stops watching and leaves. Ruth stays to accept the role of ruling matriarch, both a kind of mother and prostitute, to the family; she emerges to become 'the queen bee, not the captive' who 'wants to translate sexual power into real estate',[55] and, as in a Bacon painting, an orgy of sexual energy is imminent. Corrupted, the figure of the female has become the whore to a masculine world. In this and other compositions by Pinter all that is left at the end is the sexual in a civilization stripped of values or illusion, and titles like *The Homecoming* and *Betrayal* ironically refer to classical antecedents, like the *Oresteia* trilogy, with its emphasis on family disloyalty and social chaos. Yet, Pinter's plays are full of the trivia of contemporary English life, indeed, they are almost collections of memorabilia: an old renovated house furnished with dilapidated odd tables, a furnished flat, Italian holidays, a typical pub. What has been said of Pinter could as well be said of Bacon.

Both artists do, indeed, present a 'savage picture of the domestic life of the human animal'.[56] They represent, along with Greene, le Carré, Sillitoe, and Osborne, those English artists who remain long after the war prisoners of a psychology of enclosure, alienation, loathing, and fear – truly, post-Moderns all.

4
Debating 'Culture'

The daughters of Albion
 arriving by underground at Central Station
 eating hot ecclescakes at the Pierhead
 writing 'Billy Blake is fab' on a wall in Mathew St

taking off their navyblue schooldrawers and
putting on nylon panties ready for the night

Adrian Henri,
'Mrs. Albion You've Got a Lovely Daughter' (1969)

Books are the mirrors of the soul.

Virginia Woolf, *Between the Acts* (1941)

Once the matter of 'saving civilization' had been settled by war, the debate over 'saving culture' began. T. S. Eliot provoked it by asserting his reactionary Modernist post-war agenda in *Notes towards the Definition of Culture* (1948). He makes a troubled plea to save culture by returning to the conservative social structure of a Victorian civilization based on the idea of a church-state lead by an intellectual-artistic-clerical élite. Writing in light of the 1945 election of the Labour government, Eliot fears that the rise of the 'new civilization' is at the expense of the old English 'culture', and he seeks to control social change with tradition, citing as the epigraph for his polemic a 'rare' definition of 'culture': 'the setting of bounds; limitation'.[1] From this neo-classical perspective, he emphasizes the unifying importance of shared religious values, advocating a Christian church-state for England because 'any religion, while it lasts, and on its own level, gives an apparent meaning to life, provides the frame-work for a culture, and protects the mass of humanity from boredom and despair'.[2] At the same time, fearing greater political democracy in the post-war era, Eliot cannot tolerate the idea of a classless society; he argues that for national leadership there must

73

be a class of élite to insure that the *'transmission of culture'* (Eliot's emphasis) continues; moreover, he proposes that this class rely on heredity for its perpetuation, on 'groups of families persisting, from generation to generation, each in the same way of life'.[3] Finally, he protests against the increasing involvement of historically insular England in what he terms 'world culture'. Life in a civilization that is secular, democratic, and international is as frightening to Eliot as life in the state of Oceania in *Nineteen Eighty-Four* is to Orwell. Eliot thought 'a *uniform* culture . . . would be no culture at all. We would have a humanity de-humanised. It would be a nightmare'.[4]

Indeed, post-war life did become something of a nightmare, as even advocates of social reform admitted. For Labour M.P. Richard Crossman, assessing a decade of the policies of his party in an essay titled significantly, 'Socialism and the New Despotism', the society of 1956 was too much a reminder of 1948 – or *Nineteen Eighty-Four*. Wartime controls and rationing deliberately prolonged long after the end of the war in a socialist effort to promote equality and the fair sharing of limited resources among all economic classes resulted in wide-spread frustration with austerity. In addition, the Orwellian nightmare of a bureaucratic 'managerial society' created by the State to operate vast, public industries had become a reality even as the Cold War focused attention on the example in Soviet Russia of socialism degenerating into despotism. As a result, Crossman points to disillusionment among those who thought they were shaping society in an ideal manner:

> What brought people into the Labour Party before the war was the conviction that it was fighting the battle for popular emancipation at home and abroad. What inclined them towards Socialism was the belief that democracy was breaking down and that freedom could only be secured by transforming it into a Socialist society. It was this assumption which converted a whole University generation, who would have been ardent Liberals in 1906, into ardent Socialists during the great depression; and it was the growth of doubt about its validity which has disillusioned them in the 1950s.[5]

Thus, the very 'good causes' that had sustained the society through the war and beyond became suspect in the 1950s, and, as we have seen, literary representations of the effect of the 'after-war' on the

common man in works by the Angry Young Men conveyed the disenchantment.

Moreover, as Orwell was already saying in his 1939 essay on Dickens, the ideology of Modernism that had dominated literary culture between the wars had collapsed, its exponents having 'gone over to some or other form of totalitarianism'. Those who had witnessed the devastation of war, therefore, reacted against the Moderns' uncritical absorption of reactionary attitudes, and popular opinion about them could be vicious. Frederic J. Osborn, the articulate exponent for the town planning movement, wrote to his American friend, Lewis Mumford, in 1944:

> The decay of Joyce into *Finnegans Wake* wholly suits my spiritual as distinct from my aesthetic evaluation of *Ulysses*; it interests me all the more because it carries into his nonsense the highly-decorated and elaborate rhythms against which the staccato and documentary schools revolted, besides their arrested-adolescent nihilism . . . That Ezra Pound became the hireling of Roman Fascism, therefore, gave me malicious glee. That Eliot found what I thought his needlessly lost soul in the socially powerful but intellectually negligible Anglican Church did nothing to incline me to take his verse more seriously.[6]

Osborn later added:

> I can't see the modern literary or art movements as having anything like the social importance that Shakespeare, Wordsworth, Tennyson, Dickens, Ruskin, etc., had in their times. My mother had a Tennyson; her present parallel would not possess Eliot or Auden.[7]

The literary critic F. R. Leavis, attempting to restore a literary foundation for culture, articulated a 'great tradition' of English works that dismissed the Moderns from consideration. As Leavis said of Joyce, their movement had been 'a dead end, or at least a pointer to disintegration'.[8] Hence, anxiety about the future intensified in light of the Cold War and the proliferation of nuclear weapons, enhancing debate about the transmission of culture raised by Eliot; however, lacking a new humanistic foundation to replace a discredited Modernism, the literary scene, faced by the rise of philistinism, was

dominated by the pessimism, frustration, and anger of post-Modern works.

Inevitably emerging from the debate was the suggestion to reinvigorate culture through education on a new foundation, and the effort, amid the vigour of post-war research activity, focused on the role of science. The molecular physicist and novelist C. P. Snow in *The Two Cultures and the Scientific Revolution* (1959) joined the debate to attack directly the dominance of literary values in the formation of culture and argue that science should become the basis of education and, subsequently, society. Sharing in the contemporary rejection of Modernism, Snow argued that the movement had failed to prevent or even to respond to the horrors of the twentieth century; indeed, in his view, the 'most imbecile expressions of anti-social feeling' by 'those who have dominated literary sensibility in our time' – he specifically cites Yeats, Pound, and Wyndham Lewis – may have contributed to the violence. Nor historically has the literary culture provided an 'automatic correction' in other 'misguided periods' because, in Snow's view, 'Literature changes more slowly than science'.[9] This raises for Snow an issue of the difference between the literary and scientific attitudes in thinking about society, a topic that is central to his argument. He believes that scientists as a whole, regardless of diverse political and philosophical views, are optimists about changing the social condition even if they consider the individual condition of mankind to be tragic: 'They are inclined to be impatient to see if something can be done; and inclined to think that it can be done, until it's proved otherwise. That is their real optimism, and it's an optimism that the rest of us badly need'. Scientists, by the very nature of their intellectual searching, have 'the future in their bones'.[10] Literary intellectuals, on the other hand, are hampered in addressing social problems by 'a moral trap which comes through the insight into man's loneliness: it tempts one to sit back, complacent in one's unique tragedy, and let the others go without a meal'.[11] Unfortunately, from Snow's point of view, 'it is the traditional culture, to an extent remarkably little diminished by the emergence of the scientific one, which manages the western world'.[12] His lecture is a plea to end the division in educational specialization leading to ignorance and social polarization on both sides that promulgates 'two cultures' instead of one. For Snow, only an education acknowledging the scientific revolution and conveying an attitude of optimism in addressing social problems will be sufficient for a world in which the disparity

between rich and poor countries is increasing and the capability of nuclear devastation is in the hands of many nations.

F. R. Leavis' famous rebuttal to Snow is a tirade from one of the most elitist defenders of a literary foundation for culture. However, written in the shadow of the increased Cold War anxiety about the threat of nuclear devastation, his reaction arises from honest fear about the survival of civilization, and he employs a rhetorical knife, well-honed by the examples of eighteenth-century satirists, to attack Snow. To Leavis, Snow's argument is flawed by lazy thinking – middling intellect at the level of commentary in the Sunday newspapers; therefore, Snow in his ignorance reveals himself to be an example of the very educational problem that he seeks to address in *The Two Cultures*. Hence, Leavis insultingly titles his lecture 'The Significance of C. P. Snow' (1962); but, ignoring the – contemporary – bad manners of Leavis' *ad hominum* rhetoric, the lecturer has a fair warning to express. Leavis accepts the inevitability of scientific advancement, but he is concerned about the human qualities that are needed to manage it. As Leavis states, 'the advance of science and technology means a human future of change so rapid and of such kinds, of tests and challenges so unprecedented, of decisions and possible non-decisions so momentous and insidious in their consequences, that mankind – this is surely clear – will need to be in full intelligent possession of its full humanity'. By this, Leavis carefully points out that he does not mean something so limited and conservative in his, or Snow's, view as 'traditional wisdom'; rather, he calls for a human quality more profound and more complex than can be learned from either of the two cultures. Leavis concludes: 'What we need, and shall continue to need not less, is something with the livingness of the deepest vital instinct; as intelligence, a power – rooted, strong in experience, and supremely human – of creative response to the new challenges of time; something that is alien to either of Snow's cultures'.[13] Leavis' lecture is, finally, a desperate plea for an education that enhances the best of human thinking, whether literary or scientific, analytic or creative, to insure the continuation of life itself. His humanist's plea was joined by a chorus of artistic ones, especially in fiction, voices more melodramatic than even Leavis' own in attacking Snow's thesis.

Anthony Burgess' black humour version of *Nineteen Eighty-Four*, *A Clockwork Orange* (1962), brilliantly coalesces Snow's assertion of the necessity of scientific thinking with the anxieties emerging from the rise of the new philistinism in the socialist state: the

inability of the proletariat to understand their freedom, hostility to traditional literary culture, and fear of the example of Soviet despotism. Alex, the protagonist and narrator of the novel, is an Arthur Seaton of the near future who is kept comfortable by the policies of the state yet who is bored to the point of violence. He, like Arthur, is frequently intoxicated, appropriately for his world of adolescent fantasy, on drug-laced milkshakes, and he recounts his life of crime as the fifteen-year-old leader of a teenage gang in an ersatz language reflecting the disrespect of his generation for the literate past. Alex's speech is the slang English of a teenager corrupted further by the introduction of Russian terms;[14] he and his gang embody the nightmare of 'humanity de-humanised' produced by the 'world culture' that Eliot feared. The violence to language simply epitomizes the violence to representatives of culture, scientific and literary, perpetrated by Alex and his gang of 'droogs'. During a single night, the gang, souped-up on the concoctions at the local teenage hangout, 'The Korova Milkbar', begin their violence by 'tolchoking' a 'doddery starry schoolmaster type veck' (7) and tearing up science books that he has just taken from the 'Public Biblio';[15] they finish the night by invading the home of a writer, destroying his manuscript, and raping his wife. Returned home after the 'horror show', which for the gang means a good time, Alex listens to Beethoven on his stereo, highly amplified classical music being for him just another form of stimulation that induces violent thoughts to the point of orgasm. Hence, the world of *A Clockwork Orange*, as described by Alex, is one in which traditional culture is ravaged for the purpose of violent pleasure both in the action and in the telling.

Burgess portrays to an extreme degree what Orwell suggests: the individual will struggle violently not just against the specific administration of scientific brainwashing that seeks to effect an ideological goal, but against the whole fabric of the social order that would condition him. Alex, like Winston Smith, ends up in prison where he is subjected to psychological torture by the authorities; but his experience in prison is, far more than in Winston's world, an extreme manifestation of life in a socialist state that has almost forgotten its literary heritage of decency and respect. The manuscript destroyed by the gang at the home of the writer (ironically, one of them is wearing a 'Peebee Shelley' mask) is titled *A Clockwork Orange*, and the passage mockingly read aloud by Alex before destroying it states the theme of Burgess' alarmed protest against

the world that his England is becoming through its systematic circumscription of individuality: "'The attempt to impose upon man, a creature of growth and capable of sweetness, to ooze juicily at the last round the bearded lips of God, to attempt to impose, I say, laws and conditions appropriate to a mechanical creation, against this I raise my swordpen'" (26–27). Violence is Alex's, and his generation's, protest against the unnatural imposition of social engineering on human free will and individuality.

The 'Lodovico' technique, to which Alex is subjected in prison, is only a scientific version of his dehumanizing everyday existence. He is forced to watch atrocity films from the Second World War while being administered drugs that cause nausea; the violent films are enhanced emotionally by classical background music. When Alex protests against being averted from music along with violent acts, the scientist in charge of the 'cure' replies that he understands music only as 'a useful emotional heightener' (131). The conception and administration of such an aversion therapy intended to cure Alex's anti-social tendencies mocks C. P. Snow's notion that science with its optimism, rationality, and objectivity is best able to provide a cure for the ills of society. Alex's treatment reveals the fallacy of forgetting the imperfect nature of humanity by showing what will occur when out of scientific over-confidence and optimism about solving social problems the perfectability of mankind as a 'clockwork orange' is sought. After being treated and released, Alex himself becomes a victim: he is defenseless when beaten up my members of his old gang, exploited politically by a radical group, and even denied the pleasure of listening to classical music. But, unlike the world of Winston Smith, there is still human fallibility left amid the scientificism of Alex's world. The 'Lodovico' technique is only experimental, and after Alex publicly embarrasses the authorities by attempting suicide they are able to reverse his treatment and restore his human nature as well as his love of music. The reader finds Alex again listening to his beloved 'glorious Ninth of Ludwig van' and working himself up emotionally and sexually to a climax that undoubtedly anticipates the inevitable renewal of a life of violent crime. However, in the last chapter of Burgess' tale, when Alex has grown up to the age of eighteen, he decides to change his life for the better, exercising his free will as a human being to make a choice to give up his violence and settle down. This more mellow Alex seems at last to be like Arthur Seaton at the end of *Saturday Night and Sunday Morning*. With this surprising reversal in Alex's

personality, Burgess' novel becomes less a cautionary fable about post-war dehumanizing forces than a tract on maintaining respect for individual growth and free will in a scientific age.[16]

John Fowles in *The Collector* published in 1963, the year after *A Clockwork Orange*, adds another view of the threat of philistinism and science to traditional culture. His novel, by formally juxtaposing the 'collector' Clegg's reminiscences against his victim Miranda's journal of her captivity, becomes an allegory of the conflict between scientific and humanistic thinking, expanding on the significance of the episode in *A Clockwork Orange* of Alex's gang's attack on the writer of *A Clockwork Orange*. Clegg's tone is that of the objective collector of scientific specimens; what is terrifying about him is the cold, calculating quality of his madness – the same complacent attitude toward committing violent acts encountered in Arthur Seaton and in Alex's doctor: 'When I had a free moment from the files and ledgers I stood by the window and used to look down over the road over the frosting and sometimes I'd see her. In the evening I marked it in my observations diary, at first with X, and then when I knew her name with M' (3).[17] In contrast, Miranda's style is that of the naive and romantic art student whose elitist literacy is no defense against her captor's insanity: 'I'm so superior to him. . . . I have to give him a name. I'm going to call him Caliban. . . . I'm going to make Caliban buy me books' (137–138). Their struggle imitates the plot of Richardson's *Clarissa*, the eighteenth-century religious myth of Satanic Lovelace's attack on Clarissa's Protestant virtue having been transformed into a contemporary cultural myth of the scientific 'rape' of the humanistic tradition. Miranda's fate parallels Clarissa's, too. After her captor has drugged her, removed her clothes, and photographed her – for impotent Clegg the equivalent of the sexual act, she catches pneumonia and dies, a martyr to the philistinism of the late twentieth century.

Miranda certainly interprets her imprisonment in terms of the controversy over scientific and humane values. When Clegg proudly shows her his butterfly collection, she replies: 'I hate scientists. . . . I hate people who collect things, and classify things and give them names and then forget all about them' (55). Of his photographs, she declares: 'They're dead. . . .All photos. When you draw something it lives and when you photograph it it dies' (55). Her consciousness, which Clegg cannot violate, is filled with artistic and literary references by which she asserts her artistic identity and defines her intellectual superiority. She

identifies with the 'snobbism' and 'priggishness' of Jane Austen's Emma Woodhouse (166) while viewing Clegg as Shakespeare's untutored, half-beast Caliban. Consequently, she articulates the issue for society of the new philistinism: 'Why *should* we tolerate their beastly Calibanity? Why should every vital and creative and good person be martyred by the great universal stodge around?' (220–21). Later, after reading *Saturday Night and Sunday Morning* during her imprisonment, Miranda identifies Clegg with Arthur Seaton and criticizes Alan Sillitoe for glamorizing his protagonist: 'I think Arthur Seaton is disgusting. And I think the most disgusting thing of all is that Alan Sillitoe doesn't show that he's disgusted by his young man. . . . Perhaps Alan Sillitoe wanted to attack the society that produces such people. But he doesn't make it clear' (248). Miranda has been tutored in intellectual elitism by her artistic mentor, identified only as 'G. P'., who has taught her that it is a struggle to be an artist and an intellectual amid the indifferent even hostile Calibanity of contemporary English society: 'The feeling that England stifles and smothers and crushes like a steamroller over everything fresh and green and original'. G. P. goes on to say that amid 'the great deadweight of the Calibanity of England . . . the real saints are people like Moore and Sutherland who fight to be English artists in England. Like Constable and Palmer and Blake' (172–173). Miranda succinctly summarizes the conflict in terms of G. P.'s elitist ideas. Near the end, she states, 'It's a battle between Caliban and myself. He is the New People and I am the Few' (249), and, dying, she concludes: 'The Rape of Intelligence. By the moneyed masses, the New People' (270).

Miranda's struggle dramatizes G. P.'s ideas which represent those of John Fowles as expressed in his own philosophical work, *The Aristos* (1964), first published about the same time as the novel. Like Eliot's *Notes towards the Definition of Culture* and Leavis's attack on Snow, Fowles's work is an assertion of the value of intellect in the age of the masses. In a preface added in 1968, Fowles defends himself against the charge that he is a 'crypto-fascist' (8)[18] by interpreting *The Collector* as a 'parable' of the persistent historical struggle between 'the Few and the Many' (10) analyzed in terms of his own time. Fowles asserts that it is '*biologically* irrefutable' that mankind is divided into 'what Heraclitus understood to be a moral and intellectual *elite* (the *aristoi*, the good ones . . .) and an unthinking, conforming mass – *hoi poloi*, the many' (9); therefore, while Clegg as representative of the Many is committed to evil he is

virtually 'innocence' because his evil is 'largely, perhaps wholly, the result of a bad education, a mean environment, being orphaned'; like Burgess's Alex he is the result of the conditioning of his society. Similarly, Miranda, for her part, is good because of her background: 'She had well-to-do parents, good educational opportunities, inherited aptitude and intelligence' (10). The struggle between them remains unresolved and ends tragically with Miranda's death and Clegg's contemplation of his next victim. For Fowles, their situation and that of society is one of 'unnecessarily brutal conflict' unless 'the Many can be educated out of their false assumption of inferiority and the Few out of their equally false assumption that biological superiority is a state of existence instead of what it really is, *a state of responsibility*' (10).

Achieving a state of responsibility among the *aristoi* – of whatever origin – in an era of ontological insecurity in which the very basis of traditional culture is being questioned is finally impossible. Snow follows Forster and Eliot in seeking to identify a new, contemporary élite, but as Burgess' and Fowles's novels suggest, the values of the scientific mind, too, can become distorted. Rebecca West, recounting the history of the treason of the atomic physicists, Alan Nunn May and Klaus Emil Fuchs, lashes out at scientists like Snow who would propose themselves to be élite in possessing unusual qualifications for leadership. Suspicious of claims by scientists that their technical knowledge is a 'special gift' of 'universal wisdom', she concludes: 'The study of physics or chemistry is no more likely than the study of harmony and counterpoint to develop social omniscience in the student; nor have these or any other branches of science made any contributions to the technique of government which would give their students any right to intervene as experts'.[19] Similarly, George Steiner reassessing the Snow-Leavis controversy – and implicitly the cultural debate initiated by Eliot – comments:

> Looking back, one is struck by the underlying political, social significance of the affair. The controversy between Leavis and Snow is, essentially, a controversy over the future shape of life in England. It sets the vision or reactionary utopia of a small, economically reduced but autonomous and humanistically literate England against that of a nation renewed, energized, rationalized according to technological and mass-consumer principles. It is, thus, a debate over the relationship of England both to its own past and to the essentially American present.[20]

Hence, in contemplating culture in the 1950s and 1960s, writers continue to disagree about what should be its basic values.

In an effort both to preserve a humanistic foundation for culture and to redeem the post-war socialist vision of society, no writer explored the issues raised by the debate more thoroughly than Raymond Williams. For him, in answering specifically T. S. Eliot's concern about the transmission of culture, ways of communicating humanistic values to the broadest possible audience in the nation has been the thesis of a variety of cultural studies. By seeking means to expand education, Williams wants to overcome the resistance to literary culture by the new philistines. Whether his subject matter is from drama, or film, or television, or the novel (all topics of full-length books), Williams is always interested in the ways in which a medium serves to transmit culture to people. The 'masses' and 'mass communication' dominate a way of thinking about literary art that is Marxist, and, consequently, the focus of his historical studies of cultural values is on the period of the rise of capitalism since the Industrial Revolution.

Williams' fascination with values and social concepts has led him to identify for study the 'keywords' of modern society, the most significant of which is 'culture', and he established the major themes of his work as an historian of ideas in *Culture and Society: 1780 to 1950* (1958). Williams has said that the specific impetus for the book was his reaction to Eliot's *Notes towards the Definition of Culture* in which he found 'the concentration of a kind of social thought around this term which hadn't before appeared particularly important'. To redeem it from what he perceived to be Eliot's reactionary ideology and 'to refute the increasing contemporary use of the concept of culture against democracy, socialism, the working class or popular education',[21] *Culture and Society* clarifies the concept by studying the thoughts and feelings of various English thinkers and writers in response to changes in their society since the beginning of the Industrial Revolution. Not intended as a general theory of culture (though certainly approaching one), the study traces the evolution of meaning not only of 'culture' but of such related value-words as 'industry', 'democracy', 'class', and 'art' in a capitalistic society. Williams begins by describing the establishment of this cultural vocabulary of shared meanings in the late eighteenth and early nineteenth centuries; then, he surveys a wide-range of Romantic and Victorian writers to show specifically how their views of art emerged from their society rather than being imposed by them

upon it. Finally, he uses the views on industrialization of such twentieth-century writers as Lawrence, Tawney, Eliot, and Orwell to focus on the need to develop a new common culture that will be the basis for a democratic community in contemporary society. This new foundation would solve such fundamental problems as social relations in an industrial society, democracy in an era of mass communications, and the function of art in the common life of the nation.

Throughout Williams' career, he has displayed a socialist's concern for imparting art and culture to the majority of people, and a culminating concept of the progress of ideas traced in *Culture and Society* is, for him, the rise of multiple ways of communicating as a means for transmitting culture. His books on the theory of communications and the various media extend this concern in detailed ways. For example, in *Communications* (1962), by tracing the history of book publishing, the theatre, journalism, and film, Williams explores how these forms of communication shape social institutions. He concludes that while the audience has been expanding the means of communicating has been controlled and oriented to capitalism with an attendant dedication to authoritarian, paternal, and commercial values. He calls for reform of the media to introduce true democracy and to encourage the achievement of human liberation. This educational process, not disruptive radical acts, is the means to accomplish what he conceives to be *The Long Revolution* (1961) in changing the nature of society. Viewing his own position as one of 'radical populism', he continues his fascination with the vocabulary of culture by viewing language as arising from a consciousness of one's social being and as a product of social and economic history. Consequently, he seeks to extend the sense of the literary to a multiplicity of popular forms and rejects any elitist sense of what is 'aesthetic'.

Williams' ideological bias and knowledge of literature triumphantly unite with autobiography in *The Country and the City* (1973). As in *Culture and Society*, his method is a broad survey of English writers and an analysis of their historically varied experiences that focuses, in this instance, on the persistent images and associations of country and city; his approach is motivated and humanized, however, by his personal testimony to the effects of economic forces on the rural society of his own childhood home, the Welsh border country, and his effort to come to terms with the dichotomy between the experiences of his early life as the son of a working-class family

and his later life as an intellectual in the cities of Cambridge and London. The book is, as one critic describes it, 'a kind of *Biographia Literaria*', by which the author testifies empirically, based on his own experience, to the validity of his own judgments.[22] Conventional generic limits on what kind of book Williams is writing erode, in the manner of Orwell's wartime and post-war essays and fiction, as *The Country and the City* takes the form of a meditation on the themes of his autobiographical novels, *Border Country* (1960) and *Second Generation* (1964).

Beginning with a review of the origin of the pastoral idea in the classical understanding of a 'golden age', Williams reads the genre to suggest that its tradition disguises the historic facts of a troubled agrarian society; he carefully traces in poets like Goldsmith and Cowper and novelists like Austen and Hardy artistic responses to such historic events as the enclosure acts, the decline of rural villages, the economic disruption of the lives of the landed class as well as the rise of the city with its complex social relationships and its inhabitants' loss of a sense of a 'knowable community'. Seeking to reverse the reader's usual perception of values (in the radical manner of Blake's *Marriage of Heaven and Hell*) associated with the country and the city, Williams debunks the conventions of the English literary pastoral and 'country house' poems; he attacks as well the nostalgic fondness in his own time for the 'English heritage' of the great house and its aristocratic society that have become associated with simplicity, innocence, and freedom of the country in opposition to complexity, corruption, and imprisonment in the city. This kind of thinking about the country arouses 'anger' in Williams 'both for personal autobiographical reasons and for contemporary cultural reasons' because 'the values of the rural capitalist order which first imposed the notion of mastery are now being presented as the height of civilization'; 'these houses were primarily sites of exploitation and robbery and fraud'.[23] From Williams' point of view, there never has been an ideal time for either rural or urban life because the controlling force for both since the eighteenth century has been the capitalism which first affected the rural scene, then expanded to the growing cities, and, eventually, spread worldwide through the colonial system of Great Britain.

Tracing the literary imagery of country and city is for Williams a way of comprehending the expansion of this basic pattern of self-interest and control, but, completing his attack on the usual

assumptions about the pastoral mode, he finds hope for the estab-
lishment of a better, more democratic community not in the false
ideal of the country but in the socialism spawned in the city: 'Out
of the very chaos and misery of the new metropolis, and spreading
from it to rejuvenate a national feeling, the civilising force of a new
vision of society had been created in struggle, had gathered up
the suffering and the hopes of generations of the oppressed and
exploited, and in this unexpected and challenging form was the
city's human reply to the long inhumanity of city and country
alike'.[24] Williams views his own work to be part of the revolution
in mind and attitude that began in the city, a revolution which
necessarily will take a 'long' time in a highly developed society.
Through the exhilarating act of writing *The Country and the City*,
Williams takes a part in the 'long revolution' which gives him both
a sense of place and a sense of identity:

> Yet a deeper change has now become quite evident. All the con-
> ventional priorities are again being questioned. . . . This change
> of basic ideas and questions, especially in the socialist and revo-
> lutionary movements, has been for me the connection which I
> have been seeking for so long, through the local forms of a
> particular and personal crisis, and through the extended inquiry
> which has taken many forms but which has come through as
> this inquiry into the country and the city. They are the many
> questions that were a single question, that once moved like light:
> a personal experience, for the reasons I described, but now also a
> social experience, which connects me, increasingly, with so many
> others. This is the position, the sense of shape, for which I have
> worked. Yet it is still, even now, only beginning to form. It is
> what is being done and is to do, rather than anything that has
> been finally done.[25]

Hence, Williams presents himself and his work as an example of
how to revitalize culture by taking part in the re-examination and
re-evaluation of thinking about its sources.
 Williams' incorporation of personal anecdote and autobiography
into a treatise on *The Country and the City* that focuses on literary
attitudes fostered by capitalism disconcerts the conventional reader.
The reviewer for the *New Statesman* begins by noting that 'this
book is a combination of personal reminiscence, criticism and eco-
nomic history', then wonders 'whether the three modes of thought

are satisfactorily combined here. Mr. Williams's autobiographical involvement comes to seem obtrusive; his insistence on bearing personal witness begins to sound a little like self-dramatisation'.[26] In contrast, a scholar like Terry Eagleton who understands Williams' Marxist approach finds the finest accomplishment of *The Country and the City* to be precisely that element which most disturbs the reviewer: 'Williams's achievement, then, has been to pursue the implications of felt personal experience to the point where they are organically merged as methods, concepts, strategies',[27] and, indeed, Williams in the introductory chapter to *The Country and the City* acknowledges how the chance facts of his own life opened the way for him to identify his literary and ideological thesis:

> It happened that in a predominantly urban and industrial Britain I was born in a remote village, in a very old settled countryside, on the border between England and Wales. . . . Before I had read any descriptions and interpretations of the changes and variations of settlements and ways of life, I saw them on the ground, and working, in unforgettable clarity. In the course of education I moved to another city, built round a university, and since then, living and travelling and working, I have come to visit, and to need to visit, so many great cities, of different kinds, and to look forward and back, in space and time, knowing and seeking to know this relationship, as an experience and as a problem.[28]

With this personal approach to literary history, Williams succeeds in offering a radical answer to Eliot's concern about the transmission of culture. Williams defines the crux of the English experience since the Industrial Revolution through the invigorating contrary of city and country, and he follows Orwell in letting the felt experience of autobiography inspire his vision of culture. In *The Country and the City*, Williams both defines the English setting as well as executes the autobiographical form by which artistic expression of the late twentieth century would be known.

Interlude

John Lennon wasn't satisfied. Up to that moment, the Beatles had never remade any song, and they had just recorded this one in their usual way, the band alone playing their own instruments. But, it was a time of transition for the group, having given up touring to prove themselves as artists in the studio; therefore, to please John, an orchestral score was composed and another version of the song with a different tempo and key was recorded. He still wasn't satisfied: he liked both versions and told the producer, George Martin: 'I like the beginning of the first one, and I like the end of the second one. Why don't we just join them together?'[1] Martin did. His splice, utilizing the electronic magic of the recording studio to hide the differences in key and tempo, created a version which blends fundamentally dissimilar musical experiences into a harmonious whole. With a 'little' help from their friendly producer, the Beatles had discovered serendipitously the musical equivalent of montage in film and collage in painting.[2] The mode would go well with the style of their lyrics in creating a synthesis of images. The song was 'Strawberry Fields Forever', and the recordings were made in November 1966. Originally intended to be part of an album, the song was released on a single with 'Penny Lane' in order to maintain public enthusiasm for the group which was no longer giving concerts. Besides the miraculous splice, the record was innovative in other ways. Orchestral backgrounds enhanced the sound of the band on both songs, Paul McCartney having initiated this effect by suggesting the use of the accompaniment of a Bach trumpet on 'Penny Lane'. Moreover, the musical experimentation was accompanied by a different kind of lyric. Previously, the Beatles primarily had written music inspired by American rhythm and blues and rock and roll with the lyrics of traditional ballads, conventional love songs, and occasional novelty numbers like 'Yellow Submarine'. Suddenly, on both sides of this record, the lyrics are full of English nostalgia with autobiographical references to places and people from the Beatles' own childhood in Liverpool.

Paul McCartney's song, 'Penny Lane', pictures an ordinary neighborhood around a bus roundabout in Liverpool. The residents are recollected as if through the eyes of a child fascinated by their various odd penchants: the barber always showing photographs, the banker never wearing a 'mac' in the rain, the nurse selling poppies. However, this innocent view of the scene is ironically undercut by an adult's debunking phrases and sexual entendres: the barber's photographs show 'ev'ry head he's had the pleasure to know'; the nurse at the roundabout dreams that she is in a play but she is really in the 'y-way' (highway).[3] The setting is beneath 'suburban' skies, as the relentless refrain emphasizes. Nevertheless, in spite of the imposition of adult cynicism, the song is lively in rhythm and technique especially with the soaring flights of the trumpet, and 'Penny Lane' ends by conveying a sense of community amid the bustle of the characters converging in the barber shop.

John Lennon's 'Strawberry Fields Forever' begins with nostalgic reference, too. Strawberry Fields was a Salvation Army school where John attended garden socials, but the place name is only the starting point for hallucinogenic lyrics full of word play and contradictions. While McCartney's song is descriptive in presenting a picture of a neighborhood, Lennon's is intentionally obtuse as he attempts to approximate the mood of illogical meditation created by the drugs with which he had begun to experiment. The sound, altered electronically to permit the splicing of the versions, finally is as unreal as the rhetoric, and the union of music and lyrics successfully presents an experience of dream and hallucination. The combining of the experiences of nostalgia and dream with the musical and technical innovations on the record prepare the way for the Beatles to create a revolutionary album which was unified poetically by a single theme as well as through musical continuity by eliminating the segues or empty gooves between songs. They now had the means, both musically and lyrically, to create a record album which would be the pop epic of their age.

The 1960s was a time of war, anti-war protest, and experimentation with drugs, and through musical montage and pictorial collage the album *Sergeant Pepper's Lonely Hearts Club Band* is the true expression of the period.[4] There is no English literary work of the time that expresses the moment quite as well as the album. At the time of its creation in February 1967, feeling against the Vietnam War was intense as was a fascination with the pacifist and escapist drug culture. But also, ironically, it was the moment of a fad in

London of Victorian military memorabilia, including a shop called 'I Was Lord Kitchener's Valet'. Paul McCartney composed the song 'Sergeant Pepper's Lonely Hearts Club Band', and, as producer George Martin recalls, Paul suggested, 'Why don't we make the album as though the Pepper band really existed, as though Sergeant Pepper was making the record?'[5] Coming at the time when the Beatles were restructuring their career to become studio artists, the fiction of a band of musical alter egos taking the place of the 'early Beatles' blended perfectly with a continuation of the nostalgia first expressed in 'Penny Lane' and 'Strawberry Fields Forever'. The conception was extended on the album to a whole revue performed by the group in the guise of the Sergeant Pepper Band and comprised of music and lyrics reminiscent of pantomime, circus, and music hall experiences of a by-gone era. There is a feeling of nostalgia about the experience more anachronistic than the 'twenty years today' to which the title song refers; the atmosphere is of the far earlier time of the late Victorian or Edwardian era.

Unlike earlier records and albums, the album contains no love songs. Rather, it expresses both the vitality and the melancholy of the experience of English domestic life as perceived in the late 1960s. Vitality arises from the ironic conception of the album: fun and nostalgia in the creation of a music hall revue by a quaint military band at the very time of protest and pacifism in the light of America's involvement in Vietnam. In a sense, the album is an expresssion of an England remote from battle, and it repeatedly carries the listener into a world of childhood joys. Beginning with the title song, 'Sergeant Pepper's Lonely Hearts Club Band', and continuing with 'Being for the Benefit of Mr. Kite!', 'Lovely Rita', and the reprise of the title song, the album is punctuated by glimpses into this innocent time. Adding a playful element are the music hall novelty numbers: Ringo Starr appearing as 'Billy Shears' and singing 'A Little Help From My Friends' as well as 'Good Morning, Good Morning' with its assorted silly sound effects. Reinforcing the nostalgic vision are the songs evoking the intensity of psychedelic experience in carrying an adult into the world of fantasy: 'Lucy in the Sky With Diamonds', 'Fixing a Hole', and the Eastern rhythms of George Harrison's meditative 'Within You, Without You'. Yet, the full experience of the album is like that of 'Penny Lane': the melancholy and anxiety of real life continually intrude into the imagined world of nostalgia and fantasy. This contrast occurs in the debunking and sometimes

ironic songs about everyday English domestic life, the melancholy 'She's Leaving Home' and the apocalyptic 'A Day in the Life', that undercut the overall liveliness of the album, as well as occasional dissonant images – 'everyone you see is half asleep' – which occur even in upbeat lyrics.

Because of its juxtaposition of lyrical and musical images, 'A Day in the Life' appropriately concludes the album. Following a reprise of the joyful 'Sergeant Pepper's Lonely Hearts Club Band', the final track, in ironic contrast, immediately evokes a sense of the tragedy of real life by recounting the newspaper account of the suicide of a 'lucky man who made the grade' even if 'nobody was really sure if he was from the House of Lords'.[6] The music is initially plodding and restrained, and it continues at a monotonous four beats to the measure as the singer describes a film about the English army which had 'just won the war'. The image of 'a crowd of people turned away' coupled with the tempo suggests boredom with the military glories of the past, and the voice has the lethargy of daydream in reaching the refrain, 'I'd love to turn you on', with its sexual as well as chemical connotations. Then, the rhythm shifts to a more upbeat eight beats to the measure as we hear about the morning routine of the singer who gets up, dresses, combs his hair, and arrives at work just in time to have 'a smoke', undoubtedly hallucinogenic, and go 'into a dream' which can only be conveyed through a musical bridge. Following this musical phantasmagoria, the tempo slows to the tedium of the original four beats as the imagery returns to reading the newspaper with its terrible and strange news. This time the story is about the 4,000 mysterious holes found in 'Blackburn Lancashire', each of which must be tediously counted. Again, the singer, almost in boredom, drifts into the refrain, 'I'd love to turn you on'. The song and the album conclude with a cacophonous crescendo of sounds perhaps recapitulating all that has gone before but certainly conveying through the rising dissonance a feeling of the end of the world – at least by electronic devastation. It sounds as if the breakdown of civilization hinted throughout the album but held off by nostalgia, fantasy, hallucination and, in general, just plain fun is occurring. However, at the very end order and equilibrium seem restored by a final harmonious and triumphal chord right out of Beethoven (and, as every fan knows, a last bit of fun: the inaudible dog whistle inserted in the final segues).

This cacophonous yet synthesizing end to 'A Day in the Life' epitomizes the experience of the album as a whole. On the musical

level, the album has been described as 'a veritable sound track of the times' consisting of 'a synthesis of styles: traditional, classical, ragtime, Eastern, rock 'n' roll, pop, and psychedelic'[7]; it presents all that has gone before in pop music and all that can possibly be foreseen at the moment of its creation (similar to the parody of literary styles in Joyce's *Ulysses*). Simultaneously, the lyrics present a barrage of poetical images, some nostalgic, some playful, some melancholy, some tragic, mixed together to form a picture, partly naturalistic and partly fantastic, of the contemporary English scene. And, finally, Peter Blake's visual design for the album cover employs the same strategy by assembling images that evoke diverse emotional responses and incorporating over sixty historical figures ranging from C. G. Jung to Tarzan, from Dr. Livingston to Dylan Thomas, from Lewis Carroll to Marilyn Monroe, and turning these into a collage of nineteenth and twentieth history leading up to the moment of the Beatles – a grand 'conversation piece' of their times.

Like every epic, *Sergeant Pepper's Lonely Hearts Club Band* is a prophecy intended to encompass contemporary life, expose its flaws, and, ultimately, transform it. The Beatles in their music and lyrics mock a time of American war and English alienation. Affected at the time by the ego-enhancing and pacifist visions of their psychedelic experiences, the Beatles had come to view themselves transformed as persons: they saw themselves as no longer just a pop group. Now, they were artists creating in their studio, and they had buried the early Beatles musically with their radical new kind of songs and visually in the design on the cover for a revolutionary album. They believed their own transformation could extend to all human kind, seeing themselves in a new way as 'the ultimate vehicle of peace and goodwill'.[8] In their artistic and chemical evangelism, they understood their creativity and their music in a Blakean sense of having the power to alter the consciousness of human kind for the better. Some of their generation thought they had actually succeeded, the critic Kenneth Tynan calling the album 'a decisive moment in the history of Western Civilization'.[9] It was released in England on 1 June 1967, and later that month the Beatles appeared on the international television spectacular, 'One World', to sing 'All You Need Is Love' as a message of peace and love to millions of people throughout the world. In a few months, starting with a mere splice to create a different sound for a song and concluding with an epic album, the Beatles had thought and

acted as messiahs giving word and music to the mood of their times. But, they and their admirers would learn in the world of twentieth-century violence that, as W. H. Auden elegized in 1939, 'poetry makes nothing happen'.

John Lennon was assassinated on December 8, 1980.

5

The City: Pop Art and Brutal Architecture

> The English are town birds through and through today, as the inevitable result of their complete industrialization. Yet they don't know how to build a city, how to think of one, or how to live in one.
>
> D. H. Lawrence, *Phoenix* (1936)

> We have created somewhat godforsaken cities from which nature, or indeed the spiritual side of life, has almost been erased. We don't *have* to build towns and cities we don't want, in which we feel manipulated and threatened by architecture.
>
> Charles, *Prince of Wales, A Vision of Britain* (1989)

Conceived amid Victorian confidence and prosperity, the Great Exhibition of 1851 expressed an international vision in striving 'to present a true test and living picture of the point of development at which the whole of mankind has arrived . . . and a new starting point, from which all nations will be able to direct their future exertions'.[1] It expressed the high aspiration of a society experiencing an outpouring of cultural achievement in such mid nineteenth-century works as Dickens's *Great Expectations* (1851) and *Bleak House* (1852–3), Arnold's *Empedocles on Etna and Other Poems* (1852), Carlyle's *Life of John Sterling* (1851), Thackeray's *Pendennis* (1850), Macaulay's *History of England* (1849), Tennyson's *In Memoriam* (1850), Ruskin's *Stones of Venice* (1851–3), and Wordsworth's posthumous *The Prelude* (1850). Its grand purpose was well expressed in the exceptional monument by which the exhibition became identified, the building known as the Crystal Palace; looking back a hundred years later, Arthur Bryant still found meaning in its reflection of the glorious Victorian world:

94

The Great Exhibition of 1851 was held in an atmosphere of great national happiness. The Exhibition itself – for it was the treat of the year and one immensely enjoyed by all classes – contributed much to that happiness. Yet it was not merely the cause of a feeling of social well-being: it was the symptom of it. . . . Still, it is pleasant, despite the tragic aftermath of all those sanguine assumptions, to look back across the century that has enclosed our own troubled and our fathers' untroubled lives and revisualize the spirit and form of 1851. There was Victorian England – early Victorian England on the threshold of mid-Victorian England – dreaming of a world for ever at peace and making an image of its dreams and of human achievement, as it saw it, in a palace of glass. What an England it was![2]

The Crystal Palace, as Asa Briggs describes it, 'suggested at the same time both fairy tale and success story. Behind the glitter was human thought and human work. . . . The Crystal Palace was thought of as a temple of peace where all nations would meet by appointment under the same roof and shake each other by the hand'.[3] This greatly admired building, when it had to be removed from Hyde Park, was dismantled and rebuilt on another site from the original glass and iron; appropriate for a building dedicated to such high purpose, the reconstructed version of the Crystal Palace was destroyed by fire in 1936 on the eve of the Second World War.

The post-war Labour Government felt compelled to mark the mid-century and the survival of the nation with a Festival of Britain on the centenary of the Great Exhibition. In contrast to the 'Crystal Palace' exhibition, the Festival was conceived amid austerity, and its purpose was nostalgic and far more nationalistic than the original. In the words of the initial proposal to Parliament on 7 December 1947, its purpose would be 'the celebration of the centenary [of the Great Exhibition], and . . . a national display illustrating the British contribution to civilization, past, present and future, in arts, in science and technology, and in industrial design'.[4] Indeed, as one historian comments, 'there was pathetically little for Britain to celebrate in 1951' (indeed, there were few notable cultural achievements in the Festival year comparable to those of the time of the Great Exhibition), and 'it was their own private Britain that they had in mind'.[5] This sense of insularity was expressed quite explicitly in the Archbishop of Canterbury's sermon for the opening

ceremonies – a passage of which was reprinted as the epigraph to the *Official Book*: 'The chief and governing purpose of the Festival is to declare our belief in the British way of life. . . . It is good at a time like the present so to strengthen, and in part to recover our hold on all that is best in our national life', and the Festival Guide extended the theme in stating that 'spontaneous expressions of citizenship will flower in the smallest communities as in the greatest'.[6]

The irony of this reduced sense of national vision did not escape contemporary observers. Arthur Bryant wrote:

> The Festival Exhibition on the South Bank has as its theme the story of Britain and the British people, and the record of their joint achievements and accomplishments. It is curious that at the time of our greatest complacency as a nation – in 1851 . . . – we should have staged a great Exhibition to portray the achievements and accomplishments of the whole world, and, in 1951, at the end of a long and calamitous, if victorious, epoch of self-doubting . . . we should have staged what at first sight appears to be an exhibition of insular self-congratulation.[7]

Noel Coward mocked the lack of vision in a song, 'Don't Make Fun of the Fair':

> Take a nip from your brandy flask,
> Scream and caper and shout,
> Don't give anyone time to ask
> What the Hell it's about.[8]

Britain in 1951 was seeking to live on the past, trying to find identity and pride in its historic glory, and the need for the Festival, in spite of post-war shortages and rebuilding, was motivated by sentimentality and nostalgia.

The Festival allowed fullest expression of the insular Neo-Romantic movement that inevitably, and quite appropriately, prevailed in the arts from the beginning of the war, an outpouring of nationalism that focused primarily on advocating the British way of life and 'Recording Britain' in photographs and topographical paintings. Artists from this movement like Graham Sutherland, John Piper, Michael Ayrton, and John Minton received major commissions for the Festival; Bill Brandt's topographical photographs were published; the books displayed at the Victoria and

Albert Museum for the Festival Exhibition were selected to show aspects of the British life and character.[9] Hence, the Festival was, in Lawrence Alloway's phrase, 'the crown of the British Picturesque revival',[10] and beneath the superficial glitter of its contemporary style was tradition and nostalgia, as Elizabeth Wilson recognized in recollecting the exhibition:

> Its vision was also inward-looking, an embodiment of a romantic, non-expansionist nationalism – not Empire but Commonwealth, an illusory community of equals. The Festival promoted a particular style, a superficial, spirally modernism that could be superimposed on highly traditional structures. There were the same dining room and bedroom suites for the traditional family; but their shapes were 'scandinavian' or 'contemporary'; there were the same suburban houses revamped with abstract wallpapers and pastel paints. The Festival was also obsessed with monarchy. And Coventry Cathedral, built at the same period, epitomized the importance of the conventional Anglicanism which was still lurking behind the pseudo-modernity. In being only superficially modern and much more deeply traditional, the Festival accurately reflected the 'socialism' of postwar Britain, and also prefigured the 'materialism' of the 1950s.[11]

This 'materialism' would prove a strong tie between the style of the Festival and the artistic direction of England in the late twentieth century.

As a post-war consumer society finally emerged in England, marked by the election of a Conservative government in 1951, a more outward-looking movement was developing in the arts – Pop. Its origins lay in the fascination of a few artists, architects, and critics with American commercial design, especially the combination of glamour and hucksterism displayed in magazine advertisements. This interest found earliest expression in the late 1940s and early 1950s in collages made by Eduardo Paolozzi from what he came to call 'found images'.[12] 'I Was a Rich Man's Plaything' (1947) consists of a magazine cover from *Intimate Confessions* on which appears a provocatively posed model along with a list of titillating contents, including the title [Plate 8]. Pasted on the cover are pictures of a cherry and the label from a juice drink, 'Real Gold', that in juxtaposition to the woman comment ironically on her sensuality and on a hand holding a gun from which extends a balloon reading,

'POP!' Below the cover is a wartime postcard of an American bomber with the slogan, 'Keep 'Em Flying!', and a Coca-Cola logo. Another collage, 'Real Gold' (1950), uses a cover from *Breezy Stories* showing a 'pin-up' girl posed next to an advertisment for Real Gold and a cut-out image of Mickey Mouse (anticipating the later obsession of the American pop artist Claes Oldenberg). Another collage, 'Was This Metal Monster – or Slave' (1952), is simply the ragged cover from the February 1952, *Amazing Stories*. Clearly Paolozzi in these collages is recognizing the artistic content to be derived by isolating essential icons found in the contemporary commercial designs of a capitalistic society, and, as British society became more consumer oriented, his fascination with such sources of inspiration influenced others. The Independent Group in London, which began to meet at the Institute of Contemporary Art in 1952, knew of Paolozzi's 'found images', and a series of exhibitions which they mounted between 1953 and 1957 established the Pop Art movement in England.[13] Besides Paolozzi, the group included artist Richard Hamilton, architects Peter and Alison Smithson and James Stirling, critics Reyner Banham and Lawrence Alloway, and photographer Nigel Henderson. Their assimilation of visual designs from the post-war industrial society, especially works taken from mass-produced, primarily American, consumer culture, into works presented to the public as serious art provided a means of escape, once and for all, from the legacy of austerity and provincialism of the 1940s. Indeed, the Independent Group sought inspiration in glossy American magazines, finding in their pages, as the Smithsons remember, 'a specially loaded message about possibilities for the immediate future', and they 'turned to this forever renewed source material so that we could be in a position to give form to people's aspirations at the same time as they discovered they had them'.[14]

While the Independent Group was exploiting creatively the imagery of American consumer culture, the artistic use of images produced by technology was given authority by the painter Francis Bacon's reliance on photographs as a basis for painting. As Lawrence Alloway realized, 'Bacon's use of "mass-media" quotations differs from earlier uses by painters, in that recognition of the photographic origin of the image is central to his intention',[15] and this concept instigated a series of exhibitions by members of the Independent Group. A 1953 exhibition called 'Parallel of Life and Art' placed visitors to the Institute of Contemporary Art amid enlarged photographic images drawn from a greatly expanded range of sources,

including commercial designs and scientific and technical illustrations, while a 1955 exhibition created by Richard Hamilton called 'Man, Machine, and Motion' showed photographs linking human beings with machines as sources of fantasy as well as fact.[16]

However, it was the 1956 exhibition 'This is Tomorrow' that became the moment for proclaiming Pop as a movement with its own manifesto. In a statement for the exhibition catalogue, Richard Hamilton, defending the artistic energy of the new kind of imagery, wrote:

> We reject the notion that 'tomorrow' can be expressed through the presentation of rigid formal concepts. Tomorrow can only extend the range of the present body of visual experience. What is needed is not a definition of meaningful imagery but the development of our perceptive potentialities to accept and utilize the continual enrichment of visual material.[17]

In accommodating artistically to the richness of the material, Hamilton, following the example of Paolozzi's 'found objects', chose the medium of collage for his contribution, the entrance to the exhibition being dominated by a large photostat of his catalogue piece, 'Just What Is It That Makes Today's Home So Different, So Appealing?'[18] The collage assembles images from advertisments into a satiric view of domestic life as depicted in American magazines. The overall design is that of a typical American appliance advertisement showing the ideal couple in their contemporary home, except in this instance the man of the house is a muscle man carrying a large – phallically positioned – sucker on which is written the word 'POP' and the woman is a partially naked pin-up girl. They are surrounded by an extravagant variety of objects from a consumer culture that sells such diverse items as canned hams and vacuum cleaners by associating them with sex and glamour. While the point of view of the collage is undoubtedly sardonic, the images are largely cut-outs from American magazines, creating some sense of distance for the English viewer still experiencing an austere economy, and the overall effect of the exhibition was to unleash imagistically the audience's materialistic aspirations. As two members of the Independent Group, Peter and Alison Smithson, recall the symbolism of the moment, 'ordinary life in the "fifties" received impulses from mass-production advertising aimed at establishing

a whole pattern of life . . . principles . . . morals . . . aims . . . aspirations . . . standard of living. Advertising fell into the role the church once played'.[19]

Paintings by Hamilton that followed the exuberance of the 'This is Tomorrow' exhibition are tempered in their attitude toward Pop by an appreciation of its cultural context. Hamilton continues to use the same mass-produced sources for his images, but they are selected according to a list of contemporary and capitalistic values that intentionally refute and mock the ideals of the austere 1940s. The artist listed these values on 16 January 1957:

> popular (designed for the mass audience)
> transient (short term solutions)
> expendable (easily forgotten)
> low cost
> mass produced
> young (aimed at youth)
> witty
> sexy
> gimmicky
> glamourous
> big business.[20]

Instead of assembling works in what looks like a thrown together fashion, as he did for the exhibition, Hamilton creates very carefully composed paintings. Through his artistry, images conveying the defined values are transformed into compositions that because of their intelligent design and technical skill become beautiful icons of mass consumer culture. Hence, the fine styling and glamour of the American automobile as conveyed in advertising images is celebrated in 'Homage à Chrysler Corporation' (1957), while 'Towards a Definitive Statement on the Coming Trends in Men's Wear and Accessories' (1961) presents the glamour of the space age in focusing on an astronaut in his space suit surrounded by scientific paraphernalia. These formal compositions are always carefully conceived and stylishly presented in spite of the commonplace sources of the images – what Hamilton calls his 'component parts',[21] suggesting his artistic concern that they be understood to be seriously committed to the commercial culture that defines the age rather than merely mocking it.

Hamilton's serious purpose is clear in his description of the creation of '$he' (1962), perhaps the masterpiece of the first phase of British Pop art [Plate 9]. It consists of images taken from appliance advertising and a picture of model Vikky Dougan in a backless dress. The artist explains how he took the idea of 'Women in the home . . . which is a sieved reflection of the ad man's paraphrase of the consumer's dream' and transformed it into a painting with at least the pretense of high seriousness:

> At first sight it is easy to mistake . . . [the] intention as satirical. It looks as though . . . the painting is a sardonic comment on our society. But I would like to think of my purpose as a search for what is epic in everyday objects and everyday attitudes.[22]

Hamilton, then, claims no bias against the everyday products of a technological society; he collects commonplace images and selects from them forms that when imaginatively integrated complete a sophisticated picture of his age. The final results are quite humane forms that are comfortable with their urban origins; they reflect neither the disillusionment with contemporary life expressed by the Angry Young Men nor a perpetuation of the Orwellian post-war nightmare seen in Bacon's work. Hamilton accepts the commercial environment and finds inspiration in it. Moreover, he intends his vision of contemporary woman to be erotic, even 'sexy' in the 'slick' sense of his society, as his explanation of his artistic rendering of the pin-up of Vikky Dougan in '$he' makes clear:

> Miss Dougan's back, although too good to miss, was not quite what was needed; a rotation of the figure gave the best of both worlds plus. The shoulders and breasts, lovingly air-brushed in cellulose paint, were done with one eye on [the pin-up] the other on the Petty girl. Her breasts can be seen in two ways, one reading provides a more sumptuous profusion of flesh than the other. The cleavage on the backside suggested an apron effect in negative; this was nice – an apron, however minute, is fundamental to the woman-in-the-home image. This area is in shallow relief, 1/8 in. ply sanded down at the lower edge to merge into the panel. The relief retains some subtleties of modelling which are not perceptible in the photograph – in fact, they can best be explored by sensitive fingers rather than the eye.[23]

When Hamilton inlays on his composition a final gimmick, a winking plastic eye, '$he' confirms the dream of a consumer society – at least a male's eye view of it.

While Hamilton provides his viewer aesthetic distance by using primarily foreign – American – images combined with great technical skill, Peter Blake, who represents in the 1960s a new generation of Pop artists, achieves it in quite different fashion. He finds his images not in American mass advertising but, in a return to a form of Orwellian nostalgia, in a collection of memorabilia from his own country that includes souvenirs, knickknacks, prize fight and carnival posters, pin-up girls, and remnants from the circus and music hall world. These sources for his art appear to come from an earlier, more innocent time before the war. Even when Blake's subject is the contemporary world of international celebrities like Elvis Presley or Marilyn Monroe or the Beatles, he creates distance for the viewer by 'thrusting' the figures, as one critic describes the effect, 'into a kind of imaginary Edwardian period where they acquire before their time something of the charm, the quaintance and the pathos of performers and entertainers gone for ever'.[24]

Like Hamilton, Blake's style is painterly while depending on a well developed sense of formal composition. There is less abstraction than in Hamilton's later work, Blake presenting to his audience the realistic image of his subject in the direct manner of magazine advertising designs. At his simplest, he creates enlarged versions of what appear to be commercially reproduced designs for decals ('A Transfer', 1963) or sheet music covers ('Bo Diddley', 1964) or makes a collage of cut-outs ('The Girlie Door', 1959); the artistic simplicity and directness of commercial design and the photographic portrait linger in more ambitious works in which human figures create a real sense of impact when the viewer confronts them head on: the German wrestler 'Doctor K. Tortur' (1965) glares; the Japanese wrestler, 'Kamikaze' (1965), barechested and masked, bares his teeth; even the artist, 'Self-Portrait with Badges' (1961), looks icily uncomfortable [Plate 10]. While these figures are presented with a poster-like directness, Blake formally sets them off by enshrining them among trinkets associated with their professional personae that carry connotations of twentieth-century history. The German wrestler is surrounded by a race horse, a toy Mercedes, a guidebook of the Rhine, and German coins, while the viewer is reminded of the violence, even sadism, of his profession and the recent history of his nation by a dismembered doll in his own likeness. The Japanese

wrestler stands as aviator surrounded by a toy 'zero' airplane, a frame containing photographs of aviators and the Emperor as well as a Japanese flag; atop all sits a grimacing sculpture – right out of Conrad – of his head on a stick. While both of these figures become ironic reminders of the nightmare of the war, Blake for his self-portrait presents himself as a figure of the post-war consumer society dressed in denim work clothes and tennis shoes with clusters of political and celebrity buttons pinned on his jacket along with an American flag insignia. He holds an 'Elvis' fan magazine, a source for his celebrity portraits.

Blake, through the aura and trappings of nostalgia in his painting, is seeking to capture artistically the spirit of his age. As he says, 'For me, pop art is often rooted in nostalgia: the nostalgia of old, popular things. And although I'm also continually trying to establish a *new* pop art, one which stems directly from our time, I'm always looking back at the sources of the idiom and trying to find the technical forms that will best recapture the authentic feel of folk pop'.[25] Consequently, he adopts with fine results the tradition of the eighteenth-century 'conversation piece' used so effectively by an artist like Gainsborough to create portraits that posed subjects informally in a place that reflected their domestic and professional interests. These paintings portray people at home, often with family or friends, posed and dressed in a manner that would have been considered informal for their time, with a sign of their profession, a book or an instrument, included in the composition, and Blake self-consciously creates contemporary equivalents, like his self-portrait, that have the characteristics of the genre. He even talks of composing works according to the demands of the tradition: 'At the moment [1963] I'm working on a large conversation piece of the Liverpool song group, *The Beatles*. Each of these chaps is closely associated with the city and I hope that local Beatle fans will find in this picture a visual significance that will somehow match the mood of Beatle music'.[26] Hence, by the pose and dress of the figures and the color and style of the record album cover design in which the Beatles are framed in the composition, Blake attempts to convey a sense of them as seen by their fans. Like his self-portrait in which a sense of a person and place is rendered literally, this 'conversation' piece of the Beatles attempts formally to convey the mood of particular people in a particular time and place.

The epic achievement of Blake's conversation pieces combines the artist's dedication to the genre with the songs of the Beatles

in his design for the album cover and record jacket of *Sergeant Pepper's Lonely Hearts Club Band* (1968), a composition that is the triumph of the Pop movement in England. The conception of the design captures an autobiographical moment of the Beatles, their abandoning live performances to become studio 'artists', by posing them as the Pepper Band in attendance at the funeral for the 'early Beatles' who became famous through their concerts. They are standing among a group of historical and cult figures whom they admire and idolize, including Madame Tassaud's wax figures of the 'early Beatles' dressed in their famous Edwardian costumes. The 'new Beatles', in contrast, are posed in psychedelic 'day-glo' uniforms of the Pepper Band that represent the transformation of Victorian military memorabilia that was popular in the late 1960s into a pacifist statement from the anti-Vietnam war, 'bomb culture' underground, including its fascination with drugs. Marijuana plants surround the grave of the 'early Beatles'. Inside the album is a sheet of cutouts of a Sergeant Pepper souvenir picture card, paper moustache, two band badges and a set of military uniform stripes – items that might be mistaken for memorabilia from an Edwardian holiday. The effect of nostalgia and childish playfulness combined with the topical issues of a time of youth in revolt appropriately complement the Beatles' songs on the record as well as capture the mood of the historical moment. 'The Beatles are at their happiest when celebrating the past', one listener comments. 'They display little enthusiasm for the way we live now'.[27] Peter Blake's paintings of the period express the same feeling: while they seem to originate in nostalgia, at their most complex there is a contemporary sense of alienation and isolation about his portraits, even when painting himself. Thus, English Pop art in its second, more sophisticated, phase not only celebrated popular culture but meditated on the 'darkness' of the civilization that produced it.

As significant for attacking the provincialism and insularity of post-war England as the rise of Pop art was the impact of the International Style on English architecture, and it was the very architects associated with the Independent Group, Alison and Peter Smithson and James Stirling, who first responded to the artistic importance of the style for urban rebuilding. Since the beginning of the century, English architectural theory had been dominated by the emphasis on town planning initated by Ebenezer Howard who expressed his utopian ideas in *Garden Cities of Tomorrow: A Peaceful Path to Social Reform*, published in 1898. In reaction to the

nineteenth-century social problems created by industrialization, Howard proposed the displacement of large urban populations, especially that of London, to what he termed 'garden cities', newly formed, carefully planned communities arranged around the urban centers but separated from them by a green belt of rural land.[28] By his plan, industry would be decentralized, overpopulation and its problems in the cities would be relieved, and the countryside and villages, impoverished by the nineteenth-century migration to the cities, would be repopulated and economically revitalized. This 'marriage of town and country' would lead to the achievement of Howard's vision of a co-operative and, in the Fabian's sense, socialist community where honest people would co-operatively work and create together, the restoration of the Wordsworthian ideal of a pastoral society. At the same time, the twin problems of nineteenth-century overpopulation and industrialization would be kept under control by a commitment to planning.

Howard had no formal architectural training, and his examples of planning were dominated by designs based on symmetrical concentric circles. He 'thought in rings' both when describing and when illustrating the ideal 'garden city' with its commercial center, ring of housing, green belt, and country and village surroundings and when showing its relationship to a large city, the two being separated by an extensive ring restricted to rural use.[29] By the existence of the towns near London actually founded by Howard, Letchworth and Welwyn Garden City, and through the organized efforts of the Garden City Movement with its energetic spokesman, Frederic J. Osborn (1885-1978), and its influential journal, *Town and Country Planning*, Howard's ideas persisted to influence the planning for rebuilding London after the war. The London plans of the 1940s, beginning with that advanced by Patrick Abercrombie, an Edwardian trained at the height of Howard's influence, perpetuated Howard's 'thinking in rings' by envisioning an inner ring of central London, surrounded by a suburban ring primarily for houses, then a green belt, and finally a ring of new towns into which 300,000 people would be relocated. Density in each of the rings would be controlled by limiting the type of housing that could be built; hence, only blocks of flats would be permitted in the inner ring while detached houses would be allowed in the suburbs.[30]

The effect of the London plan was to impose planning on people that eventually failed to satisfy their needs while diverting attention from the rebuilding of the urban core. Consequently, by

the mid-1950s London faced a crisis. In 1957, only 30,000 people had relocated to satellite towns while 300,000 houses had been constructed in suburbs that were intruding into the proposed green belt. At the same time, the city center had continued to grow rapidly even amid neglect and decay, traffic was congested, and more public transportation was required.[31] Essentially, the emphasis on planning for social purposes had relegated control of rebuilding and development in the city to thinkers who not only were provincial and conservative but who subordinated design to ideology at the expense of architecture as a humane art. Indeed, in the early 1950s there were planners in the Architecture Department of the London County Council who sought 'to create an English equivalent of the Socialist-Realist architecture propounded in Russia',[32] and people living in the mediocre environment that resulted – some claimed that more than half of the people in central London did not like their neighborhoods[33] – could legitimately ask, as one public symposium of the period did, 'Why is British Architecture So Lousy?'[34] The sense had become widespread that city planning was at 'dead centre', and as architect Graeme Shankland explained in 1957 in answering the question of why urban centers had not been rebuilt, 'The reason is that Sir Ebenezer Howard's ghost still haunts British planning. . . . It would be foolish to deny the value and achievements of the garden city movement in Britain – but I think the time has come to lay the ghost of Ebenezer'.[35]

The architects who were members of the Independent Group agreed. James Stirling in 'Regionalism and Modern Architecture', published in 1957, the same year as Shankland's comment, also complained about the state of British architecture:

One only has to compare the Crystal Palace to the Festival of Britain or the Victorian railway stations to recent airport terminals to appreciate the desperate situation of our technical inventiveness in comparison to the supreme position which we held in the last century.[36]

Stirling saw the origin of the decline in the loss to urban planners of the tradition of the architect as artist:

In England, in particular, there is a peculiar breath of scandal attaching to the pursuit of architecture as art. . . . To practice architecture as an art implies an idea of *hubris*. On the whole we

feel safer if architectural aspirations are confined to the notion of building as a craft, using only well-tried methods corresponding to subservience to the social order.[37]

Stirling's model of the architect as artist was Le Corbusier, about whom he published several articles; similarly, his colleagues in the Independent Group, Alison and Peter Smithson, found inspiration in the 'Heroic Age' of modern architecture outside Britain when between the wars Le Corbusier, Walter Gropius, Frank Lloyd Wright, and Mies van der Rohe became internationally influential:

> Fundamentally, like every renaissance, it was an upsurge of confidence in man, in his potentialities and his inherent nobility. This nobility, it was felt, needed a new way of life in order to find release – a new physical environment; new city structure, new houses, new equipment, new art objects and above all, a new relationship between man and nature. It was to be the Golden Age of the machine.[38]

In asserting architecture as art in an international context, both the Smithsons and Stirling sought to escape not only the rigidity of structure dominant in English planning but also its reliance on geometrical designs, as they explained in articles that appeared in *Architects' Year Book 8* in 1957. The Smithsons declared, 'the new modern architecture is objective about the human and built situation, and *acts* in it, making use of change. Its aesthetic is necessarily "open", non-geometric, and if necessary, impermanent'.[39] Stirling, who had contributed a papier-mache object based on photographs of soap bubbles to the 'This is Tomorrow' exhibition the year before, is even more unconventional in proposing a stylistic model:

> 'Dynamic cellularism' is an Architecture comprising several elements, repetitive or varied. The assemblage of units is more in terms of growth and change than of mere addition, more akin to patterns of crystal formations or biological divisions than to the static rigidity of a structural grid.[40]

Stirling has obviously been influenced in his thinking about form by the British fascination after the war with the science of crystallography. The Institute of Industrial Design had encouraged the use of designs based on crystal formations for the Festival

of Britain, and the April 1951 issue of *Architectural Review* had a cover showing one such pattern and an illustrated article on crystallography. In 1953, James Watson and Francis Crick had published the discovery of the 'double helix' as a result of their examination of the structure of DNA. Therefore, in proposing a model to rival the arbitrary geometry that dominated the thinking of Howard and Abercrombie and their progeny of town planners, Stirling finds justification in nature.

The Smithsons look to a quite different model for breaking with tradition; they turn to the concept of the 'machine' that they discover through their study of the 'Heroic period' of modern architecture:

> The *machine* 'created' a new architecture by way of the simple geometric forms in light of Mediterranean architecture, through the disciplines of the Japanese house, and through the rediscovery of the Attic spirit.[41]

Like Stirling's 'dynamic cellularism', the Smithsons' idea of 'the machine' is a stylistic means of participating in their age which at the same time provides them a way to uphold an English sense of pastoralism without accepting the anti-urbanism of the town planning establishment:

> When all have machine-energy – cars, transistor radios and light – to throw about, then the time has come for the lyricism of control, for calm as a ideal: for bringing the Virgilian dream – the peace of the countryside enjoyed with the self-consciousness of the city dweller – into the notion of the city itself.[42]

Hence, in creating their architectural plans, the Smithsons deal with requirements for technology in a structure, like electricity, plumbing, heating, air conditioning, as part of the design, as doors and windows were treated historically, seeking, as they said, 'to melt these devices into the architecture to make them one with it: mostly by concealment or contrivance'. They seek to achieve a sense that a building is 'designed' rather than 'assembled' so that the observer is not aware of the technology.[43] The Smithsons' approach to architecture was similar to that taken by Hamilton to painting, to approach design in the sophisticated manner that they saw displayed in advertisments for American automobiles and consumer appliances.

In advocating new concepts of form, the Smithsons and Stirling were reasserting the humanistic values of architecture considered as a fine art, and in doing so they were a manifestation of the movement that had spawned Pop, though as Stirling commented, 'more the reflection of a "cottage" culture than the expression of a supposedly undesirable ad-mass society'.[44] Together, as members of the team preparing for a conference in 1957, Stirling and the Smithsons articulated their goal of restoring human concerns to architecture in documents they wrote attacking the prevalent concepts of town planning based on the idea of the Garden City:

> The method of analysis for the projects submitted was, roughly, in terms of human association rather than functional organization, thus marking a radical break in architectural thinking. . . . The modern architect is interested in the implication of his building in the community and in the culture as a whole. . . . Our functionalism means accepting the realities of the situation, with all their contradictions and confusions, and trying to do something with them. In consequence we have to create an architecture and a town planning which – through built form – can make meaningful the change, the growth, the flow, the 'vitality' of the community.

To accomplish this means the abandonment once and for all of the tradition of 'thinking in rings' and advocacy of another approach to planning:

> In the Cluster concept there is not one 'centre' but many. Population pressure-points are related to industry and to commerce and these would be the natural points for the vitality of the community to find expression – the bright lights and the moving crowds.[45]

It was this attitude, lead by the architects from the Independent Group, that resulted in the ghost of Ebenezer Howard finally being laid to rest.

Beyond theorizing, however, the Smithsons and Stirling had real buildings to build, and from the appearance and shape of their creations emerged a distinctive and definable style. The first to be designed, Peter Smithson's Secondary School, Hunstanton, begun 1949 and completed 1954, flaunted the prevailing post-war

architecture of unprepossessing symetrical slab blocks, sometimes softened with picturesque details, by exposing to view, inside as well as outside, its component materials of steel, concrete, and brick and by striving to provide a sensible environment for its inhabitants even at the expense of asymetry of appearance. As Reyner Banham describes Smithson's intention with the design, there was 'a determination to make the whole conception of the building plain and comprehensible. No mystery, no romanticism, no obscurities about function or circulation'.[46] James Stirling's Ham Common Flats (1955–58) similarly exposed, inside and outside, rough surfaces of brick interlaced with concrete beams; being a project of repeated housing units, it permitted him to try to design by the theory of arranging components 'more in terms of growth and change than of mere addition'. Whether the plans for these projects are based on the idea of the cellular or the idea of the machine, they show in their designs 'the preoccupation with habitat, the total built environment that shelters man and directs his movements'.[47] This goal and the directness of the buildings that result, especially in the obvious rough textures of their surfaces, shocked traditional viewers who thought them 'bloodyminded',[48] brutal and inhuman.

As these architects became more successful, their confidence led to even greater rebellion against the prevailing style, and their buildings became more artistically adventurous. Stirling, for instance, could risk partially burying his School Assembly Hall, Camberwell (1958–61), in a mound of earth to avoid letting it add to the chaos of building types and heights surrounding the site [Plate 11] The result is that he leaves in sight above ground a kind of huge, abstract sculpture rising in a green park, unique in appearance from each elevation, and consisting of curiously shaped walls outlined with a decorative line of banding, strangely slanted roof surfaces, and symmetrical walls of windows to provide light into the large spaces housed in the building. Even more outrageous at first glance is his Leicester University Engineering Building (1959–63) in which a multiplicity of requirements for its use – workshops with heavy machinery, offices, lecture halls, even a high water tank determines a design of strange protuberances of various shapes and sizes with solid, brick wall surfaces at ground level and full glass walls above [Plate 12]. Stirling is most obviously 'cellular' in designing the residential expansion for St. Andrew's University (1964–68) in which the lengthy extensions of the dormitory appear to ramble across the varied terrain of the spacious site

like giant caterpillars [Plate 13]. Each extension consists of a concrete skin of carefully detailed units of textured walls and windows with a band of glass enclosing a corridor running its length.

Like Stirling, the Smithsons carefully consider the setting for a building. Their Economist Building (1964–66), for example, blends in shape and height into the historic surroundings of St. James while displaying contemporary boldness in its broad concrete columns and beams framing extensive surfaces of glass [Plate 14]. However, achieving a sense of place for such a building is difficult, as the Smithsons recognize:

> The design for a building, or building group, cannot be evolved outside its context – this sounds easy – but it goes against all inherited post-Renaissance ideas . . . against the tradition of abstraction . . . of buildings as simple mechanisms: buildings unto themselves.[49]

When the design is accommodated to the site, as the Economist Building is to an historic London district, a feeling of lightness as well as appropriateness is achieved. At the same time, there is an elegance that emerges from the incipient classicism. In the design for the Economist Building as well as that for St. Andrew's University the architects succeed in subduing the artistic rebellion so evident in earlier projects to their concern for 'beauty'; the result is architecture succeeding as fine art. Such beauty in the creation of a functional design is the goal of these artistic architects, even at some professional risk. Stirling explains:

> In England I find that, when making a presentation to the client, we must never talk about aesthetics and explanations should always be in terms of common sense, function and logic. If you mention the word 'beauty' their hair might stand on end and you could lose the commission. Perhaps this philistine attitude is, in some ways, beneficial.[50]

The Smithsons are more succinct: 'Things need to be ordinary and heroic at the same time'.[51] Hence, in practice as well as in theory these architects aspire to be anything but 'brutal'.

But 'brutal' is how they are labelled because by 1955 their work was well-known enough to be given the name by Reyner Banham, a colleague of theirs from the Independent Group. Reflecting in an

appreciative article on the architects' spirit of revolt as well as the texture of the surface appearance of their buildings, Banham termed their work 'the new Brutalism'. In a lengthy elaboration published in 1966, *The New Brutalism: Ethic or Aesthetic?*,[52] Banham traced the history of the style, finding its origins in a reaction against both neo-Romanticism and the picturesque – 'romantic pasticheries of the Festival of Britain', as Peter Smithson said[53] – and the rigidity and mediocrity of the planning establishment. To Banham, these young architects were simply trying to escape 'surrender to all that was most provincial and second-rate in British social and intellectual life'.[54] However, unlike the Angry Young Men in literature of the same period, who in their reaction became even more insular and in spite of their frustration and discontent failed to achieve any kind of vision, the 'brutalists' turned away from English tradition to international models like Le Corbusier, Mies van der Rohe, and Frank Lloyd Wright. These architects, along with the painters in the Pop movement, found new inspiration by their insistence on participating in the international world of creativity and in their rejection of the 'Great Tradition' that looked at only British work. It was they who laid the foundation for rebuilding culture.

6

The Country:
The White Goddess

It's women who keep all mythologies going. Women!
Gordon Comstock in George Orwell's
Keep the Aspidistra Flying (1936)

In time of trial, like wartime, the tendency of the English psyche has been to turn to nature in search of consolation and renewal. And this pastoral desire for the ideal of peace and tranquillity inevitably means an encounter with the primitive for the English landscape is littered with relics, the stone rings and monuments of ancient civilizations, rural scene and ancient world inextricably entwined. When an English artist turns to nature then, he is in some sense renouncing the values and beliefs of his society that he perceives have led to disaster and is seeking instead the means – a myth, an ideal – by which he and his culture can begin afresh. This desire for renewal, as ancient as fertility rites during which human beings sought to purge the decadence of the old year and to celebrate the revitalization promised by the new, has led, at least since the rise in the eighteenth century of a fascination with the legends and myths of prehistory, to the recurring contemplation of primitive rites by artists who, in their contemporary distress, search the mythic past for new hope and inspiration.

Crude efforts of early mythographers to recover and compare local folklore resulted in the invention of a legendary world of English Druidism. This civilization, which preceded the arrival of the Romans, was thought to have worshipped the oak tree and to have erected the ancient stone monuments found throughout the British isles; Stonehenge on Salisbury Plain, the most renowed of these, was believed to be a place where human sacrifice was practiced and where, possibly, victims were burned in wicker cages.[1] In speculation such as these, the English idea of pastoral merged with a

113

fascination for the primitive, especially by the time of the Romantic poets. In 1793, William Wordsworth, under the influence of the theories of Druidism, composed 'Guilt and Sorrow or Incidents upon Salisbury Plain' in which a sailor, home from war, wanders among the ancient stone relics in search of refuge from a storm:

> Pile of Stone-henge! so proud to hint yet keep
> Thy secrets, thou that lov'st to stand and hear
> The Plain resounding to the whirlwind's sweep,
> Inmate of lonesome Nature's endless year;
> Even if thou saw'st the giant wicker rear
> For sacrifice its throngs of living men,
> Before thy face did ever wretch appear,
> Who in his heart had groaned with deadlier pain
> Than he who, tempest-driven, thy shelter now would gain?
>
> (ll. 118–26)

In a preface of 1842, Wordsworth describes how the poem was written after he had spent several days walking the plain at a time when 'the American war was still fresh in memory' and war with France had just been declared:

> The monuments and traces of antiquity, scattered in abundance over that region, led me unavoidably to compare what we know or guess of those remote times with certain aspects of modern society, and with calamities, principally those consequent upon war, to which, more than other classes of men, the poor are subject. In those reflections, joined with particular facts that had come to my knowledge, the following stanzas originated.[2]

Consequently, mysterious, inhospitable Stonehenge images for Wordsworth the forms of human suffering, with the past connoting the poet's present thoughts of disaster.

The early view of Druidism led William Blake to represent its culture in *Jerusalem* as 'the Primitive Seat of the Patriarchal Religion' (27:0),[3] and to portray Stonehenge metaphorically as the site for human sacrifice resulting from belief in a puritanical form of religion that punishes rather than comforts its believers. Stonehenge is the temple of a false god, 'Mighty Urizen the Architect' (66:4), its erection the equivalent of Satan's construction in Hell of his Pandemonium as a perverse rival to Heaven in *Paradise Lost*, and, like

Wordsworth, Blake follows the eighteenth-century mythographers
in imagining forms of Druidic sacrifice. He mentions the 'Wicker
Idol woven round Jerusalems children' (38: 65) and describes at
length the awful rites supposedly practiced on a sacrificial stone
at Stonehenge:

> The Knife of flint passes over the howling Victim: his blood
> Gushes & stains the fair side of the fair Daug[h]ters of
> Albion.
> They put aside his curls; they divide his seven locks upon
> His forehead: they bind his forehead with thorns of iron
> They put into his hand a reed, they mock: Saying: Behold
> The King of Canaan whose are seven hundred chariots of
> iron!
> . . .
> The Human form began to be alterd by the Daughters of
> Albion
> And the perceptions to be dissipated into the Indefinite.
> Becoming
> A mighty Polypus nam'd Albions Tree . . .
> As the Misletoe grows on the Oak, so Albions Tree on Eternity
> (66: 20–25, 46–48, 55)

At the end of *Jerusalem*, the various images of Druidic religion,
including that of its sacred oak tree, converge in 'the Cry from all
the Earth' (98:54) for salvation from its falsehoods:

> Where is the Tree of Good & Evil that rooted beneath the
> cruel heel
> Of Albions Spectre the Patriarch Druid! where all his Human
> Sacrifices
> For Sin in War & in the Druid Temples of the Accuser of Sin:
> beneath
> The Oak Groves of Albion that coverd the whole Earth beneath
> his Spectre
> (98: 47–50)

To provide relief from the all-encompassing hegemony of imprison-
ing thought imposed by the false patriarchal religion identified in its

origins with Druidism, Blake, at the end of his prophecy, imagines an androgynous figure named 'Jerusalem', with whose promise of freedom 'All Human Forms' (99: 1) identify in seeking a new, creative vision.

The idea of Druidism, and the desire expressed in Romantic tradition to escape the suffering and violence associated with its rituals, haunts the English imagination whenever this imagination is confronted by the 'darkness' at the borders of the civilized. Through the works of anthropologists like Sir James Frazer's *The Golden Bough* (1890–1915), this fascination was carried into the twentieth-century and served to provide Moderns, like T. S. Eliot and D. H. Lawrence, with a source in mythology for new constructs of order. When artists during and after the Second World War sought a means for renewal, the example of Frazer was still available, especially for those educated at the height of his influence. One in particular, Robert Graves, with his fascination with English folklore and education in classical mythology, was quite susceptible, and his creation of what he subtitled 'a historical grammar of poetic myth', *The White Goddess* (1948), was an outpouring under the duress of war of Romantic syncretic mythologizing on the model of Frazer; as such, it was part of the neo-Romantic movement that arose in the arts of the 1940s. Graves himself has described the creation of his book to have been an experience akin to the 'automatic writing' of W. B. Yeats which resulted in *A Vision* (1925), the theory of history that provided Yeats with metaphors for his poetry:

> In 1944, at the Devonshire village of Galmpton, I was working against time on a historical novel about the Argonauts, when a sudden overwhelming obsession interrupted me. It took the form of an unsolicited enlightenment on a subject which had meant little enough to me. . . . I began speculating on a mysterious 'Battle of the Trees', fought in pre-historic Britain, and my mind ran at such a furious rate all night, as well as all the next day, that it was difficult for my pen to keep pace with it. Three weeks later, I had written a seventy-thousand-word book, called *The Roebuck in the Thicket*. (488)[4]

The White Goddess is one of those books that appears out of nowhere to confound its readers with its complexity and apparent muddle; Graves recounts how one prospective publisher 'could not make either head or tail of the book, and could not believe that it would

interest anyone' (*On Poetry*, 246).[5] Being this kind of eccentric book, *The White Goddess* is easily dismissed as 'the autobiography of his soul'[6] or as 'grotesque nonsense, a personal fantasy', (*On Poetry*, 235), but Graves has refuted any interpretations that diminish his intention.

Graves, in responding at length to Randall Jarrell for accusing him 'of *inventing* the White Goddess' and describing the vision as being 'a triumphant vindication of Freud's and Jung's psychological theories . . . adding that my world picture is a projection of my unconscious on the universe', asserts, to the contrary, that his work is one of serious history and anthropology, one which seeks to extricate from pre-history and history, as well as redeem from psychology, a better theory for civilization that will replace the false values that have led to violence: 'My world picture is not a psychological one, nor do I indulge in idle myth-making and award diplomas to my converts. It is enough for me to quote authentic myths and give them historical sense' (*On Poetry*, 235–36). Graves's method in *The White Goddess*, then, is that of the Romantic comparative mythologists. He plunges into explaining what he terms the 'nonsense' (*On Poetry*, 229) of the ancient Welsh legend of a 'Battle of the Trees', then begins to decode the Druidic alphabet which he finds associated with the sequence of forest trees in it, and, in the manner of the speculative mythologists, asserts that it corresponds to the Greek Orphic alphabet. Arguing that there had to be a common source for both, Graves discovers it in the pre-historic matriarchal cults celebrating a White Goddess, cults that he believes have been overlaid by patriarchal religions which have dominated modern ideas of civilization. To these later, false religions, Graves, like Blake before him, attributes the kind of thinking that leads to violence and suffering.

Graves claims his intention is only to recover the mythology necessary to re-inspire poetry in his time: 'My task in writing *The White Goddess* was to provide a grammar of poetic myth for poets, not to plan witches' Sabbaths, compose litanies and design vestments for a new orgiastic set, nor yet to preach matriarchy over a radio network' (*On Poetry*, 237). Graves in this sense, then, is a modern poet needing, as Yeats did and by his example, to find and define metaphors for poetry, particularly his own; however, in his effort there is higher aspiration. While not proclaiming a new religion, Graves does continue a Romantic tradition in seeking to reclaim for civilization human and, perhaps, humanizing experiences of

powerful feelings to confront the dominant, patriarchal rationalism of his age. Wordsworth, in his Preface to *Lyrical Ballads* (as revised, 1802), states, 'The Poet writes under one restriction only, namely, the necessity of giving immediate pleasure to a human Being possessed of that information which may be expected from him, not as a lawyer, a physician, a mariner, an astronomer, or a natural philosopher, but as a Man',[7] and Graves writes, 'Certainly, I hold that critical notice should be taken of the Goddess, if only because poetry which deeply affects readers – pierces them to the heart, sends shivers down their spine, and makes their scalp crawl cannot be written by Apollo's rhetoricians or scientists' (*On Poetry*, 237).

Like Wordsworth in his Preface or Blake in his prophecies, Graves defends passion and ecstasy to a mid-century world dedicated to the cult of reason and death. While the 'eroticism' of Wordsworth's defence of pleasure 'is very highly sublimated', in Lionel Trilling's words,[8] Graves as a neo-Romantic in the liberated age of Freud and D. H. Lawrence specifically finds the origins of the the cultural crisis to be sexual. He affirms the creative necessity of the female principle in society by espousing the mythology of the Goddess in response to what he perceives to be a tradition of effete rationality. His Goddess is not merely another version of the traditional muse of art, but a symbol that stands for the ideal of a 'golden age' of inspiring values espoused by a matriarchal culture which has been superseded and nearly obliterated by false values associated with patriarchy:

> My thesis is that the language of poetic myth anciently current in the Mediterranean and Northern Europe was a magical language bound up with popular religious ceremonies in honour of the Moon-goddess, or Muse, some of them dating from the Old Stone Age, and that this remains the language of true poetry – 'true' in the nostalgic modern sense of 'the unimprovable original, not a synthetic substitute'. The language was tampered with in late Minoan times when invaders from Central Asia began to substitute patrilinear for matrilinear institutions and remodel or falsify the myths to justify the social changes. Then came the early Greek philosophers who were strongly opposed to magical poetry as threatening their new religion of logic, and under their influence a rational poetic language (now called the Classical) was elaborated in honour of their patron Apollo and imposed on the world as the last word in spiritual illumination: a view

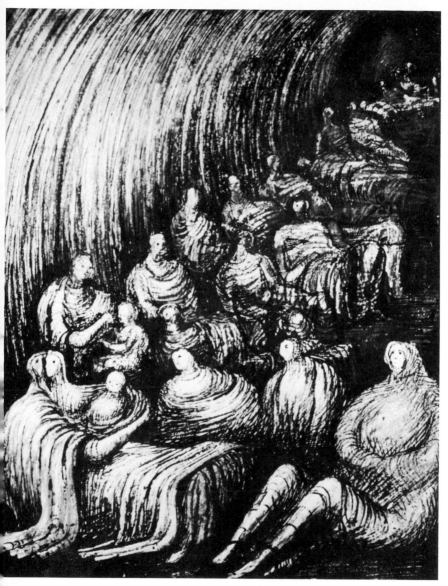

4. Henry Moore, *Shelter Scene* (1941).

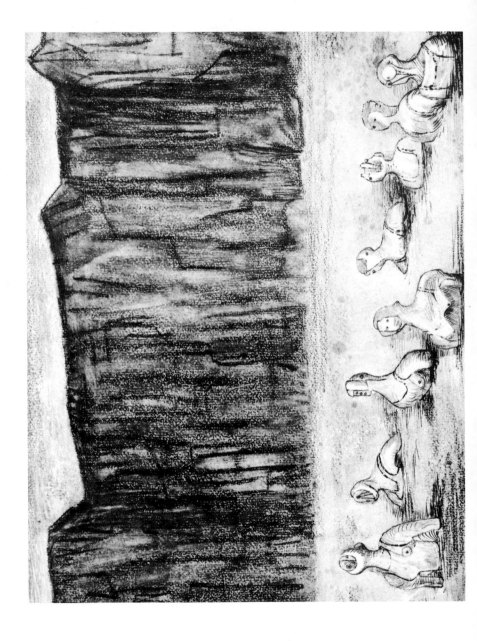

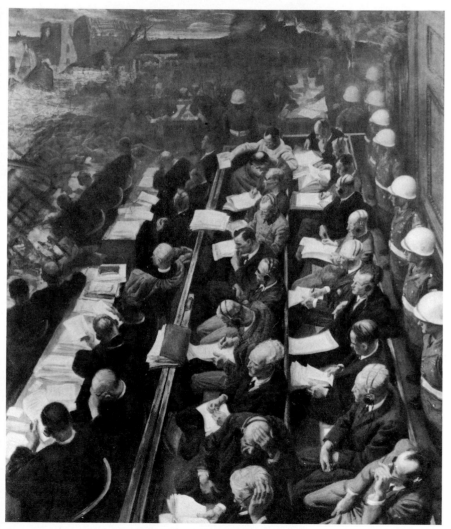

3. Laura Knight, *Nuremberg Courtroom* (1946).

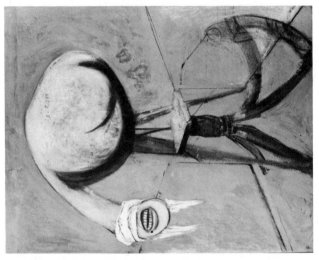

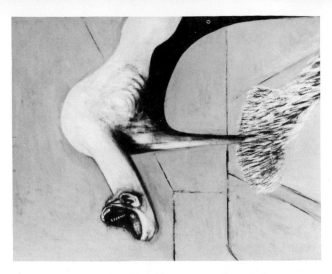

4. Francis Bacon, *Three Studies for Figures at the Base of a Crucifixion* (1944).

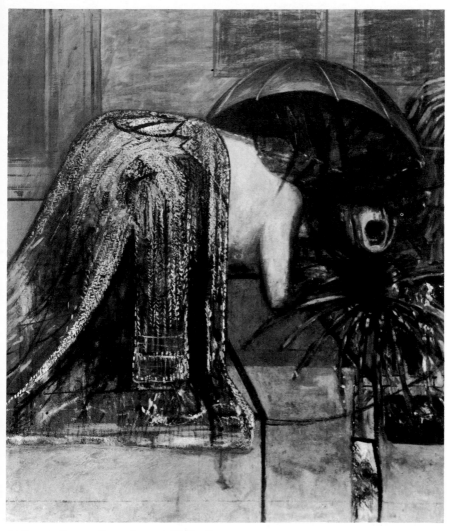

5. Francis Bacon, *Figure Study II* (1945–6).

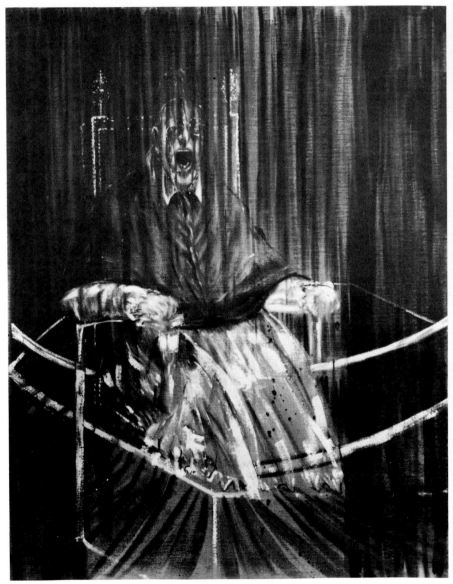

6. Francis Bacon, *Study After Velasquez's Portrait of Pope Innocent X* (1953).

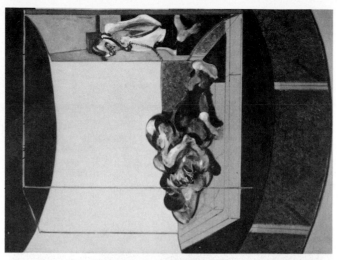

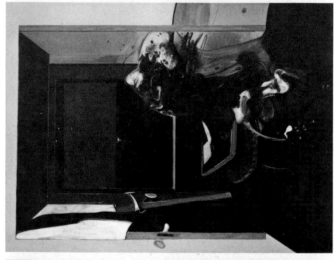

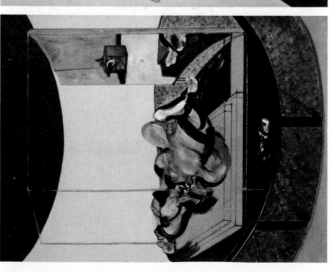

7. Francis Bacon, *Triptych. Inspired by T. S. Eliot's Poem 'Sweeney Agonistes'* (1967).

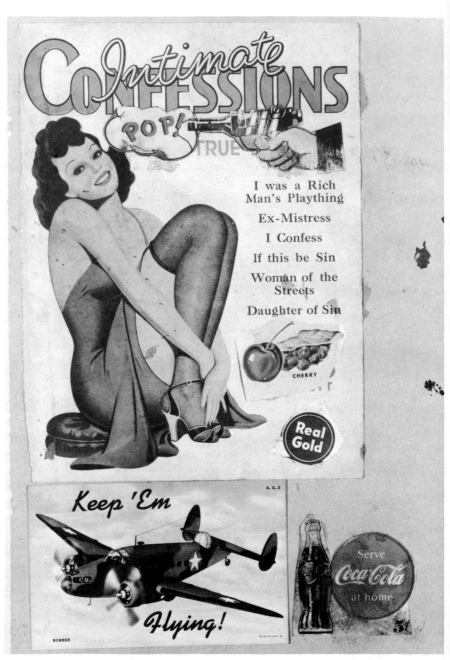

8. Eduardo Paolozzi, *I Was a Rich Man's Plaything* (1947).

9. Richard Hamilton, *$he* (1958–61).

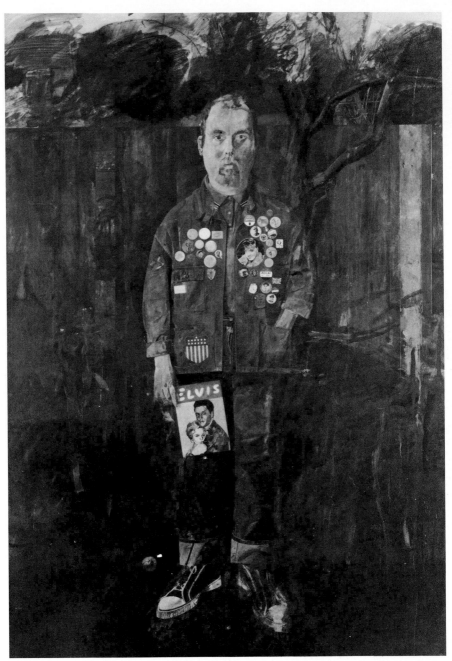

10. Peter Blake, *Self-Portrait with Badges* (1961).

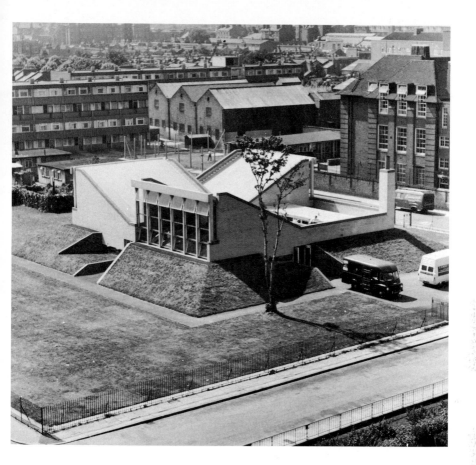

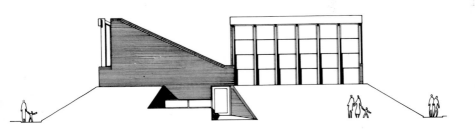

11. James Stirling and James Gowan, *School Assembly Hall, Camberwell* (1958–61).

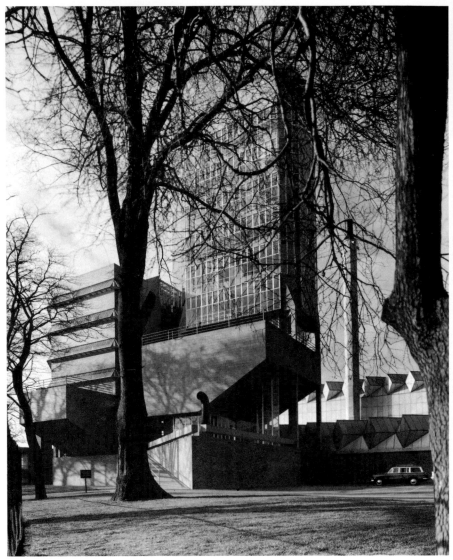

12. James Stirling and James Gowan, *Leicester Engineering Building* (1959–63).

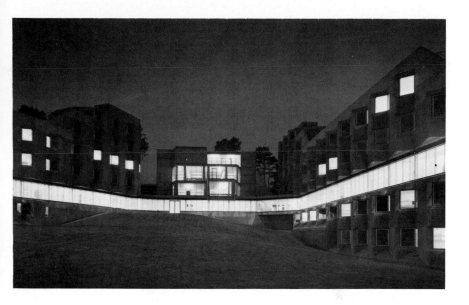

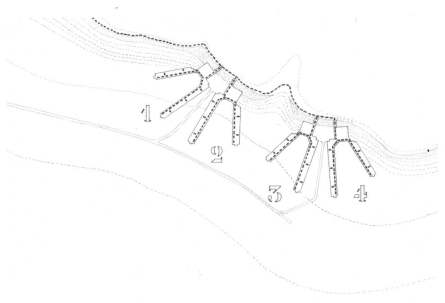

13. James Stirling, *Residential Expansion for St Andrew's University* (1964–68).

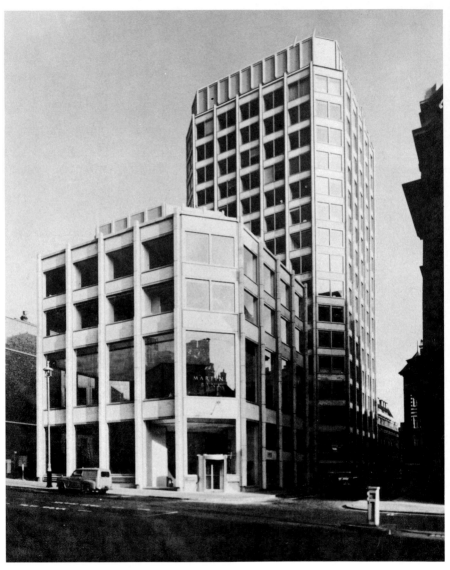

14. Alison and Peter Smithson, *Economist Building* (1964–66).

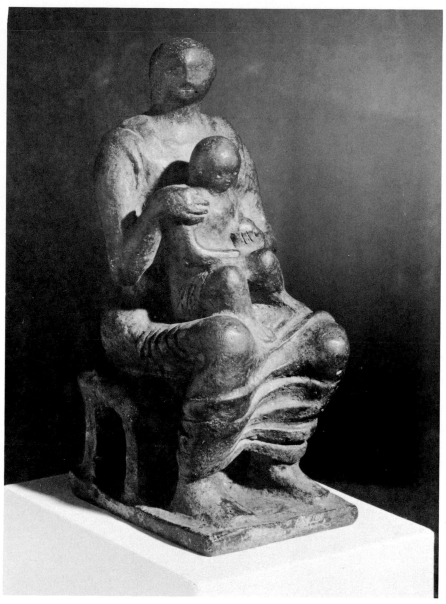

15. Henry Moore, *Madonna and Child* (1943).

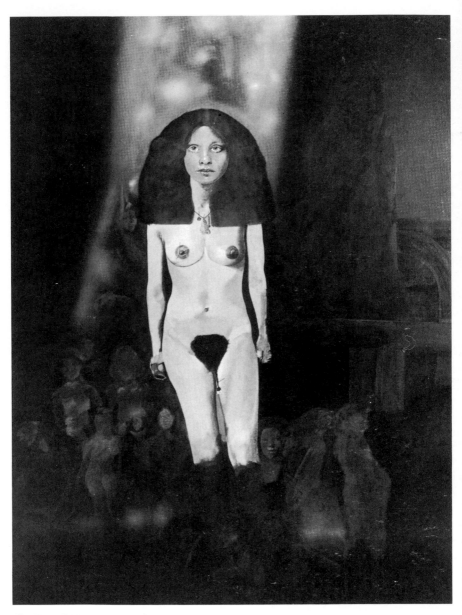

16. Peter Blake, *Titania* (1976).

that has prevailed practically ever since in European schools and universities, where myths are now studied only as quaint relics of the nursery age of mankind. (9–10)

Graves rejects the Apollonian order not only on poetic but also on cultural grounds. In his view it is the source and basis of a sordid civilization from which he has had to exile himself:

'What is the use or function of poetry nowadays?' . . . The function of poetry is religious invocation of the Muse; its use is the experience of mixed exaltation and horror that her presence excites. But 'nowadays'? Function and use remain the same; only the application has changed. This was once a warning to man that he must keep in harmony with the family of living creatures among which he was born, by obedience to the wishes of the lady of the house; it is now a reminder that he has disregarded the warning, turned the house upside down by capricious experiments in philosophy, science and industry, and brought ruin on himself and his family. 'Nowadays' is a civilization in which the prime emblems of poetry are dishonoured. In which serpent, lion and eagle belong to the circus-tent; ox, salmon and boar to the cannery; race horse and greyhound to the betting ring; and the sacred grove to sawmill. In which the Moon is despised as a burned-out satellite of the Earth and woman reckoned as 'auxiliary State personnel'. In which money will buy almost anything but truth, and almost anyone but the truth-possessed poet. (14)

Indeed, as the product of the particular moment for cultural reassessment that occurred just near the end of the war, *The White Goddess* may be idiosyncratic, but Graves in his mythmaking strives to restore a sense of life and vitality through representations of fecundity and passion.

For Graves, as he pursues his mythological analysis of the 'neurosis' of civilization, the source of the Apollonian tradition is psychological, 'the male intellect trying to make itself spiritually self-sufficient' (12); the sexual manifestation of this effort – historically represented by the example of Socrates – is homosexuality. In Graves' view, 'Socrates, in turning his back on poetic myths, was really turning his back on the Moon-goddess who inspired them and who demanded that man should pay woman spiritual

and sexual homage: what is called Platonic love, the philosopher's escape from the power of the Goddess into intellectual homosexuality, was really Socratic love' (11). Graves rejects the effort of psychoanalysis to usurp such an approach. In an article attacking 'Jungian Psychology', he states: 'A science of myth, then, should begin with a study of archaeology, history, and comparative religion, not in the psychotherapist's consulting room'.[9] Graves attacked Jung because of the masculine version of mythology that results from the psychoanalytic methodology. Jung celebrates, instead of the Goddess, the archetype of the 'Wise Old Man', evidence for Graves of the male intellect at work. Graves argues, 'It is obvious that Jung has been misled by his experiences in the consulting room, where the "wise old man" of his patients' dreams is not an archetype at all, but a flattering portrait of Jung himself'.[10] Hence, the myth of the Goddess is in this sense an affirmation of both the role of women and the importance of the artistic, spiritual and physical union of women and men. Culture must be feminist, and the artist heterosexual, at least intellectually. As Graves concludes, 'The main theme of poetry is, properly, the relations of man and woman, rather than those of man and man, as the Apollonian Classicists would have it' (447). If Graves's vision of culture were to prevail, art would be restored to its proper role, and civilization would be revived by the love of man and woman.

The White Goddess traces the survival of what Graves takes to be the one true poetic 'theme' that originates in rituals to the moon. As he states, 'The elements of the single infinitely variable Theme are to be found in certain ancient poetic myths which though manipulated to conform with each epoch of religious change . . . yet remain constant in general outline' (21). Consequently, the validity of a poem and a poet is in readers' discovery of the inspiration and influence of the Goddess:

> The test of a poet's vision, one might say, is the accuracy of his portrayal of the White Goddess and of the island over which she rules. The reason why the hairs stand on end, the eyes water, the throat is constricted, the skin crawls and a shiver runs down the spine when one writes or reads a true poem is that a true poem is necessarily an invocation of the White Goddess, or Muse, the Mother of All Living, the ancient power of fright and lust – the female spider or the queen-bee whose embrace is death. (24)

Hence, fully experienced, the significance of the Goddess is simultaneously creative and destructive, but, as a result of the classical dedication to Apollo, western civilization has ignored the Goddess. The consequent acceptance of 'a patriarchal god, who refuses to have any truck with Goddesses and claims to be self-sufficient and all-wise' and of 'a theocratic society . . . in which everyone who rightly performs his civic duties is a 'son of God' and entitled to salvation' becomes what Graves, writing with the disillusionment of war, terms 'the prime causes of our unrest' (475).

While still completing the poetic grammar, Graves, in working on his translation of *The Golden Ass*, found the embodiment of the Goddess in Apuleius's description of the goddess Isis. Viewing Apuleius's epic as a work by a 'priest of Osiris' portraying the process of conversion – a kind of comic antecedent to St. Augustine's *Confessions*, Graves by means of his translation presents the vision of Isis as the perfect cognate for the artist's experience of inspiration. To Graves, the protagonist Lucius in the form of an ass literally embodies the 'lust, cruelty and wickedness' (*Golden Ass*, xiv)[11] of his society, and his punishment for foolish eroticism is allegory appropriate to Apuleius's religion. As Graves argues, 'The ass, as the Goddess Isis herself reminded Lucius at Cenchreae, was the most hateful to her of all beasts in existence' because 'the ass was in fact sacred to the God Set, whom the Greeks knew as Typhon, her ancient persecutor and the murderer of her husband Osiris' (*Golden Ass*, xiii–xiv).

In following the steps of the ritual to religious conversion, Lucius experiences the equivalent of the process of poetic inspiration by the White Goddess. His prayer for salvation is an invocation to the Muse in which the poet seeks inspiration from whatever version of the feminine vitality that will respond,

'Blessed Queen of Heaven, whether you are pleased to be known as Ceres, the original harvest mother . . .; or whether as celestial Venus . . .; or whether as Artemis . . .; or whether as dread Proserpine',

and the mythic associations of these figures parallel those of the triple-goddess of birth, copulation, and death. When Isis appears, she has the same inspiring effect on Lucius that the White Goddess has on the poet. As Lucius describes it, 'the Goddess herself will perhaps inspire me with poetic imagery sufficient to convey some

slight inkling of what I saw' (*Golden Ass*, 262–63), which she does in the lengthy description of her that follows. Invoked and envisioned, the Goddess confirms that she does indeed embody all of Lucius's mythic desires in her single being:

> 'You see me here, Lucius, in answer to your prayer. I am Nature, the universal Mother, mistress of all the elements, primordial child of time, sovereign of all things spiritual, queen of the dead, queen also of the immortals, the single manifestation of all gods and goddesses that are. . . . Some know me as Juno, some as Bellona of the Battles; others as Hecate, others again as Rhamnubia, but both races of Aethiopians, whose lands the morning sun first shines upon, and the Egyptians who excel in ancient learning and worship me with ceremonies proper to my godhead, call me by my true name, namely, Queen Isis'. (*Golden Ass*, 264–65)

Thus, Graves finds in Apuleius confirmation of his vision of the White Goddess; through his translation both the ancient and the modern poet become, through their creativity, priests of Isis.

As latter-day priest, Graves finds evidence of a continuing respect for the Goddess in the national myth of his own country. Like Blake, he identifies the establishment of patriarchal religion in England with the creation of Stonehenge. After elaborately rationalizing its design to connect it to the Temple of Apollo, Graves proclaims, 'The Sun-god of Stonehenge was the Lord of Days' (291), and he compares him to the Egyptian god, Osiris. Indeed, he finds the shape of Stonehenge to be suspiciously similar to an 'ass-shoe' (rather than a horse-shoe), connecting it thus to accounts of rites of Osiris in Plutarch and Apuleius. Plutarch describes the sacrifice of asses during celebrations of the victory of Osiris over Set, who as 'the red-haired ass, came to mean the bodily lusts, given full rein at the Saturnalia, which the purified initiate repudiated', and Graves associates the rites with his understanding of the *Golden Ass*:

> The metamorphosis of Lucius Apuleius into an ass must be understood in this sense: it was his punishment for rejecting the good advice of his well-bred kinswoman Byrrhaena and deliberately meddling with the erotic witch cult of Thessaly. It was only after uttering his *de profundis* prayer to the White

Goddess . . . that he was released from his shameful condition and accepted as an initiate of her pure Orphic mysteries. (290)

However, after identifying manifestations of the Goddess in a variety of English folklore, including the tales of Robin Hood and Lady Godiva, he expresses the hopeful belief that 'there is an unconscious hankering in Britain after goddesses, if not for a goddess so dominant as the aboriginal Triple Goddess, at least for a female softening of the all-maleness of the Christian Trinity' (406).

Graves cites evidence for this hope in the popular views by the English of their queens, Elizabeth and Victoria. Child of the Edwardian age that he was, Graves may have shared something of the nostalgia of his generation for a Victorian golden age, seeing both Elizabeth and Victoria as having managed in their times to subdue prevailing – male – orthodoxies and to have restored something of the ancient cult of the female: Elizabeth by becoming head of the Anglican Church and being 'regarded as a sort of deity; poets not only made her their Muse but gave her titles – Phoebe, Virginia, Gloriana – which identified her with the Moon-Goddess'; and Victoria by preferring 'the part of War-goddess in inspiring her armies, and proved an effective substitute for the Thunder-god' of her puritanical society (406–7). Consequently, out of faith in his speculative method of combining anthropology and history, Graves concludes his analysis of the myth of Britain, undertaken when the nation is literally under attack from Germany, in defiance of the enemy, an enemy in its violence and its lies that embodied the worst of a patriarchal cult out of control:

The British love of Queens does not seem to be based merely on the common-place that 'Britain is never so prosperous as when a Queen is on the Throne': it reflects, rather, a stubborn conviction that this is a Mother Country not a Father Land – a peculiarity that the Classical Greeks also noted about Crete – and that the King's prime function is to be the Queen's consort. Such national apprehensions or convictions or obsessions are the ultimate source of all religion, myth and poetry, and cannot be eradicated either by conquest or education. (408)

Graves writes with hope for he can already anticipate rule by another queen, the second Elizabeth, to restore the power of the Goddess.

Other artists of the time, affected by the neo-Romantic revival of English myth, also sought renewal amid the national calamity and created their own versions of the cult of Isis. Composed almost simultaneously with *The White Goddess* is Evelyn Waugh's *Brideshead Revisited* (1944), and the plot of the novel seems almost a fictionalization of Graves's thesis. Indeed, the progress of the protagonist of this *Bildungsroman*, Charles Ryder, could be described as beginning in a classical, Apollonian world represented by a coterie of effete, homosexual intellectual undergraduates at Oxford before the war, advancing through the sterile country presented in the setting of the 'great house', the estate of Brideshead, and reaching, finally, the island of the White Goddess where the muse resides and art is nurtured. Charles begins in the company of the brilliant Sebastian Flyte at Oxford where he discovers the pleasure of youth:

> with Sebastian, it seemed as though I was being given a brief spell of what I had never known, a happy childhood, and though its toys were silk shirts and liqueurs and cigars and its naughtiness high in the catalogue of grave sins, there was something of nursery freshness about us that fell little short of the joy of innocence. (46)[12]

But to grow Charles must reject these ways and discover the feminine principle in the form of Sebastian's sister, Julia. At first, Charles in his affection can barely tell sister from brother, commenting that Julia 'so much resembled Sebastian that . . . I was confused by the double illusion of familiarity and strangeness' (73). However, as the Goddess increasingly possesses Charles and he increasingly rejects Sebastian and his world, he can more readily discriminate between brother and sister, between the male principle and the female: 'As Sebastian in his sharp decline seemed daily to fade and crumble, so much the more did Julia stand out clear and firm' (165). Charles, in the ecstasy of discovering his passion for Julia, realizes finally that the Apollonian world is captivating but also imprisoning:

> A door had shut, the low door in the wall I had sought and found in Oxford; open it now and I should find no enchanted garden.
> I had come to the surface, into the light of common day and fresh sea-air, after long captivity in the sunless coral palaces and waving forests of the ocean bed. (156)

Like Alice leaving her Wonderland, Charles Ryder has grown up in his affections, and his maturity is marked by his achievement in art.

While Ryder's 'aesthetic education' begins under the domination of Sebastian who 'set' him to drawing the estate of Brideshead (78), the male muse proves to be a limiting one. Charles has little success in exhibiting architectural paintings of Brideshead and other great estates. However, he achieves fame when under the influence of his love for Julia he gives up architectural painting and exiles himself from England in order to paint landscapes of Latin America. Only in the New World, away from the overlay of false and sterile values that England has become to him, can he find the truly primitive that will renew him:

> I travelled through Mexico and Central America in a world which had all I needed, and the change from parkland and hall should have quickened me and set me right with myself. I sought inspiration among gutted palaces and cloisters embowered in weed, derelict churches where the vampire-bats hung in the dome like dry seed-pods and only the ants were ceaselessly astir tunnelling in the rich stalls; cities where no road led, and mausoleums where a single, agued family of Indians sheltered from the rains. There in great labour, sickness and occasionally in some danger, I made the first drawings for *Ryder's Latin America*. (209)

Returning from America by ship, Charles meets Julia and finally achieves fulfilment in love with her, and, thereafter, on the night on which his highly successful exhibition of landscapes from the New World opens he rejects once and for all his past association with the homosexual world by abandoning one of his old Oxford friends, the '"aesthete" *par excellence*' (35), Anthony Blanche, in a gay bar in London. Ryder has found his true muse in the White Goddess, and the inspiration revitalizes his art and his life.

But, as Graves knew, while the female can be inspiring, she can also be destructive, and Waugh personifies the darkness of the Goddess in the deadly Lady Marchmain. She represents the sterility of the tradition and conformity of an outmoded faith, and the estate which she rules, Brideshead with its Catholic chapel, is yet another metaphor for the state of England before the war. Her husband has already found a vital goddess in the mistress with whom he is in exile in Italy, and Lady Marchmain in her abandonment becomes

a latter day Miss Havisham dealing disaster and even death to all her children: the brilliant Sebastian to dissipation, drink, exile, and death; the beautiful Julia, first to an unhappy and barren marriage to Rex Mottram, who Ryder describes as 'something in a bottle, an organ kept alive in a laboratory' (183), then, to rejection of her own love for Charles, and finally to exile as a nurse abroad; and the youngest, Cordelia, to a spinster's lonely life of service. The sterility of Brideshead is embodied in the first-born son who bears its name; as Charles says of Bridey, 'I was in a strange world, a dead world to me, in a moon-landscape of barren lava, on a plateau where the air struck chill, a high place of unnaturally clear eyes and of toiling lungs' (151). Lady Marchmain's Brideshead is like Shakespeare's England in *King Lear*; all its children – even its Cordelia – are victims of its rejection of natural love and affection in an effort to uphold an unnatural and old-fashioned faith. Like Shakespeare's loyal Edgar, only the outsider Charles Ryder endures, but at the expense of knowing the Marchmain tragedy and sharing in it in his final loss of Julia to tradition and faith at the end of the novel.

Brideshead in its dedication to the past, to the time before the war, is the world of England lost, and Waugh, writing amid the war, finds the future bleak. In the framing narrative of Ryder revisiting Brideshead during the war when the estate is being used as a troop bivouac, we are provided a final emblem of what Graves had conceived to be the consequence for civilization of ignoring the Goddess and losing its vitality. Brideshead is now in the hands of philistines like the recruit Hooper who in his incompetent, uncultured, and ignorant manner is viewed by Charles Ryder as a 'symbol' of 'Young England' (15). Ryder separated as he is from his true love and muse, Julia, finally describes himself as 'homeless, childless, middle-aged, loveless' (318) – a version of Lear. In Charles's dedication to the pursuit of the muse, he survives as an artist to tell his tale; the rest of his life is bitterness and sadness. *Brideshead Revisited* is a novel of nostalgia for England between the wars and its inevitable loss of grandeur and innocence, but, like Graves' *White Goddess*, it is an indictment, too, of the prevailing patriarchal culture manifested as enduring curse.

In functioning as an intended 'historical grammar of poetic myth', *The White Goddess* is a new *Golden Bough*, but one displaying the effect of being written in and for wartime. While Frazer gave Modern writers the means to describe the feelings of ennui and paralysis

between the wars, Graves gives Contemporary artists a way to confront the horror of the violence and to seek passage through it to a vision of the potential for renewal which can only be sought at the darkest and deepest depths of nature and psyche. In its description of violence and sacrifice, the primitive world of the *White Goddess* is, after all, an extended metaphor for the condition of humanity in the 1940s. It establishes for the mid and late twentieth century a landscape of violence at the borders of the civilized as Blake did for the late eighteenth century and Conrad for the late nineteenth. When Graves proclaims,

> Poetry began in the matriarchal age, and derives its magic from the moon, not from the sun. No poet can hope to understand the nature of poetry unless he has had a vision of the Naked King crucified to the lopped oak, and watched the dancers, red-eyed from the acrid smoke of the sacrificial fires, stamping out the measure of the dance, their bodies bent uncouthly forward, with a monotonous chant of: 'Kill! kill! kill!' and 'Blood! blood! blood!' (448)

he is echoing both Blake's description in *Jerusalem* of the awful sufferings of human victims of Druidic ritual and Conrad's portrayal in *Heart of Darkness* of Marlow grappling with his double, Kurtz, in the flickering firelight from nearby cannibalistic rites that represent the horror of the Inner Station:

> We were within thirty yards from the nearest fire. A black figure stood up, strode on long black legs, waving long black arms, across the glow. It had horns – antelope horns, I think – on its head. Some sorcerer, some witch-man, no doubt: it looked fiend-like enough.[13]

To find renewal, then, all who will follow the Goddess must suffer the abuses of Lucius, struggling in the shape of another, a double, toward conversion into being a priest of Isis.

For the poet Ted Hughes, who was born in a place in Yorkshire called Mytholmroyd, who studied first English then archaeology and anthropology at Cambridge, who personally dealt with the love and despair of the Goddess in his marriage to Sylvia Plath, following Graves into poetic vision seems fate. Graves influences Hughes throughout his career, but *Gaudete* (1977), which combines

poetry with prose in the manner of Blake's *Marriage of Heaven and Hell*, is the epitome of the desperate search for the White Goddess in our time. Rather than Conrad's illustrious European on the model of Kitchener who as Marlow's double represents the threat to civilization at its borders, Hughes's double for his protagonist, the Reverend Lumb, is the oak tree of the Druidic rites. After Lumb is lashed to the tree and flogged, his oak double takes his place for a time, unleashing, like Kurtz, Dionysian energy that is prolific and devouring. Lumb's primitive double transforms his Christian ministry into orgiastic rites leading to suicide and murder, but in the epilogue the real Lumb reappears, now changed into a priest of Isis, to leave a legacy of his metamorphosis in the form of a holy book of poems. The plot of this contemporary *Golden Ass* moves from a civilization that is stagnate in its rigidity and convention to a primitive world where the vitality of fecund nature in its destructiveness as well as creativity is revealed; it returns then to civilization with a message, poetic and enigmatic, promising renewal.

Hughes's world of Lumb is that of Eliot's 'Little Gidding' become Yeats's 'Byzantium' and twisted together into the even greater violence and horror of Blakean prophecy. In the Prologue, Lumb finds himself on the border of violence between the present and the primitive, the imagery vacillating temporally in Blakean fashion between the recognizable and the mythic. His initial encounter with 'dead bodies . . . piled in heaps', a 'mass-grave', and infant corpses 'tumbled separate, like refugee bundles' (11–12)[14] images the modern holocaust, and in the midst of the devastation, like Eliot meeting the shade of Yeats after the blitz in 'Little Gidding', a ghastly form from a Fuseli nightmare overtakes Lumb:

> And suddenly out of the twilight of corpses
> A flapping shape –
> A wild figure gyrating toward him.
> A flailing-armed chimpanzee creature, bounding over the
> bodies and shouting.
>
> (13)

Revealed as the epitome of the worn-out Yeats confronting a Europe on the brink of war, the 'old man, in scarecrow rags, gasping for breath' leads Lumb into the 'subterranean darkness' (13) of the hell of the modern psyche where first he finds the corpse of a woman

'tangled in the skins of wolves' (14), a figure of slain innocence that anticipates the outcome of the violence in the village that Lumb's oaken double will cause. Then, knocked unconscious, Lumb is carried even further into nightmare into the darkness of a primitive myth of Druidic rite where he is brutally crucified on the oak and beaten into union with his double then baptized into the industrial age in a blood bath that occurs in a modern slaughter-house for cattle. Initiated into the false religion of sacrifice and violence, his double is ready to take Lumb's place.

In the context of this devil's history stands Hughes's rural village which should be pastoral and tranquil but is disturbed out of its tradition, orthodoxy, and dullness into being a contemporary suburb of sexual anxiety and promiscuity. Indeed, Hughes's description, having its origins in a screenplay,[15] retains the glossy hyperbole of a typical horror film version of the quaint village invaded by alien body snatchers or a coven of witches. In this instance, it is Lumb as a figure of irresistible primitive fecundity who becomes displaced into the setting to become the god of a latter-day false religion of feminine sexual abandonment, releasing the collective id of the women of the village who are in search of salvation from the sterility of their lives. Only the most powerful feelings of the blood and the loins can still be arousing in this village that becomes a parody of contemporary suburban life. The village is presented as a Baconian world of copulation observed by voyeurs as the daisy chain of Lumb's conquests unfolds observed by first one and then another of the men of the village. These sexual tableaux exist in the narrative of the poem until fixed in photographs taken by the most persistent Peeping Tom of all of the villagers, the poacher Joe Garten; his photographs rouse the men of the village to action. Those who fight are veterans of the wars of the century, still honored because they are known by their rank, like Major Hagen and Commander Estridge, and they attack the enemy with sophisticated tools of modern warfare like binoculars, telescopes, and rifles.[16] They become the villagers of any time who when confronted by a disruptive force – a witch or a criminal or the creation of a Frankenstein – take it upon themselves to expel or destroy the usurping alien in their midst.

The village, in its cinematic exaggeration, is a wierd microcosm of contemporary patriarchy. Women in the village in their aroused sensuality threaten the control and tranquillity of the men more by the energy of their passion than by their

promiscuity. Indeed, the women are described with simian features as if evolution had reached a particular moment when an instinctual bestial force suppressed in them suddenly shows itself. One villager, Commander Estridge, watching his twenty-two-year-old daughter Jennifer play the piano sees a 'lemuroid' profile and 'oppressed/By the fullness of her breasts, and the weight of flame in her face' is 'stricken with the knowledge that his dream of beautiful daughters/Has become a reality . . . But the reality/Is beyond him. Unmanageable and frightening' (41). Lumb in a nightmare envisions all of the women of the village buried alive up to their heads in mud in torturous punishment by the men for their sexual energy; among them, he finds one who is an emblem – like Yeats's 'rough beast' – of the frightening new order:

> The rain striking across the mud face washes it.
> It is a woman's face,
> A face as if sewn together from several faces.
> A baboon beauty face,
> A crudely stitched patchwork of faces,
> But the eyes slide,
> Alive and electrical, like liquid liquorice behind the stitched
> lids,
> Lumb moves to climb, to half-crawl
> And feels her embrace tighten.
>
> (104)

When this clinging bride of Frankenstein, described as a 'baboon woman', is finally pulled away, it is as if some part of Lumb, the new Adam, were being excised to create the new Eve: 'He imagines he has been torn in two at the waist and this is his own blood everywhere' (106).

Gaudete presents both creative and destructive manifestations of Hughes's White Goddess, mystery residing in the very ambiguity of the versions of the figure. The contrast is best represented in two of the characters, Felicity, Lumb's chosen bride, who 'at eighteen, is in her second spring of full flower' (91), and Maud, the chief priestess of his cult of female initiates:

> Maud
> Is standing naked.
> She is sponging her self with the bunched rag of the pigeon's
> body.
> She is painting her breasts,

Her throat and face, her thighs and belly,
With its blood.
Swaying her head, she continues to paint herself
Whispering more rapidly and sobbingly, more absorbed,
As if she were crazed,
As if she were doing something crazy
With the body of her own child.

(118)

These two embodiments of the Goddess confront one another in the rites of the Women's Institute held in the basement of the village church; it is ritual that could have been taken directly from Graves's account of 'the roebuck in the thicket' or Conrad's imaginings of the native ceremonies led by Kurtz in the Inner Station. Surrounded by chanting, clapping naked women, Lumb, 'under stag antlers, the russet bristly pelt of a red stag flapping at his naked back', in the consummating act of the fertility rite mounts from behind the drugged Felicity, with the 'blueish pale-fringed skin of a hind over her shoulders', while she is being held down by the priestess Maud, robed in 'the long ragged pelt of a giant fox' (145). The violent Maud murders the innocent Felicity and, just before committing suicide, arouses the village women against Lumb for planning to abandon the cult and become commonplace in eloping with Felicity 'like an ordinary man/With his ordinary wife' (147). Lumb escapes, commencing an extraordinary flight pursued by the villagers, men along with the suddenly awakened women; however, unlike Graves's legendary roebuck – 'how many kings in how many fairy tales have not chased this beast through enchanted forests and been cheated of their quarry?' (54), the oaken Lumb is fallible before the weapons of modern technology, in this instance a Mannlicher rifle. He is shot – myth ends for the villagers, and their home is restored to its ordinary sterility under patriarchical rule, the evidence of the human sacrifices to Lumb's fertility cult destroyed by a fire in the church.

But, if there is no place for myth left in the village, there is place in Hughes's poem. In the Epilogue, Lumb reappears on the West Coast of Ireland, the country where Yeats's 'terrible beauty is born' and land of violent revolution still. Three little girls tell a priest about a stranger who had given them a tattered notebook and performed a miracle of summoning from the ocean a sea-creature, mysterious to them but identified by the priest as a sea-otter. Listening to them has

the same effect on the priest as actually encountering the Goddess; the girls' tale inspires vision:

> His thoughts flew up into a great fiery space, and who knows what spark had jumped on to him from the flushed faces of the three girls? He seemed to be flying into an endless, blazing sunrise, and he described the first coming of Creation, as it rose from the abyss, an infinite creature of miracles, made of miracles and teeming miracles. And he went on, describing this creature, giving it more and more dazzlingly-shining eyes, and more and more extraordinary beauties, till his heart was pounding and he was pacing the room talking about God himself, and the tears pouring from his eyes fell shattering and glittering down the front of his cassock. (175)

The Triple Goddess is present through the reaction created by the presence of the three little girls just in the way that Graves describes her – 'the hairs stand on end, the eyes water, the throat is constricted, the skin crawls and shivers run down the spine', and the priest, a convert to the Romantic religion of man united with nature and the primitive, begins a new ministry by transcribing the poems from Lumb's tattered notebook. The poems represent the gospel of the metamorphosis of Lumb, testimony to the ambivalence of human experience on the border between the civilized and the primitive. There is violence in both worlds: Hughes's own Goddess of poetry is very cruel, but only by imaginatively yoking the two together can vision still be attempted in a sterile and conformist culture.

Art historian Lucy Lippard summarizes the feelings of her generation about the ambiguity of the civilized and the primitive after choosing in 1977 (the same year Hughes published *Gaudete*) to retreat to an isolated farm in the South of England to write. Reminiscent of Wordsworth's complaint in his Preface to *Lyrical Ballads* about the intrusive pressures of his times,[17] she wanted to escape 'from a complicated urban life of criticism, organizing, and activism', and she found herself, like her Romantic predecessor, suddenly confronted amid raw nature by evidence of the primitive:

> Hiking on Dartmoor, with nothing further from my mind than modern sculpture, I tripped over a small upright stone. When I

looked back over my shoulder, I realized it was one in a long row of such stones. They disappeared in a curve over the crest of the hill. It took me a moment to understand that these stones had been placed there almost 4,000 years ago, and another moment to recognize their ties to much contemporary art. I looked around that vast open space; the dog waited expectantly; I leaned down and touched the stone. Some connection was made that I still don't fully understand . . . (1)[18]

What Lippard finds appealing about suddenly encountering the primitive, like Wordsworth and Graves before her, is the element of mystery in it and the possibility for a creative response that circumvents the limits of rational thinking: 'What interests me most about prehistory is precisely what cannot be known about it. The new 'speculative history' of the megalithic cultures offers a way back into the labyrinth partially closed off by traditional archaeology and its fear of the unproven' (3). From this neo-Romantic perspective, Lippard emphasizes that 'one of art's functions is to recall what is absent – whether it is history, or the unconscious, or form, or social justice' (4), and she follows Wordsworth's line of thought in the Preface to 'Guilt and Sorrow' in arguing that 'the real challenge to a socially aware artist . . . is to make the resurrected forms meaningful *now*, not in terms of nostalgia, but in terms of present struggles and dreams and hopes and fears' (6). Consequently, exploring the inextricable relationship between nature and primitive continues to be for Lippard, as for her Romantic and neo-Romantic predecessors, a means for cultural renewal:

> Speculation about the close relationship between nature and culture in prehistory is not starry-eyed idealization, nor is it ahistorical fantasizing about a Golden Age. People living between earth and sky, with few human-made distractions, had to be far closer to natural forces and phenomena than people living on our crowded planet now. They were undoubtedly aware of their environment in ways lost to us. Obviously we do not relate to nature in the same way, but the re-establishment of a coherent relationship between nature and culture is a critical element in any progressive view of the future. (12)

In her contemporary retreat to a rural setting and in her assertion of the cultural importance of encountering the sublimity of

the primitive, Lippard finds a basis for the artistic forms of her contemporaries:

> Certain forms have survived the intervening millenia as the vehicles for such a vital expression. The concentric circle, the spiral, the meander, the zigzag, the lozenge or diamond shape, the line in the landscape, the passage and labyrinth and welcoming, terrifying shelter are still meaningful to us, even if we cannot cite their sources and symbolic intricacies. These forms seem to have some basic connection to human identity, confirming bonds we have almost lost with the land, its products and its cycles, and with each other. Symbols are inherently abstract. Certain images, rooted then uprooted, can still carry seeds of meaning as effectively as the most detailed realism, even to our own individualistic society, estranged as it is from nature. (10–11)

To Lippard, it is the retention of mystery, the hint of the vital but unknown lingering in relics from pre-history, that maintains the needed link between art and nature, artist and Goddess, in art of the late twentieth century.

But, well before the examples of primitivism in contemporary work cited by Lippard, the power of the Goddess had appeared in the sculpture of Henry Moore. In works created during and after the war under the same cultural pressure that prompted Graves's vision, Moore revealed his own version of the Goddess. This dedication to an ideal is the difference between the life-affirming quality in his work and the morbid sense of his contemporary, Francis Bacon. Moore's work upholds a 'humanist faith' in the life force expressed in images of the female and the family while Bacon in what Graves would view as masculine self-sufficiency dwells on mortality and continues to express the isolation of the individual. As Moore has said, 'An artist works because he believes that life is worth being lived, that his work is worth being accomplished, and there is in the world something that deserves being expressed',[19] and major motifs of his sculpture are women revealed in the fullness of their fertility and maternity and family groups shown as nurturing and caring. The figures express an essential vitality not outside of the violence of the 'present reality' but in spite of it. Yet, Moore clearly places his art within history, stating that 'the meaning and significance of form itself probably depends on the countless associations of

man's history', even knowing, like Orwell, how disturbing and paradoxical his age is:

> We have a society which is fragmented, authority which resides in no certain place, and our function as artist is what we make it by our individual efforts. We live in a transitional age, between one economic structure of society which is in dissolution and another economic order of society which has not yet taken definite shape.

Yet, amid the chaos, Moore finds energy and life: 'All that is bursting with energy is disturbing – not perfect. It is the quality of life. The disturbing quality of life goes hand in hand with the disturbing quality of our time'.[20]

The sculptural objects unveiled by Moore after the war, then, express a life-force which is embodied in the primal, primitive, and sometimes Christian iconography of the female form. His artistic inspiration was nurtured by his absorption in his formative years of the Romanticism of D. H. Lawrence and Thomas Hardy;[21] his forms achieve a quality of mythic affirmation. Moore's obsession with the artistic tradition of the female nude focuses on what he calls the 'wide, broad, mature woman'[22], who, in his sculpture, clearly becomes the 'concept of fruitfulness, the Mother Earth', his equivalent of Graves's Isis'.[23] At the same time, Moore's employment of natural materials, various kinds of wood and stone, as well as his dedication to creating works for outdoor settings suggest his fascination with the fecundity of nature. 'Sculpture is an art of the open air', he states. 'Daylight, sunlight, is necessary to it, and for me its best setting and complement is nature',[24] He has admitted that as an artist he has something of a 'Wordworth relationship to nature',[25] and he respects light – natural light – as something almost divine.

Moore's sense of nature contributes a religious aura to his works. Unlike Bacon, Moore's use of religious iconography expresses a sense of faith rather than its loss. Moore has commented on the problem of religion for the post-war artist and attempted to reconcile it with his humanism: 'Religion no longer seems to provide inspiration or impetus for many artists. And yet all art is religious in a sense that no artist would work unless he believed that there was something in life worth glorifying. This is what art is about'.[26] Occasionally, then, Moore's sculpture directly images Christian iconography. He has done variations on the theme of mother with

child, but one of his wartime works was specifically a 'Madonna and Child' (1943–44) for a Northampton church [Plate 15]. In addition, the series of outdoor pieces called 'Upright Motives' (1955–56) are connected to the the idea of the Crucifixion. 'Upright Motive No. 1' in its creation took on, as Moore describes it, 'the shape of a crucifix – a kind of worn-down body with a cross merged into one',[27] and because of its location at Glenkiln Farm it has become known as the 'Glenkiln Cross'. Related to this work are two more sculptures, 'Upright Motives Nos. 2 and 7', and, as Moore conceived them, 'three of them grouped themselves together, and in my mind, assumed the aspect of a Crucifixion, as though framed against the sky above Golgotha'.[28] For Moore, then, the renewal and even resurrection of life is ever a possibility, an optimist's response to living in a transitional age. Moore seems to accept in his own way the validity of T. S. Eliot's assertion in *Notes towards the Definition of Culture* that 'any religion, while it lasts, and on its own level, gives an apparent meaning to life, provides the frame-work for a culture, and protects the mass of humanity from boredom and despair'.[29] In Moore's sculpture, then, faith in man, nature, and, in Wordsworth's sense, 'something' of a belief in the immortal endures, and even a difficult historical time like that after the war offers opportunity for expressing the old values of fertility and regeneration.

The search for the Goddess inevitably involves juxtaposing, and even choosing between, the values of the city and those of the country, and the career of Pop artist Peter Blake mirrors the ambiguity of the choice. Surrounding himself in a London studio with the memorabilia to indulge his fascination with popular music and celebrities finally became insufficient for his artistic development, and, as an underlying pastoralism emerged from his nostalgia, both the technique and the content of his work changed. Technically, he changed from using acrylic paint for his medium, which gave the flat, commercial finish to his Pop subjects, to using oil paint, a more subtle, and traditional, technique. Also, a series of works based on *Alice Through the Looking Glass* (1970–71) directed his attention to the mythic qualities of nineteenth-century expression. Consequently, in 1969 Blake moved to Cornwall, and in 1975 he founded the Brotherhood of Ruralists with other artists who had also moved to the country to work.[30] Modelled on the nineteenth-century Brotherhood of Ancients and the Pre-Raphaelite Brotherhood, the Ruralists stated their goal: 'to express through personal vision and experience of our native heritage a celebration of the English countryside'.[31]

Through immediate, living contact with the landscape, they were at their most Romantic in searching for 'the idea of a *genius loci* or spirit of place',[32] a mystical perception of the fantasy and power of nature usually found expressed through legend and folklore. Hence, the subjects of the Ruralists were not only landscape and conversation pieces showing, in the late eighteenth-century manner, members of the Brotherhood in settings near their homes, portrayals of man and nature in living harmony with one another, but also topics with rich connotations of fantasy. As joint projects, they chose subjects like Shakespeare's 'Ophelia' (the theme for a 1980 exhibition), created original illustrations for the covers of a new Arden edition of Shakespeare, and agreed that each would paint 'The Definitive Nude'. In this way, members of the Brotherhood attempt to restore a sense of tradition as well as sentiment and myth to painting through their use of such genres and subjects.

Out of the interest of the Ruralists in 'the mythical and fantastic elements of "being in the country"' emerges Blake's version of the White Goddess, his painting of 'Titania', created between 1976 and 1983 [Plate 16]. Inspired by the great nineteenth-century children's writers like Lewis Carroll, Blake attempts to capture a child's sense of the possibility of encountering fantasy in everyday experience, of moving instantaneously between the real world and fairyland. His description of creating 'Titania' expresses his effort to recover this sense in his art: 'I wanted to feel how the Queen of the Fairies might feel and what she might do. I was trying to invent a morality. One concept was that she might not cover the important parts that a mortal might cover so she might well decorate her breasts and her pubic hair. I've never seen her, but if they do exist, she is just as likely to wear badges I might have lost down there by the river'.[33] However, there is more than innocence in Blake's painting of the fairy queen. One of the interests of the Brotherhood of Ruralists was in the eroticism of Victorian art, and they admired it not only in the work of the pre-Raphaelites but also in Carroll's photographs and the 'fairy' paintings of Noel Paton, Richard Dodd, and John Simmons. Consequently, considering its heritage, Nicholas Usherwood finds Blake's 'Titania' to be 'a truly convincing twentieth-century attempt at a large fairy painting, its disturbing eroticism banishing any trace of whimsicality'.[34] And, indeed, there she stands, Blake's Goddess, facing the viewer directly with intense, staring countenance, in blatant but elegant naked- ness wearing only the odd memorabilia lost by her creator as

necklace and pubic decoration. Stepping confidently out of the darkness, she is the very vision of the Goddess, whom, as Graves suggests, 'Shakespeare knew and feared' in creating the 'extraordinary mythographic jumble' of his *Midsummer-Night's Dream* where appear 'the Wild Ass Set-Dionysius and the star-diademed Queen of Heaven as ass-eared Bottom and tinselled Titania' (426).[35]

The viewer of Blake's painting beholds Titania as Bottom might have on his mad mock-wedding night in the forest, and in the early version (1976) that shows her with long, straight black hair and dark, possibly Egyptian, features she is the very image of Apuleius' Isis come to inspire a priest of her religion. Appearing with these features, Blake's 'Titania' embodies the ultimate contemporary vision of the Goddess as conceived by Robert Graves. In an Oxford lecture of 1963, 'Intimations of the Black Goddess', Graves describes a less volatile and ambigious figure than the White Goddess who as 'more-than-Muse' represents the artist's final hope for unity and order in a turbulent world: 'She promises a new pacific bond between men and women, corresponding to a final reality of love, in which the patriarchal marriage bond will fade away. . . . she will lead man back to that sure instinct of love which he long ago forfeited by intellectual pride'. Graves, to hint at the profound knowledge of the Black Goddess, quotes his poem, 'The Hearth', which concludes:

> How shall he watch at the stroke of midnight
> Dove become phoenix, plumed with green and gold?
> Or be caught up by jewelled talons
> And haled away to a fastness of the hills
> Where an unveiled woman, black as Mother Night,
> Teaches him a new degree of love
> And the tongues and songs of birds?
>
> (*On Poetry*, 447; 446)

Blake, in his later version, repaints 'Titania' with pale features and blonde hair, a closer equivalent to the more ambiguous Goddess that Graves first described in his poem 'In Dedication' which appears at the beginning of *The White Goddess*:[36]

> All saints revile her, and all sober men
> Ruled by the God Apollo's golden mean –
> In scorn of which I sailed to find her

In distant regions likeliest to hold her
Whom I desired above all things to know,
Sister of the mirage and echo.

It was a virtue not to stay,
To go my headstrong and heroic way
Seeking her out at the volcano's head,
Among pack ice, or where the track had faded
Beyond the cavern of the seven sleepers:
Whose broad high brow was white as any leper's,
Whose eyes were blue, with rowan-berry lips,
With hair curled honey-coloured to white hips.

Green sap of Spring in the young wood a-stir
Will celebrate the Mountain Mother,
And every song-bird shout awhile for her;
But I am gifted, even in November
Rawest of seasons, with so huge a sense
Of her nakedly worn magnificence
I forget cruelty and past betrayal,
Careless of where the next bright bolt may fall.[37]

In versions by Blake, as well as by Moore and Hughes, the
Goddess – black and white – in her mystery, her allure, her prom-
ise, endures.

7

The Contemporary English Epic: Lessing

These novels will give way, by and by, to diaries or autobiographies – captivating books, if only a man knew how to choose among what he calls his experiences that which is really his experience, and how to record truth truly.

Ralph Waldo Emerson quoted by Henry Miller
as the epigraph to *Tropic of Cancer* (1934)

Born 28 Novr 1757 in London & has died several times since.
From William Blake's autograph
in the Album of William Upcott,
January 16, 1826

'As society changes, or twists its old knowledge about, its writers – its artists – produce new theoretic forms which in turn require fresh psychologies; and sometimes a new psychology will seem to come from nowhere, or from the ear of Zeus, and be restless and frustrate unless it finds a theoretic form' – so writes R. P. Blackmur addressing the issue of the nineteenth-century European novel.[1] In doing so, his description of the intellectual milieu for Tolstoy's *Anna Karenina* could be applied to the situation in England in the late twentieth century:

> To accomplish this art of psychology, this art of the psyche, this driving form and drifting form (as the stars drift) is perhaps the characteristic task of the novel in a society like that of the nineteenth century: a society without a fixed order of belief, without a fixed field of knowledge, without a fixed hierarchy; a society where experience must be explored for its significance as well as its content, and where experience may be created as

well as referred. This is the society where all existing orders are held to be corruptions of basic order; or, to put it differently, where, in terms of the confronted and awakened imagination, the creation of order has itself become a great adventure. This is what Anna and Levin have, great personal adventures in the creation of order: an order is the desperate requirement each has for the experience each bodies forth.[2]

Doris Lessing perceives the similarity of Tolstoy's – as well as Anna's and Levin's – predicament to that of her own times. As she says in her essay, 'A Small Personal Voice' (1957),

> If there is one thing which distinguishes our literature, it is a confusion of standards and the uncertainty of values. . . . Words, it seems, can no longer be used simply and naturally. All the great words like love, hate; life, death; loyalty, treachery; contain their opposite meanings and half a dozen shades of dubious implication. Words have become so inadequate to express the richness of our experience that the simplest sentence overheard on a bus reverberates like words shouted against a cliff. One certainty we all accept is the condition of being uncertain and insecure. It is hard to make moral judgement, to use words like good and bad.
> Yet I reread Tolstoy, Stendhal, Balzac, and the rest of the old giants continuously.[3]

Why? Because Lessing finds in their work 'realism', a quality that she finds missing in the art of recent time. She rejects the example of European contemporaries like Camus, Sartre, Genet, and Beckett for their lack of real 'pity' or a sense of humanity,[4] and she finds modern British literature, especially the work of the Angry Young Men, to be provincial, 'I mean that their horizons are bounded by their immediate experience of British life and standards'.[5] Consequently, she looks back to the nineteenth-century tradition of the European novel for her inspiration:

> For me the highest point of literature was the novel of the nineteenth century, the work of Tolstoy, Stendhal, Dostoevsky, Balzac, Turgenev, Chekhov; the work of the great realists. I define realism as art which springs so vigorously and naturally from

a strongly-held, though not necessarily intellectually-defined, view of life that it absorbs symbolism. I hold the view that the realist novel, the realist story, is the highest form of prose writing; higher than and out of the reach of any comparison with expressionism, impressionism, symbolism, naturalism, and any other ism.[6]

Lessing's definition of realism is that of a socialist, as she goes on to proclaim in the essay, and her intellectual source is the literary theories of the Marxist Georg Lukács. It is appropriate, then, that in her effort to revitalize the novel in the post-war era Lessing would turn to, in Blackmur's terms, a 'theoretic form' evolved in Europe in reaction to the First World War and look for inspiration in Lukács' very ideal of prose fiction, the nineteenth-century historical novel.

In *Theory of the Novel*, written in 1916 in 'vehement, global . . . rejection' of the Great War,[7] Lukács found his literary ideal in Homer's epics conceived as expressions from a 'golden age' of an integrated civilization, one in which 'man does not stand alone, as the sole bearer of substantiality, in the midst of reflexive forms: his relations to others and the structures which arise therefrom are as full of substance as he is himself, indeed they are more truly filled with substance because they are more general, more "philosophic", closer and more akin to the archetypal home: love, the family, the state'.[8] The modern genre of the novel inherits from the epic the hero's quest for a sense of wholeness but in a world in which the individual is alienated from society. As Lukács says, 'The novel is the epic of an age in which the extensive totality of life is no longer directly given, in which the immanence of meaning in life has become a problem, yet which still thinks in terms of totality'.[9] For its hero, then, the novel in its structure inevitably records a quest for the sense which has become concealed. 'The novel', according to Lukács, 'seeks, by giving form, to uncover and construct the concealed totality of life',[10] but the ultimate vision of an integrated society remains unobtainable. Lukács' definition of the 'inner form of the novel' well summarizes the sense of alienation and incompleteness both in the genre and in its hero:

The inner form of the novel has been understood as the process of the problematic individual's journeying towards himself, the road from dull captivity within a merely present reality – a

reality that is heterogeneous in itself and meaningless to the individual – towards clear self-recognition . . . the conflict between what is and what should be has not been abolished and cannot be abolished in the sphere wherein these events take place – the life sphere of the novel; only a maximum conciliation – the profound and intensive irradiation of a man by his life's meaning – is attainable.[11]

Lukács finds his theory of the novel best revealed in practice in the rise of the nineteenth-century historical novel, and his book on that specific genre was written in 1936–37 and first translated in 1962. Most influential is the description of Sir Walter Scott's protagonist as a 'mediocre, prosaic hero',[12] and, as Lukács insists, 'Scott's novel hero is in his way just as typical for this genre as Achilles and Odysseus for the real épopée. . . . The principle figures . . . are also typical characters nationally, but in the sense of the decent and average, rather than the eminent and all-embracing'.[13] While Marxist criticism traditionally eschews concern with aesthetic form, Lukács makes a point of it in *The Historical Novel*: 'the important modern historical novels show a clear tendency towards *biography*',[14] yet the biographical psychoanalytic method should be avoided. Instead, the form of presentation must show 'how very much the man of genius is bound up with the entire economic, social, political and cultural life of his time . . . he proves his genius by the originality with which he extends, concentrates and generalizes these most important tendencies in the life of an epoch'.[15] The hero is best understood, then, not by the "deepest' psychological analyses of . . . [his] various loves and friendships',[16] but through an anti-biographical method which emphasizes the development of individuals and stresses the way in which they embody the forces of their time. Heroes in such a form are portrayed as 'great because they possess this concentrating power, because they are able to answer the problems most deeply affecting the life of the people at this moment. Like the Homeric heroes physically, they are intellectually taller than other people by a head'.[17] The formal artistic strategies to reveal this, then, involve establishing the hero, first, amid his social and cultural environment, then using retrospection 'to put the accidental nature of any experience occasioning a deed or event into its rightful place'.[18] By replacing the conventional biographical form with the retrospective one, the fictional presentation

answers *artistically* why it should have been just this particular individual at this particular time who secured the leading role: he is capable of giving answers to the diverse problems of popular life. . . . The novel simply reflects, profoundly and authentically, how necessity and chance interlock in historical life . . . how the concrete historical forces of a particular period have become concentrated in the life of this particular individual.[19]

Through this form, the protagonist of the novel, like the hero of the epic, becomes 'realistic' in that he is typical in representing issues and values beyond a single individual's unique biography or destiny. Lukács concludes his theory of the historical novel by calling for a renewal of the vitality of the novel which he believes has become entrapped by the biographical form. He seeks 'a renewal in the form of a negation of a negation'.[20] The work of Lessing and other writers and theorists who have been influenced by Marxism in the 1960s and 1970s is an effort to achieve such a renaissance.

A 'theoretic form' based on such assumptions, new for the English novel of the late twentieth century, would likely, as Blackmur warns, 'frustrate' the reader. Lessing's *The Golden Notebook* of 1964 did – and does. Like Graves's *White Goddess*, it is one of those works that appear out of 'nowhere', out of the very lack of order and form that mark the civilization, to puzzle the reader by not permitting him or her to approach the literary experience in a conventional manner. George Steiner describes the dilemma that works such as these pose for readers:

> Starting in late eighteenth and early nineteenth centuries, books have appeared which allow no ready answer to the question: what species of literature am I, to what *genre* do I belong? Works so organized – we tend to forget the imperative of life in that word that their expressive form is integral only to themselves, that they modify, by the very fact of their existence, our sense of how meaning may be communicated.[21]

The Golden Notebook is such a work; in reading it, the reader is confronted with a 'novel' divided into sections and separated by 'notebooks' designated by different colours. Out of these fragments is constructed the final notebook, the golden one, in which the voices of two narrators, female and male, merge. Much has been

written to explain the form – and the content – of the novel, and the author herself has offered some explanation.

In an introduction written in 1971, Lessing states that her 'major aim was to shape a book which would make its own comment, a wordless statement: to talk through the way it was shaped' (xiv).[22] Lessing wanted in self-consciously manipulating the form of expression to let her book 'make its own comment about the conventional novel' (xiii) and to reject the elitist approach of critics – like F. R. Leavis – who attempt to preserve a relevant literary heritage by making a 'private list' of what is 'valuable' (xix). Therefore, since the novel focuses on the figure of an artist who, overwhelmed by the Orwellian 'formlessness' of her age, has a 'block', the narrative structure becomes fragmented, reflecting the 'breakdown' which is the protagonist's response to the confusions of her existence. The form of Lessing's effort inevitably raises a question like that of Steiner in attempting to describe the book: 'What is Doris Lessing's *Golden Notebook*, that acute portrayal of woman and urban society: a novel or an autobiography, a political essay or a psychiatric case-book?'[23] Lessing understands that her reader is blinded by the conventions of the typical novel, indeed, by parochial notions of the very genre itself in England: 'it was not possible to find a novel which described the intellectual and moral climate of a hundred years ago, in the middle of the last century, in Britain, in the way Tolstoy did it for Russia, Stendhal for France. . . . To read *The Red and the Black*, and *Lucien Leuwen* is to know France as if one were living there, to read *Anna Karenina* is to know that Russia. But a very useful Victorian novel never got itself written' (x–xi). Therefore, in introducing *The Golden Notebook*, Lessing tries to help the reader by explaining 'that the book is more in the European tradition than the English tradition of the novel . . . a novel of ideas' (xiv); she wants us to read it to know *that* England.

The Golden Notebook consists literally of the literary pieces, scraps of stories and autobiographical journals, of a writer's life. They are collected and assembled – a collage of material, but their order and meaning are unclear until the creation of the last notebook, the 'golden' one. This problem of form is a manifestation of the problem of the protagonist with the Tolstoyan name, Anna; Lessing's heroine is quite clear about her predicament as a writer in the mid-twentieth century: 'The novel has become a function of the fragmented society, the fragmented consciousness. Human beings are so divided, are becoming more and more divided, *and more*

subdivided in themselves, reflecting the world, that they reach out desperately, not knowing they do it, for information about other groups inside their own country, let alone about groups in other countries. It is a blind grasping for their own wholeness, and the novel-report is a means towards it.' Consequently, Anna, also fragmented, has a 'block', unable to write the kind of novel for which she aspires, 'a book powered with an intellectual or moral passion strong enough to create order, to create a new way of looking at life' (61), one that offers, in Blackmur's terms, a new theoretic form for life.

If Lessing's novel, as she claims, is truly one of ideas, then it is one, too, about the frustration and failure of ideas found wanting: specifically, the politics of Marxism in a Stalinist age; the psychology of Freud in an age of women's liberation; and, most obviously at the very surface of the reader's experience of reading, the aesthetics of fiction and the problem of differentiating between authentic and inauthentic art in the cultural chaos of post-war England. But, this 'theme of breakdown' in Lessing's words is also, of course, a search for integration: the notion 'that sometimes when people 'crack up' it is a way of self-healing, of the inner self's dismissing false dichotomies and divisions' (viii). Lessing's implication seems to be that it is a way of preparing for the next step in the evolution of human understanding, an evolution that may be only beginning in the creation of the Golden Notebook in *The Golden Notebook*. Illumination is achieved in this final – extra – notebook. Anna and her American lover, Saul Green, through the very intensity of their mutual longing and passion break out of the psychic fragmentation and imprisonment imposed on them by the violent madness of the mid twentieth century and in coming to know one another finally find in themselves the necessary sense of meaning and form to continue to live vital existences. For them, as writers, this means that each inspires the other to create, and Anna, given by Saul a first sentence by which to begin, written by him in the golden notebook, overcomes her writer's block to create a novel, *Free Women*.

But, to reach this fulfilling end, Lessing takes her heroine through a tortuous 'journey into the self'. While the form of this journey perplexes the reader with its convolutions, it is, in a sense, quite old-fashioned. Aesthetic direction is given, once again, by Lukács, discussing the tragedy of Anna Karenina. He emphasizes, 'If tragic collision is a necessary form of social life, it is so only under very definite conditions and circumstances. It is also a fact of social life that conflicts abate or peter out, achieve no clear and definite

resolution, either in the lives of individuals or in society as a whole', then he describes the structure of the plot and subplots of the novel:

Tolstoy, for example, has several plots to parallel the tragic fate of Anna Karenina. The pairs Kitty-Levin, Darya-Oblonsky are only the big central complements to Anna and Vronsky; there are many others, more episodic, parallel plots besides. . . . In *Anna Karenina* the parallel plots stress that the heroine's fate, while typical and necessary, is yet an extremely individual one. Obviously her fate reveals the inner contradictions of modern bourgeois marriage in the most powerful terms. But what is also shown is first, that these contradictions do not always necessarily take this particular path, thus that they may have an altogether different content and form, and, secondly, that similar kinds of conflict will only lead to Anna's tragic fate in very specific social and individual conditions.[24]

Similarly, Lessing's novel is one of plot and subplots with parallels complementing the heroine and her fate provided not by other characters in the social setting but, rather, by 'characters' who she as a writer imagines. Lessing's setting is psychological, the writer and her works, rather than social like Tolstoy's, though the dilemma of the heroine is very much shaped, like Anna Karenina's, by 'definite conditions and circumstances' of her context, the Cold War period in England. Around this heroine, the author Anna trying to overcome writer's block and start her second novel, are the parallels, the fate of each, as Lukács emphasizes, differing with circumstances.

There is 'Anna', the author-protagonist of Anna's *Free Women*, who like her creator eventually takes an American lover, called 'Milt' instead of Saul, whose choice in life is finally very different than her author's; she abandons writing to take a job in the office of a marriage counselor. Also, there is 'Ella', the author-protagonist of a fictionalized autobiography, 'The Shadow of the Third', who while working for a women's magazine is trying to write a novel about a woman who – shades of Tolstoy – commits suicide. Named for a magazine writer whom Anna met at a party and who like her writes reviews, 'Ella' has an unhappy affair with a psychiatrist that parallels Anna's with her long time lover, Michael; he, like Saul Green, tries to help 'Ella' with her writing, and he is named 'Paul', after Anna's lover in Africa, Paul Blackenhurst, who died and who

is part of the experience at Masahopi that inspired her first novel. When 'Ella's' affair with 'Paul' ends, she, like Anna after Michael leaves her, cannot write 'this story inside her' of betrayal and rejection in love because 'she is afraid that writing it might make it come true' (460). The yellow notebook that contains 'Ella's' narrative ends with nineteen ideas for stories about frustration in love that could be the creations of 'Ella' or her author. As Anna recognizes, 'Ella' is and is not quite a reflection of herself (and 'Ella's' fate as a writer is left unclear though she is conceiving ideas for stories when the yellow notebook is abandoned):

> I see Ella, walking slowly about a big empty room, thinking, waiting. I, Anna, see Ella. Who is, of course, Anna. But that is the point, for she is not. The moment I, Anna, write: Ella rings up Julia to announce, etc., then Ella floats away from me and becomes someone else. I don't understand what happens at the moment Ella separates herself from me and becomes Ella. No one does. It's enough to call her Ella, instead of Anna. (459)

Or, there is the significant, and significantly different, subplot about Tommy in Anna's novel, *Free Women*. Tommy is the son of the actress Molly, the protagonist 'Anna's' friend in *Free Women* with whom she feels 'interchangeable' like a twin (7). Tommy's life seems governed by a kind of perverse retelling by the novelist Anna of the myth of Oedipus; after experiencing the chaos of reading 'Anna's' notebooks, he attempts suicide – like the protagonist of 'Ella's' novel – and blinds himself. In doing so, he matures, seems to acquire the classical wisdom of blindness, and, like Oedipus, desires to roam the earth in search of good works to perform – and, of course, given the resonances of *The Golden Notebook*, his preference is for Africa. 'Anna' and Molly have been stereotyped by their mutual psychiatrist, Mrs. Marks, whose name alludes to the political context of the novel; called by her 'Electra' and 'Antigone', they, along with blind Tommy, are characters in a Modernist fiction of retold myth. In the typical familial confusion of ancient tales, Anna shows Tommy accompanied in his wandering by Marion, his father's estranged second wife who has become a good friend to the first 'M', Molly, and 'Anna'. So it goes, with other subplots and parallels; indeed, reading *The Golden Notebook* is like looking into a set of self-reflecting mirrors, the images seem almost infinite. The problem for the viewer is not one of disorder but of too much order.

It is like finding the 'house of fiction' described by Henry James to be a house of mirrors where the reader is satiated in characters who are 'reflectors'. Like the audience to the pageant of history in *Between the Acts* when the actors hold up mirrors at the end, we as readers and Lessing's heroine Anna are 'douched' with 'too much Reality' and cannot for a while find in it any sense of order. Hence, Lessing's presentation of the 'theme of breakdown'.

To understand this theme, let us begin with the 'crack-up' of Marxism, or in a Marxist's confidence in History as meaningful. While Lessing in *The Golden Notebook* remains a socialist expressing herself novelistically in a form on the model of Marxist aesthetics, her novel, nevertheless, is very much about her protagonist's inability to sustain a belief in History. Writing at a time in the century after the very ideal of civilization and progress had been under trial (literally, at Nuremberg), after the vision of the Soviet revolutionary experience had become bloodied by Stalin's tyranny, after the policies of the post-war Labour Government had proved stultifying, *The Golden Notebook* is an acknowledgement of the breakdown in belief in the fundamental tenet of History that had supported twentieth-century ideologies. Indeed, the novel is a study of the problem manifested in a person who has believed that History is meaningful and provides a basis for promulgating ethical social values and who discovers her faith shattered. For Anna's situation amid the politics of the Cold War is like that of a French Republican idealist dismayed at the end of the eighteenth century by the violence of the 'Terror' that has evolved from the Revolution; the result is alienation from society and personal despondency.

Specifically, Lessing established the political setting of her novel among Marxists. She does so, as she explains in her introduction, 'to give the ideological 'feel' of our mid-century . . .because it has been inside the various chapters of socialism that the great debates of our time have gone on; the movements, the wars, the revolutions, have been seen by their participants as movements of various kinds of socialism, or Marxism, in advance, containment, or retreat' (xi). For Lessing's heroine, the experience begins as a young woman in her early twenties in Central Africa where she meets three young graduates from Oxford assigned to the regional air base and becomes a member of their local communist group. Amid the camaraderie and in her youth, Anna experiences a 'golden' time of innocence; her experience is similar to that of young Charles Ryder at Oxford in *Brideshead Revisited*, and the background of Anna's friends is

essentially the same. They meet, debate history, and in practicing their liberated ideas of equality and sexuality cause mischief and disorder. However, as Anna says, looking back, 'what is so painful about that time is that nothing was disasterous. It was all wrong, ugly, unhappy and coloured with cynicism, but nothing was tragic, there were no moments that could change anything or anybody. From time to time the emotional lightning flashed and showed a landscape of private misery, and then – we went on dancing' (135). Anna's weekends with the group at the Masahopi hotel becomes the 'Source', as she designates it in the Black Notebook, for her first novel, *Frontiers of War*, as she experiences there with her communist friends a kind of utopia of youth, a 'Shangri-La' similar to that described by Lessing as the ideal of her parents, a place in the Kenyan Highlands 'populated thickly, for my mother, with nice professional people who were nevertheless *interesting*; and sparsely, for my father, with scamps, drunkards, eccentrics and failed poets who were nevertheless and at bottom *decent people*'.[25] In contrast to the African community, Anna describes in her appropriately Red Notebook the steps in her process of disillusionment with the rigid and stultifying anti-intellectualism of the British Communist party.

Anna decides to leave the party after realizing that what she was seeking from it is a myth, some kind of personal organizing principle. She first begins to look at it in this way when she finds sticking in her mind Arthur Koestler's comment 'that any communist in the West who stayed in the Party after a certain date did so on the basis of a private myth' (160), but it takes time for Anna to understand hers. She dreams at one point of the Soviet Union embodied as a glowing red fabric embroidered with 'illustrations of the myths of mankind' expanding into nations around the globe. This view of Stalinist ambition badly frightens Anna; but, then, modern history turns into

> vision – time has gone and the whole history of man, the long story of mankind, is present in what I see now, and it is like a great soaring hymn of joy and triumph in which pain is a small lively counterpoint. And I look and see that the red areas are being invaded by the bright different colours of the other parts of the world. The colours are melting and flowing into each other, indescribably beautiful so that the world becomes whole, all one beautiful colour, but a colour I have never seen in life. This is a moment of almost unbearable happiness, the happiness seems to

swell up, so that everything suddenly bursts, explodes – I was suddenly standing in space, in silence. Beneath me was silence. (298–99)

Combined in Anna's myth with this apocalyptic dream of peace and unity is a search for a wise father figure, a kind of god. It finds expression in her mocking anecdote of Comrade Ted, an enthusiastic true believer, who on visiting Moscow with a delegation finds himself escorted in the middle of the night to the Kremlin to consult for hours with Stalin himself about communist policy toward Great Britain. Upon returning to his hotel room, Comrade Ted confides his faith in his diary: 'Now I had something to record indeed! And I was at my work until the sun rose, thinking of the greatest man in the world, less than half a mile away, also awake and working, in custody of the destinies of us all!' (305). But, for Anna, the myth of Stalin and communism cannot hold, and she copies into her notebook the account of Harry Matthews, a comrade who had fought in the Spanish Civil War, who goes with a delegation to the Soviet Union and cracks up. In ironic contrast to Anna's fictional Comrade Ted, Comrade Harry ends up in his Moscow hotel room ranting for hours in the middle of the night about the history of the Russian Communist Party 'and addressing History itself' (530). This anecdote ends the Red Notebook and completes Anna's coming to terms with her myth of communism.

No wonder then that Lessing is drawn to Tolstoy and Stendhal and the great nineteenth-century historical writers. She appreciates not only their 'realism' but, also, the fundamental premise that underlies it, their recognition of the 'paradox of history', particularly as discussed at length by Tolstoy in his two lengthy epilogues to *War and Peace*. Nicola Chiaromonte sums up Tolstoy's view:

What he maintain was that history failed precisely in what nineteenth-century philosophers and students of history considered to be its primary function: giving an account of facts and events in wholly concrete and rationally adequate terms. Hence Tolstoy came to the contemptuous conclusion: 'The new history is like a deaf man, who answers questions nobody asks of him', and, conversely, does not answer those that are addressed to him. What was left in the end was, on the one hand, the history of historians, either unreal or mythical, and, on the other, reality itself, history as it is actually experienced by the individual and

the community. Between the two was an unbridgeable chasm, as between fiction and truth.'[26]

With this attitude, Tolstoy turned in his fiction from the effect of history on national life in *War and Peace* to its effect on personal life in *Anna Karenina*. Without history on which to rely, there is great 'dependence on others',[27] and Chiaromonte interprets the meaning of *Anna Karenina* in this way:

> In *Anna Karenina*, the sense of destiny is possibly even stronger than in *War and Peace*, since the story revolves around individual passion rather than collective history. At the very beginning of his great love story Tolstoy makes us feel that the two lovers are doomed. . . . Anna's passion is not condemned by the sixth commandment, but by the order of nature itself – by universal entropy, one is tempted to say – since a happy fulfillment of her love would mean that the moral and social weight of what has already happened (Anna's life as wife, mother, and society woman) can be nullified. In this sense, *Anna Karenina* reveals Tolstoy's fundamentally tragic outlook (his rediscovery of Fate and Nemesis in a modern context) even more clearly than *War and Peace*. At a time when European man was utterly confident in his ability to shape his own future, the rediscovery of Fate was also the rediscovery of wisdom. The kind of wisdom Tolstoy was looking for, and which, of course, he failed to find, cannot be found just because one is looking for it, and certainly not where one thought one could find it; such wisdom is the result of spiritual growth, and cannot be derived from any given system.[28]

Hence, Lessing found in Tolstoy – and his contemporaries – a model for the kind of searching in which her own Anna is engaged.

Indeed, her own philosophical musings take Lessing, in her disenchantment with a vision of the future of humankind based on history, away from realism in her fiction into the fantasy of science fiction as an expression of hope based not on history – not in the progress of 'things to come' in H. G. Wells's sense, but, perhaps like Tolstoy, in nature and in the evolution of humanity – in the sense George Bernard Shaw dramatized in *Back to Methusaleh* – as the only way out of the disaster of late twentieth-century civilization. In seeking fictional 'realism' on her

own terms, Lessing, thus, is probing the problem of an individual's alienation from grounding her identity on the failed concept of History. No wonder, then, that the reader's encounter with *The Golden Notebook*, the novel emanating as it does out of Lessing's late twentieth-century realization of the predicament of History, is disorienting. The reader finds this novel of ideas posing – at the political level – the alienating dilemma anticipated or announced by Tolstoy in his fictional and philosophical ruminations on History, defined by Nordau in his conception of 'degeneration', and, finally, protested by Lukács in a kind of desperate effort in *The Historical Novel* to save the genre of fiction by looking back to the origins of the problem in the nineteenth century, a direction followed by Lessing in creating her twentieth-century Anna.[29]

Anna in her search for order also finds the old psychology, Freud's psychology, breaking up, and the process of her disillusionment with it parallels that of her break with Marxism. This is revealed both in Anna's notebooks and in her novel. *Free Women* initially expresses her frustration with the theory in the cynicism of 'Anna' and Molly as they discuss their psychiatrist, 'Mother Sugar'. For them, the nickname conveys both the childishness of the ritual of analysis and the inadequacy of its attitude, 'a whole way of looking at life traditional, rooted, conservative, in spite of its scandalous familiarity with everything amoral' (5). Psychiatrists, like Marxists, are victims of History; they can only stereotype their patients, 'You're Electra' or 'You're Antigone' as 'Anna' recalls, in the setting of the Freudian theatre of the consulting office: 'the big room, and the discreet wall lights, and the Buddha and the pictures and the statues' (5). 'Anna's' description merely mirrors the intellectual inefficacy of her author Anna's own experience in going to Mrs. Marks. She goes, unwilling to admit that she has writer's block, claiming to need help in getting in touch with her own feelings and in discovering real direction, but she finds a 'Mother Sugar, who is nothing if not a cultivated woman, a European soaked in art, uttered commonplaces in her capacity as witch-doctor she would have been ashamed of if she were with friends and not in the consulting room' (62). Mrs. Marks, like Marx, must depend on History and on 'continuity' to define the forms and shapes of her patients' symptoms. This belief in continuity is clarified in the life of Anna's *alter ego*, 'Ella', who argues with her lover, the psychiatrist Paul Tanner, over its significance. When Paul asserts that 'there's a continuity, some kind of invisible logic to what

happens', 'Ella' replies, 'A continuity isn't necessarily right, just because it's a continuity' (190). The problem with psychiatry is that its historical basis is no longer realistic enough for addressing life in the mid-twentieth-century; in the terms of the artist, the form – of History – and the content – of Life – have diverged too much, as Anna tries to explain to Mrs. Marks who insists that 'the details change, but the form is the same'. Anna protests, 'I believe I'm living the kind of life women never lived before', not just in being an artist-woman who is independent and who has sexual freedom, but because the historical situation is new:

> 'I don't want to be told when I wake up, terrified by a dream of total annihilation, because of the H–bomb exploding, that people felt that way about the crossbow. It isn't true. There is something new in the world. . . . And I don't want to be told when I suddenly have a vision (though God knows it's hard enough to come by) of a life that isn't full of hatred and fear and envy and competition every minute of the night and day that this is simply the old dream of the golden age brought up to date . . . because the dream of the golden age is a million times more powerful because it's possible, just as total destruction is possible. Probably *because* both are possible.'

Anna wants to find and to learn about the new, not receive a codification of the old: 'I want to be able to separate in myself what is old and cyclic, the recurring history, the myth, from what is new, what I feel or think that might be new' (472-73). Around her she sees others who are also seeking this ineffable 'new', telling Mrs. Marks about a man she met at a party, 'there's a crack in that man's personality like a gap in a dam, and through that gap the future might pour in a different shape – terrible perhaps, or marvellous, but something new' and that 'sometimes I meet people, and it seems to me the fact they are cracked across, they're split, means they are keeping themselves open for something' (473). In 'The Shadow of the Third', Anna's perception is almost parodied in the figure of Cy Maitland, the American brain surgeon who specializes in leucotomies, and who brags to 'Ella', 'Boy, I've cut literally hundreds of brains in half!' (328). Anna is discovering her age to be that of R. D. Laing's divided self, an age of schizophrenia,[30] and the fragmentation of her intellectual and emotional life into its various subplots and parallels for fiction is appropriate to such a psychology in such a time.

Rejection in *The Golden Notebook* of the two fundamental twenti-eth-century myths of Marx and Freud culminates in the short novel about the Algerian soldier handwritten at the end of the Golden Notebook by Saul Green, which is his continuation of the first sentence given him by Anna. It is presented in brief synopsis form by the Author – delineated from the rest of the notebook by brackets. The story tells of an Algerian soldier conversing for long hours through the night with one of his French prisoners, a young student – the situation reflects those of Comrade Ted and Comrade Harry recorded in Anna's Red Notebook. Declaring him-self in an 'intellectual prison-house', the French intellectual tells the Algerian how he 'recognised, had recognised for years, that he never had a thought, or an emotion, that didn't instantly fall into pigeon-holes, one marked 'Marx' and one marked 'Freud'. His thoughts and emotions were like marbles rolling into predetermined slots . . . he wished that just once, just once in his life, he felt or thought something that was his own, spontaneous, undirected, not willed on him by Grandfathers Freud and Marx' (642–43). When the Commanding Officer finds the Algerian and the Frenchman conversing, he orders them both shot at dawn. Set off as it is as a summary by the Author, Saul Green's novel becomes an allegory about the inadequacy of worn-out ideas in the present world of violence and madness as well as about the pressures in the 'intellectual prison-house', those of History and Continuity, to preserve them.

To break out of this prison-house is to find the new theoretic form of life that Anna seeks. She is, as Blackmur describes Anna and Levin, indeed having a great personal adventure in the creation of order, and in her case, as a writer, she finds the means through her fiction. The materials that she assembles – *Free Women*, her diaries, her clippings – constitute an array of documents out of which to form order, and they range in content from truth to fiction and from the authentic to the inauthentic. When Mrs. Marks comments, 'I understood that you people insisted on separating form and content?', Anna replies, 'My people may separate them, I don't' (474). Anna's goal, like her Author's, is to find form and meaning for her life and art while eschewing the old myths of Marx and Freud, and her success in her adventure must come through her role as artist, in the heroism of sorting out the differences in the materials of her life, in knowing what to keep and what to eliminate. Finally, that which is significant is synthesized in the

special notebook, the Golden Notebook that she shares with Saul Green. The act of discrimination begins with upholding the difference between the authentic and the inauthentic in art; the problem is to maintain any reasonable critical discrimination in an anti-intellectual and conservative environment. As the reader first encounters it, the Black Notebook is literally split in half with Anna's real experiences in Africa, the basis for her first novel, *Frontiers of War*, recorded on one side under the heading 'Source' and the efforts of various film and television representatives to convince her to change it for their purposes recorded on the other side under the heading 'Money'. Indeed, the Black Notebook begins with Anna's synopsis, written tongue-in-cheek, of her novel titled *Forbidden Love* which had, in fact, been approved by the synopsis desk of her agent. This parody with its tone of breathless melodrama and mockery of real relationships sets a standard of the inauthentic in narrative, especially by its juxtaposition in the notebook against Anna's enthralling journal of life at Masahopi. The 'Money' side of the notebook is later filled with Anna's hilarious accounts of encountering media people who want to exploit her novel, one wanting to set it in England to make another version of *Brief Encounter*, another wanting to treat it as a musical using stage sets. The efforts of these commercial philistines are governed by economics – shooting in Africa is too costly – and by convention – seeking to pigeon hole the plot according to their notions of popular taste. In another section of the 'Money' side of her notebook, Anna, in response to a request that she receives from a literary magazine asking to publish a portion of her journals, begins to create the imaginary journal of a young American writer, son of an insurance executive, who is playing the expatriate in Paris and London; with help from an American writer friend, James Schafter, who finishes it (anticipating Saul Green's role in the Golden Notebook), the parody is published. Anna and James immediately compose another acceptable parody journal, 'as written by a lady author of early middle-age, who had spent some years in an African colony, and was afflicted with sensibility' (437). Anna also pins into her notebook a carbon copy of a story written by Schafter which is a pastiche of the clichés found in African stories; when it, too, gets accepted for publication, they triumphantly give up their literary jokes.

Unfortunately for Anna, a lack of taste and intelligence is not confined to the world of capitalist values; she finds it as well in

the Communist Party, which contributes directly to her disillu-
sionment and break with it. Reviews of her novel, *Frontiers of
War*, in Communist journals, bound as they are by ideological bias,
seem to Anna to be parodies, and she collects them in her Black
Notebook alongside the parodies done with Shafter. A meeting of
the writers' group of the party seems to Anna 'nonsense' when the
members discuss a pamphlet on linguistics by Stalin, the group in its
intellectual discomfort adopting 'a sort of comfortable philistinism'
(301). Finally, the failure, because of ideology, to exercise critical
discrimination by the Communist publishers for which Anna reads
manuscripts manifests itself in her psyche as a recurring nightmare.
In it, she sees a man who is about to be executed by a firing
squad when fighting suddenly breaks out in the street. When the
commanding officer discovers that his side has lost, he unties the
prisoner and takes his place. As the two exchange places before the
former prisoner has the officer executed, they smile at one another;
for Anna, this is 'the moment of horror in the nightmare' because
that smile 'cancels all creative emotion' (345). When Anna reviews
two manuscripts, one of which she finds to be honest and the other
dishonest, and the publishing house for ideological reasons accepts
both, Anna's disillusionment as an intellectual with the Party cul-
minates in her bitter denunciation of one of her comrades:

> 'What you've said sums up everything that is wrong with the
> Party. It's a crystallisation of the intellectual rottenness of the
> Party that the cry of nineteenth century humanism, courage
> against odds, truth against lies, should be used now to defend
> the publication of a lousy lying book by a communist firm which
> will risk nothing at all by publishing it, not even a reputation for
> integrity.' (348)

Anna's difficulty with the politics of Marxist publishing is mirrored
in the problem of psychology encountered by 'Ella' in selecting
stories for the magazine, *Woman at Home*. She cannot bring herself
to purchase a story that she is sent to Paris to buy knowing that it
'is so French in flavour that we would have to have it re-written'.
As 'Ella' knows, 'The stories written for women's magazines are
always psychologically correct. But the point is, on what level are
they correct?' (310).

One of Anna's dreams defines her role as an artist in such a politi-
cally and psychologically limiting environment, its source seeming

to be from another frustrated artist, William Blake. The dream is an allegory of Anna's efforts to create in such an environment as well as an assertion of her will to succeed at it. She pictures herself carrying a crystal casket containing her work through an art gallery or lecture hall 'full of dead pictures and statues'. She thinks that she is taking something precious to her audience, but when it turns out to be 'all businessmen, brokers, something like that' she feels like she is in a farce and finds in her casket only a 'mass of fragments, and pieces' that remind her of violence throughout the world. The experience suggests that of Blake's 'Crystal Cabinet' which contains a vision of 'Another England' and 'Another London' until it shatters. Anna gives the casket to the audience of capitalists, and when they open it they delighted to find 'a small green crocodile with a winking sardonic snout' made of jade or emeralds with tears that turn to diamonds running down its cheeks. After telling this dream to her psychiatrist, Mrs. Marks, Anna, upon seeing her own reflection in a shop window, finds 'there was a wry look on my face which I recognised as the grin on the snout of that malicious little green crocodile in the crystal cabinet of my dream' (252–253). The image reminds one of the wry smile on the face of the serpent that decorates Blake's title-page for his poem on revolution, *Europe* (1794). Hence, in Anna's society and in her imagination, politics and psychology forge limits to creativity, limits that she seeks, furtively and slyly like Blake, to evade and to escape.

Anna cannot escape them entirely, and, while she is successful on her own terms in finally writing a second novel, *Free Woman*, it is a far more conventional work than *The Golden Notebook*. Indeed, in juxtaposing parody against autobiography at the beginning of The Notebooks, Lessing seems to be warning the reader to distinguish between Anna's novel and the Author's. *Free Woman*, while having an original conception in portraying honestly the lives of liberated women living alone in a stultifying society, nevertheless shows some of the limitations of the conventional 'well-made' novel. There is a sense of the inauthentic about it, of trying too hard in the writing to achieve a sense of order. Its Modernist plot is structured, like T.S. Eliot's plays or James Joyce's novels, by analogy to classical myth. There is a quality of melodrama, inevitably arising from the Oedipal source, in the pivotal event of Tommy's attempted suicide and blinding, and even a sense of soap-opera in the presentation in which the narrative is suspended at the moment of crisis. The ending of the novel, too, in which 'Anna' gives up writing for a

job in a marriage counsellor's office, taking her place in society like her friend Molly, who performs as an actress, and like Tommy, who takes a position in his father's business, is conventional, indeed, even bourgeois in a Marxist sense; it is reminiscent of the acceptance of things as they are at the end of a novel like Alan Sillitoe's *Saturday Night and Sunday Morning*. Incidents such as those in which 'Anna' and Molly buy strawberries from a man on the street and 'Anna's' struggle to bring herself to evict her homosexual boarders seem contrived. The style of *Free Women*, also, blatantly directs the reader in too forceful a manner to consider its themes, as in 'Anna's' very first words, '"The point is . . . the point is, that far as I can see, everything's cracking up"' (3), or the overstatement of Tommy's problem in the stilted phrase, 'paralysis of the will' (262). In these ways, then, *Free Women*, while original in content and even competent in form, is not 'realistic' enough; it is a parochial work derivative of Modernist tradition. As Lessing admits in her introduction, 'To put the short novel *Free Women* as a summary and condensation of all that mass of material, was to say something about the conventional novel, another way of describing the dissatisfaction of a writer when something is finished' (xiv). For Lessing, the word 'finished' in this instance may mean not only 'complete', but 'too well-designed', to the point of being somewhat lifeless – creativity limited to the level of that achieved by contemporaries like the Angry Young Men.

The Golden Notebook, as 'a book which would make its own statement, a wordless statement: to talk through the way it was shaped' (xiv) is something quite different, and the novel as a whole is experienced in reference to the novel in part, *Free Women*. Readers feel a loss of restriction and sense of liberation as they move from the enclosed rooms that are the setting for *Free Women* into the vaster, more authentic world of 'The Notebooks' that freely express Anna's mind.[31] Her fiction even after she overcomes her writer's block – and this is a triumph of Lessing's creativity – cannot attain the vision desired by her own aspiration and imagination: that must be found by the reader in the notebooks as a whole. Just as when the reader moves from *Free Women* into the notebooks for the first time in *The Golden Notebook* and feels a sense of liberation, this feeling intensifies through the novel as the subplots and parallels, foreshadowings and references emerge from the various documents of a writer's life. Therefore, to appreciate *The Golden Notebook* the reader's own consciousness must expand beyond conventional expectations for reading a novel, expectations addressed

adequately by *Free Women*, to discover amid the superficial untidi-
ness and disorder Lessing's 'realism' of a higher order. This order,
too much to comprehend at first or even at first reading, leads to
a climax in the Golden Notebook that coalesces the whole of *The
Golden Notebook* and brings forth unifying, though not necessarily
definable or definitive, vision.

For Anna, vision begins in nostalgia, in the evocation in the Black
Notebook of the African world of her youth. It begins when the
imagination starts to recognize opportunities for fiction, art begin-
ning to create a perspective or a version of life. Anna finds it in
reading over her reminiscence of Masahopi: 'It's full of nostalgia,
every word loaded with it, although at the time I wrote it I thought
I was being "objective"' (153). The lengthy narrative of Africa at the
beginning of the Black Notebook with its rhapsodic poeticization of
experience contrasts sharply in style with *Free Women*. While the
world of Anna's novel is like a play by Pinter in its 'claustrophobia'
(13), paralysis, sterility, and failure in creativity, the presentation of
Africa is like a novel by Lawrence in its freedom and passion, and
in being the 'Source' for creativity. At Masahopi not only does Anna
become fully aware for the first time of her own powerful sexual
feelings, but she is part of a world of sexual release in the face of war
and death. As Anna describes the setting, 'It was the early part of the
war; they were waiting to be called up; it was clear in retrospect that
they were deliberately creating a mood of irresponsibility as a sort
of social protest and sex was part of it' (75). Amid this atmosphere,
the budding novelist in Anna is first aroused when she responds to
the settler George Hounslow in his anguish over his affair with the
native cook's wife:

> Looking back I want to laugh – because I automatically chose to
> argue in literary terms . . . 'Look,' I said, 'In the nineteenth cen-
> tury literature was full of this. It was a sort of moral touchstone.
> Like Resurrection, for instance'. (130)

The configuration of passion with creativity culminates on the last
weekend at Masahopi when Anna, impulsively, runs away from the
dance with Paul and makes love with him in the grass. Lost in the
darkness, the couple cannot find their way back to the hotel, and
they spend the night on a hilltop awaiting first light. When dawn
comes, they find themselves to be in a place which is a primitive
shrine to art:

And now we could see that the rock we sat on was the mouth of a small cave, and the flat rock wall at its back was covered with Bushman paintings. They were fresh and glowing even in this faint light, but badly chipped. . . . 'A fitting commentary to it all, dear Anna, though I'd be hard put to it to find the right words to explain why, in my present state'. He kissed me, for the last time, and we slowly climbed down through the tangles of sodden grass and leaves. (150)

It takes a final element in the experience to transform it into the material for fiction: the shocking confrontation with the fact of death. A few days after Anna makes love with Paul, he is killed when he walks into the propeller of a just landed airplane. Hence, in configuring passion and death, even in the symbolism of his name, 'Blackenhurst', Paul rather than Anna's closer friend in Africa, Willi Rodde, becomes the model for the 'gallant young pilot' who is the protagonist of *Frontiers of War*. Both his name and his fate dictate Anna's choice of the Black Notebook in which to describe her 'Source'.

In the middle of *The Golden Notebook*, separate from Anna's initial reminiscence of Africa, is a passage from the Black Notebook recording a kind of epiphanic incident from the Masahopi days that epitomizes the whole of that Lawrencian idyll. Anna's recollection is triggered when she witnesses in London an incident in which a man rushing to his bus kicks a pigeon and kills it. The incident disturbs Anna, she even dreams of it, and it reminds her of a weekend at Masahopi when her group went out from the hotel to shoot pigeons for a pie. They encounter an incredible scene of the instinctual sexuality of nature in finding millions of intensely-coloured grasshoppers copulating. Paul reminds the friends that underlying this natural plenitude is its contrary, death:

'As is well-known, I say, nature is prodigal. Before many hours are out, these insects will have killed each other by fighting, biting, deliberate homicide, suicide, or by clumsy copulation. Or they will have been eaten by birds which even at this moment are waiting for us to remove ourselves so that they can begin their feast'. (418)

The same day, while Paul shoots pigeons, the others watch the silent war being carried on in the tiny pits of insect ant-eaters as

they destroy their prey, a microcosm of the human world around them on the brink of war. Going back to the hotel, the friends all become slightly sick at the smell of the blood of the dead pigeons, and, thereafter, Anna finds the smell of blood with its connotation of death to be repugnant. The incident implicitly explains a passage recorded earlier in Anna's notebooks in which she is meditating on the artistic problem of 'being truthful in writing (which is being truthful about oneself)' (340) and complains that she cannot describe a woman's menstruation as authentically as James Joyce had described defecation:

> It is the only smell I know of that I dislike. I don't mind my own immediate lavatory smells; I like the smell of sex, of sweat, of skin, or hair. But the faintly dubious, essentially stale smell of menstrual blood I hate. And resent. (340)

Blood, then, especially the stale residual odour of menstrual blood, inevitably evokes for Anna the day of the pigeon hunt, a day marked by her discovery of the paradox of the natural inter-relationship of fecundity and death.

For Lessing, while passion is the human resistance to death, creativity is the artist's protest against it. Anna may write about Tommy who attempts suicide in *Free Women* and 'Ella' who writes a novel about suicide in 'The Shadow of the Third', but she herself seeks to sustain love and creativity, and her affirmation occurs in the Golden Notebook. Like the dream of a golden age which, as Anna tells Mrs. Marks, depends on the very possibility of destruction, the Golden Notebook is a record of the vision that must complement the nostalgia which is the 'Source' for her art in the Black Notebook. In Tolstoy, Anna Karenina's end is despondency and suicide and Levin's philosophical speculation; in Lessing, Anna embodies the spirit of both her antecedents in fiction in her 'death' by passion that leads to her awakening, to her resurrection, as an inspired writer ready to create *Free Women*.

Like Anna Karenina, Anna 'dies' out of love. Anna's passion for Saul Green becomes the means for annihilating her stifled self:

> Then there was a moment of knowledge. I understood I'd gone . . . right inside his craziness: he was looking for this wise, kind, all-mother figure, who is also sexual playmate and sister; and because I had become part of him, this is what I was looking

for too, both for myself, because I needed her, and because I wanted to become her. I understood I could no longer separate myself from Saul, and that frightened me more than I have been frightened. (587)

In a sense Anna and Saul are female and male forms of the same person: both are writers, both keep journals, both have leftist political commitments, both seek personal freedom. They are doubles for one another; after falling in love with Saul, Anna finds she cannot 'summon up' other 'Annas' (592). Indeed, she finds herself ready to give up her four notebooks, telling Saul, 'it's been necessary to split myself up, but from now on I shall be using one only' (598), and she purchases the Golden Notebook – unique in its manufacture (605) – to which she and Saul both, as one, will contribute. In the presence of Saul, an intellectual side of Anna – the 'Levin' in her – emerges which seeks to unite objective everyday experience with philosophical concern for the place of human beings in the cosmos. Initially, this aspiration takes the form of a 'game' that she first tried as a child; in playing it, she attempts within her mind to unite imaginatively the small world that she experiences directly with the vast universe about which she can only fantasize:

> First I created the room I sat in, object by object, 'naming' everything, bed, chair, curtains, till it was whole in my mind, then move out of the room, creating the house, then out of the house, slowly creating the street, then rise into the air, looking down on London, at the enormous sprawling wastes of London, but holding at the same time the room and the house and the street in my mind, and then England . . .

As mental traveller, she eventually moves out into space where she 'watched the world, a sunlit ball in the sky, turning and rolling beneath me. . . . Sometimes I could reach what I wanted, a simultaneous knowledge of vastness and of smallness' (548). This Blakean game is, in fact, the game of art conceived at the highest level of achievement to be an act of unification, and Anna's inspiration to play is appropriate imaginative preparation for keeping only one notebook to be the 'source' for a new novel.

The coalescence of Anna and Saul clarifies other anxieties. Anna has long been bothered by a recurring nightmare in which she is menaced by a dwarf in various shapes – her notebooks record

several versions of the dream, and she initially defines the figure as the 'anarchic principle' (250). Suddenly, because of her passion for Saul the meaning of the dream is clear:

> I was the malicious male-female dwarf figure, the principle of joy-in-destruction; and Saul was my counterpart, male-female, my brother and my sister . . . There was a terrible yearning nostalgia in the dream, the longing for death. We came together and kissed, in love. It was terrible, and even in the dream I knew it. Because I recognized in the dream those other dreams we all have, when the essence of love, of tenderness, is concentrated into a kiss or a caress, but now it was the caress of two half-human creatures, celebrating destruction. (594–95)

When Saul awakens passionate, Anna discovers 'in the love-making was the warmth of the love-making of the dream' (595). Later, viewing Saul standing at her door, Anna associates him with an ancient mythological embodiment of vital force:

> I saw the white door with its old-fashioned unnecessary mouldings, very clear. I thought how the mouldings on the door recall a Greek temple, that's where they come from, the pillars of a Greek temple; and how they in turn recall an Egyptian temple, and that in turn recalls the bundle of reeds and the crocodile. (598)

For Anna in her vision of the creative principle, Saul is ultimately a kind of Osiris to her Isis, male and female principles that merge in every conceivable fashion, familial and sexual, as an emblem of maintaining the fertility of the land. Their union has become mythic; therefore from it can come a sacred book, a 'golden' one containing the secret of their mutual creativity protected appropriately by a curse:

> Whoever he be who looks in this
> He shall be cursed,
> That is my wish.
> Saul Green, *his* book.(!!!)

Though only an 'old schoolboy's curse', it is appropriate protection for the notebook in which Anna resolves to begin anew, whole

and inspired: 'I'll pack away the four notebooks. I'll start a new notebook, all of myself in one book' (607).

The Golden Notebook is a Contemporary testament to the mythic rites of creativity that blend death and renewal. It is an effort by Lessing to describe what in usually indescribable, the most intense crisis of the psyche, an identity crisis, and even Anna as a writer (echoing Yeats's Old Man in *The Death of Cuchulain*) acknowledges that it is the kind of experience usually avoided by an author: 'The fact is, the real experience can't be described. I think, bitterly, that a row of asterisks, like an old-fashioned novel, might be better. Or a symbol of some kind, a circle perhaps, or a square. Anything at all, but not words' (633). Lessing's creation of the Golden Notebook is the equivalent, for example, of trying to portray Anna Karenina's consciousness as she flings herself under the train, the moment being presented by Tolstoy with a discreet ellipsis ('"God forgive me everything!" she said, feeling the impossibility of struggling . . .').[32] Therefore, even for the reader of *The Golden Notebook*, who has already encountered in it a variety of narrative styles, reading the Golden Notebook is still disorienting. It is dream taken to extreme, the ultimate dream of self-discovery that is the culmination of all of Anna's other dreams which have been false-starts and anticipations of it. In style it has the aura of its time and place in the early 1960s, a 'trip' displaying the characteristics, but without the origins, of the hallucinogenic and the psychedelic. But, once again, like the referential structure of the novel as a whole, the Golden Notebook depends on old-fashioned fictional technique, stream-of-consciousness particularly as shaped by the experience of cinematic montage, and it is organized to lead to a conclusion, Anna's start on her novel, *Free Women* (and Saul's short novel set in Algeria).

The Golden Notebook is an account of Anna Wulf's rebirth as an artist. In it, she describes how her sense of chaos and paralysis – the 'Anna Karenina' in her – is overcome by her sense of artistic ordering and philosophy – the 'Levin' in her. Anna and Saul are mutually dependent on each other through the process, which occurs within the period of a day. Saul embodies for Anna the voice that has always been inside her urging her toward integration for her life – 'the disinterested personality who had saved me from disintegration' (616) – as she describes it, and when her process of rebirth ends she assists him in his; the notebook concludes with both having new beginnings not only for their writings but for

their lives. It begins with Anna's happiness in sleeping with Saul, her flat, once so claustrophobic, becoming, in his words to her in bed, 'an extraordinary room . . .like a world' (611). To her, it is now a light, warm place in which, no longer feeling fragmented, having abandoned her four notebooks, she can began really to play 'the game', not just projecting herself into other 'Annas' like 'Ella' formed out of her ego, but imaginatively reaching states of mind alien to her very being:

> This feeling of being alien to my own body caused my head to swim, until I anchored myself, clutching out for something, to the thought that what I was experiencing was not *my* thought at all. I was experiencing, imaginatively, for the first time, the emotions of a homosexual. (612)

In her night-passage, dreaming for Anna is like a visit to a cinema where she confronts a montage of images created out of her old anxieties; she identifies Saul with the disinterested projectionist who takes her through the experience urging her not to drown in 'subjectivity, yourself, your own needs' but 'to fly. Fly' (614–15) in resolving her fears. Consequently, her dreaming reveals a new confidence and an emerging understanding of herself. She escapes from a roaming tiger, that she associates with Saul, with only a slash on the arm that quickly heals. She envisions the Masahopi Hotel covered with white butterflies which even when it turns into the image of a hydrogen bomb explosion remains beautiful: 'a white flower unfolded under the blue sky in such a perfection of puffs, folds and eddying shapes. . . . It was unbelievably beautiful, the shape of death' (617). By successfully confronting these images, Anna is coming to terms with her fears of personal commitment in love and of the threat in the Cold War of instantaneous devastation.

As the montage continues, Anna defines a new philosophy of life. Michael, the communist refugee who had been her lover for five years, and Paul Tanner, the psychiatrist lover of 'Ella' who is his analogue in 'The Shadow of the Third', merge together in her dream to form a single figure who presents to Anna the essential wisdom, the central idea of life, that she needs to complete her self-discovery:

> 'But my dear Anna, we are not the failures we think we are. We spend our lives fighting to get people very slightly less

stupid than we are to accept truths that the great men have always known. . . . They have always known that violence breeds violence. And we know it. But do the great masses of the world know it? No. It is our job to tell them. Because the great men can't be bothered. Their imaginations are already occupied with how to colonise Venus; they are already creating in their minds visions of a society full of free and noble human beings. Meanwhile, human beings are ten thousand years behind them, imprisoned in fear. The great men can't be bothered. And they are right. Because they know we are here, the boulder-pushers. They know we will go on pushing the boulders up the lower slopes of an immensely high mountain, while they stand at the top of the mountain already free. All our lives, you and I, we will use all our energies, all our talents, into pushing that boulder another inch up the mountain. And they rely on us and they are right; and that is why we are not useless after all.' (618)

This version of the myth of Sisyphus is the necessary wisdom that Anna needs to continue and to create.[33] It is her substitute for the major visions of human existence by Marx and Freud that she has already rejected; the dream represents her recognition that she will not reach the top of the mountain to be among the great men. She will not find nor achieve through her art a new father-figure for civilization; she must content herself in being a boulder-pusher.

This idea, this moral, of Anna'a rebirth is linked by the appearance in her dream of Paul Tanner to 'The Shadow of the Third' where the philosophy has been foreshadowed at the end of 'Ella's' narrative. In the episode, 'Ella' visits her old father who lives in isolation in Cornwall and discovers that he writes poems for his own pleasure. 'Ella' is amazed that he can be contented with such private creativity and his simple life, explaining to him her belief – being the writer Anna's *alter ego* – that people should 'be prepared to experiment with ourselves, to try and be different kinds of people'. Her father answers that he finds it 'bad enough to cope with what one is, instead of complicating things even more' (466). The conversation with her father inspires in 'Ella' an idea for a story that anticipates Anna's discovery of her philosophy of the Golden Notebook:

A man and a woman – yes. Both at the end of their tether. Both cracking up because of a deliberate attempt to transcend

their own limits. And out of the chaos, a new kind of strength. (467)

'Ella's' idea is essentially the plot that leads to wisdom in the Golden Notebook. In it, Anna awakens, transformed, from her cinematic dreaming to proclaim to Saul her vision of the boulder-pushers:

> 'There's a great black mountain. It's human stupidity. There are a group of people who push a boulder up the mountain. When they've got a few feet up, there's a war, or the wrong sort of revolution, and the boulder rolls down – not to the bottom, it always manages to end a few inches higher than when it started. So the group of people put their shoulders to the boulder and start pushing again. Meanwhile, at the top of the mountain stand a few great men. Sometimes they look down and nod and say: Good, the boulder-pushers are still on duty. But meanwhile we are meditating about the nature of space, or what it will be like when the world is full of people who don't hate and fear and murder.'

When Saul says he wants to be one of the great men on top of the mountain, Anna replies, 'Bad luck for both of us, we are both boulder-pushers'. Saul, tiger-like, explodes in anger, sputtering 'I, I, I, I, like a machine-gun ejaculating regularly' (627–28) in being confronted with this idea that attacks his sense of ego; he cracks up, paralleling Anna's earlier state of mind, and she, in turn, must comfort him in his discovery of the naked truth. Hence, Anna emerges from her night-passage having freed first herself, then Saul, of the limits imposed by ego, and she is ready with his help to give up the old shape of her life for a more realistic one. This change, too, is marked by dream:

> As soon as the dream came on, the projectionist said, in Saul's voice, very practical: 'And now we'll just run through them again.' I was embarrassed, because I was afraid I'd see the same set of films I had seen before – glossy and unreal. But this time, while they were the same films, they had another quality, which in the dream I named 'realistic'; they had a rough, crude, rather jerky quality of an early Russian or German film. Patches of the film slowed down for long, long stretches . . . The

projectionist kept saying, when I had got some point he wanted
me to get: 'That's it lady, that's it.' And because of his directing
me, I watched even more emphasis, or to which the pattern of
my life had given emphasis, were now slipping past, fast and
unimportant. (634)

When this European-style cinema of the psyche ends, ideas for
stories pour from Anna's imagination as they had from 'Ella's'
after she visited her father. Anna is ready to write her novel, not
one that will achieve the heights of the 'great men' to which in her
egotism she had aspired previously, but a book that at least will be a
credit to the boulder-pushers and show that they are still at work. As
Anna and Saul in creative union at the end of the Golden Notebook
exchange first lines for stories, she is free – free of ego, free of self,
free of the other Anna, the destructive 'Anna Karenina' in her, free
to write *Free Women*.

In Lessing as in Tolstoy, it is only the philosophical person, the
person with ideas, who can endure creatively in a world of violence.
Both Anna and Levin must learn to cope with the lost beliefs of their
epochs: Anna with Politics and Psychology, Levin with Religion and
History. Both await the appearance of new orders that they so much
desire; in the meantime, caught in cultural interregna, they must
cope, like 'Ella's' father in Cornwall, with what they have, curbing
their aspirations for the ideal. There can be no golden age, only a
Golden Notebook. Anna's idea, hardly a philosophy, of the wise
men on the mountain remains vague; the figures seem like the
'Eternals' envisioned by William Blake in his prophecies who reside
beyond the disorganized human world, watching the artist-figure,
Los, that Romantic boulder-pusher, to make and keep some order in
struggling to build the new Jerusalem. The late twentieth-century
writer, Anna, tries, too, composing in her workmanlike fashion
a second novel, her room becoming the world of her characters,
'Anna' and 'Molly' and 'Richard' and 'Marion' and 'Tommy' and
'Ivor' and 'Milt'. Having accepted her boulder-pusher's lot, there
is little else that Anna can do. Lessing's reader feels the lack of
an ending to her novel, *The Golden Notebook*, the completion of
Anna's novel, *Free Women*, not seeming sufficient. Tolstoy had the
same trouble in ending his novel without being able to describe
a new order for the late nineteenth-century. At the end of *Anna
Karenina*, it is a time of disaster and war, Anna is dead and her
beloved Vronsky is leaving for the Russo-Turkish War, but Tolstoy

does not end with their fate but with Levin and his wife Kitty at home on their estate. Levin is calmly and happily watching the sky during a thunder storm at night, speculating on the meaning of life. He has an idea, a vague doctrine of 'goodness', that he intends to develop; he is content.[34] At the end of *The Golden Notebook*, it is also a time of chaos, but Lessing leaves us with Anna and Saul in her room discussing their stories. She has an idea, the vague doctrine of the boulder-pushers that she intends to develop; she is content. For Levin, for Anna, their 'great personal adventures in the creation of order' are finished; the novels about their lives are complete. But, for the Author, for Lessing, one novel can only be the beginning of another as she remains in search of the eternal wise men on the mountain, always eager to play 'the game' of art as high as it will take her into the philosophical heavens.

8

The Contemporary English Epic: Fowles

I know of no better image for the ideal of a beautiful society than a well executed English dance, composed of many complicated figures and turns. A spectator located on the balcony observes an infinite variety of criss-crossing motions which keep decisively but arbitrarily changing directions without ever colliding with each other. Everything has been arranged in such a manner that each dancer has already vacated his position by the time the other arrives. Everything fits so skillfully, yet so spontaneously, that everyone seems to be following his own lead, without ever getting in anyone's way. Such a dance is the perfect symbol of one's own individually asserted freedom as well as of one's respect for the freedom of the other.

> Letter from Schiller to Korner,
> 23 February 1793, quoted by Paul de Man,
> *The Rhetoric of Romanticism* (1984)

Daniel Martin is an epic novel about a writer's effort to write an epic novel that turns out to be *Daniel Martin*. As epic, the novel displays the conventions defined by Homeric tradition modified by the artistic self-awareness of a late twentieth century intellect; as novel, the epic presents the kind of contemporary realism defined by Lukács. It fulfills the function of novel in tracing the protagonist's progress toward self-recognition and the function of epic in presenting a history of the culture that the hero embodies and represents. In doing so, *Daniel Martin* becomes formally and contextually self-defining, both stating its ideology through its form as well as referring to it through its content.

Like Lessing's *The Golden Notebook*, Fowles's novel embodies the problem of finding an adequate aesthetic strategy for Contemporary

171

fiction. As early as 1940, George Orwell, in writing about Henry Miller, recognized the emergence of the dilemma for writers posed by the breakdown of belief in a literary culture. Looking at the upheaval around him and the kind of meaningless art emerging from it, Orwell saw 'a demonstration of the *impossibility* of any major literature until the world has shaken itself into its new shape'.[1] Given the situation, the form of Henry Miller's fiction intrigued Orwell: '*Tropic of Cancer* is a novel in the first person, or autobiography in the form of a novel, whichever way you like to look at it. Miller himself insists that it is straight autobiography, but the tempo and method of telling the story are those of the novel'.[2] *Daniel Martin* presents the same problem of definition, but from the opposite perspective: Fowles presents his work as a novel, but the tempo and method of telling the story are those of autobiography.

The reaction of a traditional reader to such unconventional fiction is predictable. Reviewer Jeremy Treglown, complaining that Fowles suffers from 'long-windedness and didacticism', demonstrates what he thinks is the paucity of the plot of *Daniel Martin* by sarcastically summarizing it (adequately, he thinks) in a few sentences and then questioning its eclectic form:

> The 704-page plot is easily summarised. While at Oxford, Dan slept with another undergraduate, Jane, whose twin sister Nell he subsequently married, Jane settling for a budding philosophy don, Anthony. The Dan–Nell set-up produces a daughter before it disintegrates; she will have an 'affaire', as Fowles calls it, with another Oxford contemporary of Ma and Pa. Meanwhile, Nell remarries – the husband being Oxford contemporary number six (I think), a landed lord – and Dan goes off with a film-actress the age of his own daughter. But as the generation game enters injury time, the stopwatch is put back by Anthony's melodramatic death, leaving room for a conclusion which, since few other readers are likely to reach it and you've guessed anyway, I have no hesitation in revealing: his widow Jane, who, you remember, was twin number one, shacks up with Dan in his childhood home.
>
> So what fills it all out? First, a very great deal of interpersonal discussion of interpersonal relationships. Second, many lengthy passages about the degeneracy of the media, the condition of England, the condition of America and related topics. Third, descriptive writing. And fourth, several parentheses in Dan's

sex life, including a scene with two Cockney sisters, this time simultaneously, and his sexual initiation with a farmgirl.[3]

Obviously, Treglown fails to discover any aesthetic vitality in Fowles's form; in contrast, George Steiner, has recognized the pioneering significance of such experimental works. Emphasizing how 'the pressure of the world grew implacable on the imagination' and rivals to the realism of fiction have arisen, particularly from journalism and autobiography, Steiner states:

> While most of the energies and inheritance of prose fiction are being assimilated by documentary forms, there is a small group of experimental works from which the poetics of tomorrow may emerge. These are the most exciting, least understood of modern books; in them, the classic divisions between poetry, drama, prose fiction, and philosophic argument are deliberately broken down. These works admit of no definition; they declare their own forms of being.[4]

Daniel Martin is a work of this kind, and, like *The Golden Notebook*, *The White Goddess*, and *The Country and the City*, it is a manifestation of the struggle to find, in Blackmur's phrase, 'new theoretic forms' for expression in a changing society.

Like Lessing in her fiction and Williams in his criticism, Fowles in his novel is committed artistically to finding a meaningful form for his times and expressing a creative self-consciousness that arises from the prevailing ideologies of his culture – an epic task. While Lessing confidently allows ideology to prescribe form, Fowles is far more tentative in his struggle to achieve a proper balance between theory and plot. Indeed, it is the very self-consciousness of the effort that instills a captivating vitality to the shape of his expression. Believing that a novel 'must have relevance to the writer's now', Fowles is troubled by the pressure to discover a new form. Acknowledging French writer Alain Robbe-Grillet's challenging question, '*Why bother to write in a form whose great masterpieces cannot be surpassed?*', Fowles feels that this 'obsessive pleading for new form places a kind of stress on every passage one writes today. To what extent am I being a coward by writing inside the old tradition? To what extent am I being panicked into avantgardism?' Therefore, Fowles wants to uphold, even while experimenting, what he finds to be the traditional purposes of

the genre, 'to entertain, to satirize, to describe new sensibilities, to record life, to improve life, and so on'.[5] Consequently, while Fowles in *Daniel Martin* has written an epic about being English in our time, one which, following Lessing's lead, partakes in the ideology of its form from Lukács' theory of the novel, a bourgeois epic embodying a Marxist perception of culture, the novel does not necessarily express commitment to such a political paradigm. Indeed, the careful distinction made within the novel between the protagonist Dan's intellectual curiosity about the ideas of Lukács and the Italian Marxist Antonio Gramsci in contrast to his friend Jane's commitment to the politics of socialism indicates the skeptical manner in which theory should be understood in relation to its influence on the shape and meaning of the novel.

Daniel Martin is John Fowles's response to the challenge and inspiration of Lukács and the intellectual climate of his own time. Fowles's originality is in his going beyond the model of Lukács's historical novel and substituting a fictional life in place of autobiography. The character Daniel Martin is and is not the author John Fowles, but the form of the novel insists on the ambiguity, confusing character and author, subject and narrator. Daniel Martin even has a professional pseudonym, 'Simon Wolfe', that anagrammatically hints at the novel's authorship. The plot is structured in such a way as to look backward as well as to look forward – retrospectively and antecedently, and the narrative shifts tenses between third person and first usually mid-chapter and sometimes mid-sentence. This ironic way of seeing – intentionally disorienting but certainly directing attention to the issue of form – confuses the reader's usual orientation to the genre of the novel. Like readers of Lessing or of Graves or of Williams, he or she rightly asks: are we reading novel, biography, autobiography, literary or cultural criticism, or something else? The reader encounters Fowles playing with time and structure and style as a means of revealing not the development of his hero as much as the inner form of civilization in his time. Thus, the reader finds in Fowles a novelist who – in terms of Terry Eagleton's definition of Lukács' meaning – seeks to be a 'realist writer' who 'penetrates through the accidental phenomena of social life to disclose the essences or essentials of a condition, selecting and combining them into a total form and fleshing them out in concrete experience'.[6]

This kind of 'realism' impresses a self-consciousness on the artist that once and for all breaks with the traditional sense of aesthetic

decorum which attempts to maintain the formal illusion that art and life are separate. If the hero must be presented in such a manner as to place him amid the relationships of his society, then the author must acknowledge his own relationship to society and the ways in which he himself has come to be shaped by the values and opinions of his place and time. Consequently, author and subject must become obviously intermingled in a manner which is for the reader at first disorienting as the usual categories of discourse become intentionally confused: the personal with the impersonal, the real with the fictional, the autobiographical with the biographical. In aesthetic terms, the separation of art and life maintained in theory by the Renaissance 'mirror' and the Romantic 'lamp' gives way to the Contemporary 'open door' through which the personal enters the artistic.[7] Indeed, as Steiner recognizes, it is precisely those literary occasions when, by chance or design, the door between life and art is left open that are renewing; they provide a kind of epiphany because at these moments the abstraction and the alienation caused by contemporary society become comprehensible. *Daniel Martin* consists of innumerable personal references to John Fowles, but, specifically, the whole of the novel seems a vast elaboration on the theme of an essay published by him in 1964 called 'On Being English But Not British' in which he explains how 'for a decade now I have been haunted by the difficulty of defining the essence of what I am but did not choose to be: English'.[8] Appropriately, on the original American book cover of the novel the words of author and title are presented in identical type, mirror images of one another.[9] The novel as a whole embodies in the character of Daniel Martin John Fowles and his views on coming to terms with his country.

Within the context of Lukács' theory of the epic, Fowles writes his epic, and the plot of *Daniel Martin* acknowledges its heritage through being shaped by reference to Homer's *Odyssey*. The novel begins in childhood, with the hero, Dan, being his own Telemachus, participating in a harvest in his English 'Ithaca', specifically at the rural farm, 'Thorncombe', where he spent his summers and to which later in life he will be nostalgic to return. The pastoral harmony of the work and natural tranquility of the scene – evocative of Lukács' vision of the golden age of an integrated society – are suddenly interrupted by a German plane flying overhead; this usurping intrusion indicates that the time is during World War II. The narrative focus of the novel then abruptly shifts forward in time to a now mature contemporary Odysseus, Dan, revealed – in terms

of his epic life, *in medias res* – estranged from his native land and lingering with his Calypso. Her name is Jenny, and she is an English actress working in America. Dan and Jenny are in Hollywood, a lotus eaters land of adolescent temptation and pleasure remote from home, and the Mercury who interrupts their idyll is a telephone call.[10] Dan is summoned home to England by his Penelope, Jane, the woman with whom he fell in love twenty years before when he shared her bed as an undergraduate at Oxford and to whom, for the remainder of the novel, he will struggle to return. Jane tells Dan that her husband, an Oxford philosophy don named Anthony, is dying and has asked to see Dan. Anthony, who is compared in appearance to Anthony Eden and who is a Catholic, embodies the dying spirit of an older, more traditional England. When Dan returns, Anthony tells him that he knows that he was Jane's lover at Oxford and asks him to care for her after his death. Soon after this meeting, Anthony commits suicide, and the rest of the novel records Daniel Martin's long journey toward again sharing Jane's bed and marrying her.

The epic hero's struggle to find home and reunite with the woman he really loves is circuitous, and in *Daniel Martin* it is a psychological as well as a literal journey. The history of the twenty years since the end of a war – which is presented in the Homeric epic through Odysseus' tales – becomes in the novel Dan's lengthy reminiscences during the airplane journey home to England. When he finally reaches England, Dan, like Odysseus, finds the country which he has been ignoring and evading to be culturally and socially wasted. Therefore, before he can unite with his Penelope, the hero must reckon with the consequences of this decadence and decide personally how to confront it. For the kingly Odysseus, this meant scheming the slaughter of the usurping suitors; for a late twentieth-century Englishman like Dan, it means preparing himself psychologically to accept life in the diminished world power that his native country has become. He undertakes this initiation in the final third of *Daniel Martin* which recounts a journey that Dan takes, accompanied by Jane, to Egypt and Syria. The pretense for this trip is to scout locations in order to write a screen play about the conqueror of Khartoum, Lord Kitchener, but the journey becomes for Dan a process of personal and cultural redefinition. He gets to know Jane again and convinces her to accept his love; he begins to come to terms with his aspirations to be a true artist, struggling as he is to emerge from the screen writer's commercial work of hack writing into being a serious novelist. Also, Dan finds a renewed

sense of the vitality of civilization amid the artifacts of the ancient world. Dan's personal epic is complete when he finds Jane to be not just his Penelope but also his Athena, providing him wisdom about himself and his work. As Dan stirs psychologically to attempt to write serious fiction again, he is able to recognize the need to give up his less mature, drifting, inauthentic life in America with Jenny and to commit himself to Jane as well as England and its condition. Dan's odyssey is a true one that ends in the self-recognition which unites mind and body with a sense of place.

That which guides the hero in shaping his sense of himself in his art are readings in Marxist theory and thought provided by his wise companion, Jane. Like the fateful direction to the hero given by the gods in the classical epic, Dan through the reading of these signs that happen to come increasingly to his attention is able to come to terms with his own identity as well as to understand the English culture which he has shunned. It is by the ideology of these readings that Daniel Martin shapes the novel of his life by John Fowles. Specifically, the life and the plot are understood through selections from writings by Antonio Gramsci and Georg Lukács. From Gramsci, Fowles chooses an Orwellian epigraph to introduce the novel that describes the historic predicament confronting his hero Daniel Martin:

> The crisis consists precisely in the fact that the old is dying and the new cannot be born; in this interregnum a great variety of morbid symptoms appears.

Author's context becomes novelist's content when Dan, after visiting the dying Anthony, chances upon Jane's copy of Gramsci's *Prison Notebooks* and reads passages which set him thinking about how an individual's personal relations intersect and are conditioned by the whole of his or her society (194–195). This linking of the psychological to the cultural motivates Dan's quest for greater self– and social–understanding, and he invites Jane to accompany him on his trip to the ancient civilizations of Egypt and Syria after a discussion with her of Gramsci's humanism during which she explains the Marxist's conception of the 'ideological hegemony . . . by which he meant a sort of all-pervasive organizing principle in bourgeois society – a belief-system that more and more takes the place of the overt police state' (392), a concept that defines for them both the stagnation and the hopelessness of English culture. Like

Athena, then, Jane imparts wisdom that helps the hero understand his situation and the needs of his society.

The growth in Dan's understanding that occurs during his journey with Jane through the ancient world is guided not by supernatural portents but her gift on the flight to Cairo of a collection of Lukács' essays. Dan, while remaining politically unconvinced by Marxism, is confronted in Lukács by critical questions for his own art and life. He reads:

> 'The crucial question is whether a man escapes from the life of his time into a realm of abstraction – it is then that *angst* is engendered in human consciousness – or confronts modern life determined to fight its evils and support what is good in it. The first decision leads then to another: is man the helpless victim of transcendental and inexplicable forces, or is he a member of a human community in which he can play a part, however small, towards its modification or reform?' (500)

Another passage helps Dan understand himself and 'his own sense of defeat'. It is Lukács' description of the hero and his relationship to his society in the novels of Sir Walter Scott:

> 'The "hero" of a Scott novel is always a more or less mediocre, average English gentleman. He generally possesses a certain, though never outstanding, degree of practical intelligence, a certain moral fortitude and decency which even rises to a capacity for self-sacrifice, but which never grows into a sweeping human passion, is never the enraptured devotion to a great cause.' (551)

Each of Dan's encounters with Gramsci and Lukács are almost coincidental; the texts, originating as they do from the muse-guide Jane, become circumstantial signposts leading the hero toward his destiny.

Daniel Martin is a contemporary hero because in Lukács's terms he is intellectually 'tall' enough to come to understand how he has been conditioned by history and entrapped by his own psychology. Being of the wartime generation, he has a sense of being passed by and unprepared for the future. Dan laments to Jenny: '"We had all our values wrong. We expected too much. Trusted too much. There's a great chasm in twentieth-century history. A frontier.

Whether you were born before nineteen thirty-nine or not. . . . We antediluvians have been left permanently out of gear, Jenny"' (49), and initially he sees no place for himself in the post-war world: 'I disowned all this world for so long simply because I saw it as freakishly abnormal. . . . My contemporaries were all brought up in some degree of the nineteenth-century, since the twentieth did not begin till 1945. That is why we are on the rack, forced into one of the longest and most abrupt cultural stretches in the history of mankind' (86). Feeling caught in a sense between the cultures of different times – the past and the future – Dan is stranded as well between two countries, England and America. His 'mediocrity' in Lukács' sense is in his lack of commitment to either and in his acception of the role of screenplay writer that compromises his artistic talent. But, in his mediocrity Dan remains a hero because of the intelligence which enables him to comprehend his predicament: 'I let myself be dazzled by the gilt chimeras of the career: that happiness was always having work, being in demand, belonging nowhere, the jet life, the long transatlantic phone call about nothing. I became one third American and one third Jewish; the one third English I camped up or suppressed, according to circumstances' (71).

As in any odyssey, the hero is defined by being reflected in and upon by other figures who compare and contrast to him. Odysseus, contemplating his homecoming, is repeatedly warned of the consequences of Agamemnon's return, and Daniel Martin with his literary mind also finds appropriate analogues for his situation. In the first half of the novel, the wandering hero makes these comparisons in terms of the artifice of the film world of Hollywood which has become his professional place as a screen writer and his residence with Jenny. Consequently, Dan finds a sense of his alienation in 'the old *Camelot* set' with its 'betrayal of myths' and feels 'totally in exile from what I ought to have been' (15). At another point he expresses understanding of his situation by referring to the film, *Citizen Kane*, and 'how the great master-stroke was the Rosebud symbolism, how the worst corruption of the corrupt practitioners of a corrupt art was the notion that you could *buy* back innocence' (34). Dan's 'Rosebud' is his holding on to Thorncombe with its associations of childhood and innocence.

Dan even recognizes the image of his emotional predicament in his Oxford classmate, Barney Dillon, who has become a famous television personality and critic. When Barney begins an affair with Dan's daughter, Caro, who serves in the novel as the equivalent

of Homer's Nausikaa, the protagonist is hung on his own 'petard'. In the chapter with that title, Dan, like Odysseus speaking with Nausikaa, tries to give Caro advice about love:

> 'Middle-aged men may seem mature and knowledgeable and all the rest of it. But when they have to have girl-friends of your and Jenny's age, they're not. Deep down they're still frustrated adolescents. Running scared. They're in a panic.' (123)

Dan recognizes himself and Barney to be 'hollow men' – also a chapter title – who 'as with Ken Tynan . . . destiny then pointed to far higher places than the ones actually achieved' (100). In a sense they feel cheated out of their heritage:

> They had just caught the last of the old Oxford, which had trained them to admire and covet the enduring accolade of history, *aere perennius* as the supreme good . . . and just as the essential corollary, all the stabilizing moral and religious values in society, were vanishing into thin air. Reality had driven them, perhaps because they were pitched willy-nilly into a world with a ubiquitous and insatiable greed for the ephemeral, to take any publicity, any celebrity, any transient success as a placebo . . . It infested all the morbid areas in their culture, the useless complications and profit-obsessed excesses of capitalism, the plastic constructs: tellyland, popland, movieland, Fleet Street, the academic circus, the third-rate mortalized by the fourth rate . . . Dan thought grimly of a bit of jargon he had read somewhere in California. The cosmeticization of natural process. . . . The real function was not to amuse; but to excuse from thinking. (261–262)

Barney is Dan's double to the extent that the hero is enslaved by his own history and psychology; his relationship with Caro promises to perpetuate the adolescent superficiality of his mediocre life. He is the type of the false Ulysses who like Joyce's suspicious sailor, W. B. Murphy, is a consummate liar, a 'hollow man'. In contrast, Dan eventually will fulfill the promise of his intelligence by seeking something more than Barney through his relationship with his more mature guide and muse, Jane.

If Barney represents for Dan the false glamour of the international life of the times, Jane's husband, Anthony, embodies for him the

paralysis of the cultural past. Dan initially becomes estranged from him after mocking Anthony's donnish respectability and Catholic conventionality in the form of a play about a kind of 'young Establishment Tartuffe' (164). Dan believes that Anthony in his religious devotion and in the dominance of his rationality over his emotion forced Jane to curtail and inhibit her instinctual nature. Yet Anthony, facing death, confesses to reaching the same conclusion about his life as Dan has, and Anthony becomes an intellectual double for the hero in recognizing that his scholarship on linguistics and ethical theory, is, as with the screen writer's craft, merely 'the word as game' and 'the word as tool'. Like Dan, Anthony sees the inauthentic drama of it all: 'The twentieth century was like realizing we're all actors in a bad comedy at precisely the same moment as we realize that no one wrote it, no one is watching it, and that the only other theatre in town is the graveyard' (181–82). As Anthony's philosophy turns existential, he achieves Dan's perception of the contemporary dilemma and, in asking Dan to care for Jane, challenges him to achieve something more meaningful.

In the second half of the novel, under the influence of his muse-Athena, Dan finds another reflector of himself in his screenplay on the life of Kitchener, a subject which he finds would have been appropriate for an epic of nineteenth-century Britain, but which in the late twentieth-century better suits an American audience. The project begins as still another commercial assignment dreamed up by a producer to exploit 'a considerable latent nostalgia in the States for imperialism' (279), but it becomes for Dan an absorbing artistic endeavour. As he develops the fictional strategies for capturing the essence of his subject, Dan is, in fact, describing the strategies based on the theories of Lukács for analyzing the complex relationships of his own life in Fowles's fiction. Like the novel that is his life, Dan in the screenplay 'wanted to catch Kitchener somewhere in mid-career and at some central focus geographically; and then sally from that point in flashback and flash-forward to the rest of his life' (279). The way of seeing Kitchener in his time becomes for Dan a recognition of how to interpret his own life in his own time – 'we are above all the race that live in flashback, in the past and future' – as he draws on his admiration for *Citizen Kane* not just for his screenplay but for the artistic means to define himself by acting as both hero and author in the novel *Daniel Martin*: 'The tiny first seed of what this book is trying to be dropped into my mind that day: a longing for a

medium that would tally better with this real structure of my racial being and mind . . . something dense, interweaving, treating time as horizontal, like a skyline; not cramped, linear and progressive' (331).

As Dan, with Jane, traces Kitchener's past route through Egypt, his understanding of the necessary artistic structure grows ever more complex:

> I took refuge in Kitchener; read back over what had been written to date; jettisoned one draft scene, and rewrote it; saw a chance to use a flashback inside a flashback, and possibly a flashback inside that as well; a Chinese-box gimmick, but with possibilities. (416)

Even as his form grows more complex, Dan's understanding of his subject becomes more profound. Kitchener becomes one means by which Dan comes to discriminate between those values in the lives of the English that alienate him and those that attract him:

> that their Britishness, their obsession with patriotism, duty, national destiny, the sacrifice of all personal temperament and inclination (though not personal ambition, of course) to an external system, a quasi-mythical purpose, was profoundly foreign to him, even though he was a myth-maker of sorts himself. Empire was the great disease . . . *aut Caesar, aut nullus*, and profoundly un-English. The whole nineteenth-century was a disease, a delusion called Britain. The true England was freedom to be self, to drift like a spore, to stay unattached to anything, except transiently, but the drifting freedom. (422–23)

Ultimately, as Dan's own quest deepens, he attributes to Kitchener his own need to find what the ancient Egyptians described as *ka*, 'a man's ideal image of his own life' (512), and he imagines a scene for his screenplay in which the soldier would have this ancient notion explained to him, 'a scene where the shrewd old self-promoter saw the valency of the concept in some ancient monument . . . the methods of conquering time; to each his pyramid' (513). In this fashion, the screenplay on Kitchener contributes to the development of Daniel Martin's *ka* that ultimately manifests itself in his 'pyramid', a massive 'autobiographical' epic called *Daniel Martin*.[11]

While Dan's male contemporaries share his cultural paralysis, the hero's possibilities and choices for life – past, present, or

future – are defined by the embodiments of the female principle. Indeed, at the level of sexual myth, Fowles combines Homer with Robert Graves in creating his own version of the triple goddess. In an essay titled 'The Trouble With Starlets', Fowles writes:

> Man's adoration of woman has taken many forms. primitive societies it was generally the mother (as fertility goddess) who was chosen as the ideal. . . . In the classical age it was the virgin who symbolized the more mystical and noble of man's feelings about the second sex. Pallas Athene and the Roman Minerva stood for wisdom and reason . . . Artemis (Diana), goddess of the moon, of chastity, of lust controlled, reaches far back into civilization, but she was perhaps the earliest of all man's attempts to turn himself into a moral being.[12]

In the novel, Dan, in distinguishing among the women in his life, makes his choices of culture in our time, and each is associated with the values of a style of life and of a place. The two sisters, Nell and Jane – Dan's once and future wives, embody contrasting aspects of England, while Jenny, though English, accepts the future in America. And, at the core of Dan's psyche and the myth of his identity, is his memory of his adolescent love, Nancy – whom he poetically calls 'Phillida' – and the innocence and sensuality of her secret, pastoral bower at Thorncombe.

Dan's marriage to Nell represents 'how utterly obsessed by self-denial England's become' (57). Entrapped by a sense of convention, Dan marries Nell in spite of his acknowledging his love for Jane, and Jane, in turn, marries Anthony in spite of her love for Dan. Dan's marriage fails in spite of sexual pleasure and mutual understanding because of his sense of Nell's 'hint of shallowness, of fickleness, an impatience' (108), and she eventually finds her proper sphere in her second marriage to their aristocratic classmate, Andrew. Nell's husband is the lord of an eighteenth-century country estate, Compton, which Dan visits upon his return to England to see dying Anthony. There he encounters the lingering Victorianism of people who still think of themselves as 'British' and dedicate their lives to preserving pre-war values. The present only intrudes on them in the form of a Concorde airplane being tested nearby. Dan meets Fenwick, a kind of latter-day Menelaeus, who reminisces about the good old days of British grandeur and even about his being introduced as a child to Lord Kitchener. For Fenwick, the 'history

of this century is one of increasing madness' (314), but for Dan the encounter with the world of Compton leaves him 'with a feeling of absurdity – of an almost calculated nonsense' (316) at the effort to conserve the Old England of John Bull and imperialism.

In contrast to Nell and her aristocratic life in the past, Jenny represents youth and the future, accepting – more or less – her times in a way that it is the fate of Dan's generation never to be able to do. She gets the first and last chance in the novel to describe Dan, and, like her epic antecedent, Calypso, Jenny is prescient as the novel begins in anticipating the impending change in direction in the hero's life: 'Something will happen. Like a window opening. No, a door. Like a door in a wall' (17). Immediately the telephone rings calling Dan away from her and back to England and eventually to Jane. Later, when Jenny realizes that she is losing him, she sends three 'contributions' in the form of letters to Dan commenting on him or, at least, 'Mr. Wolfe' (31), Dan's pseudonym as a Hollywood writer. 'Mr. Wolfe' represents Dan's inauthentic self who Jenny knows, and her commentary analyses the schizoid person he has become in exile from home. While Jenny responds to Dan's humanity, imagining him to be 'Mr. Knightley to my Emma', she dislikes the obsession of Dan and his generation with a sense of 'loss – both all he's lost in the past and all he has still to lose. In some way to him loss is a beautiful, fertile thing' (234). Jenny, being of a later generation, can accept becoming international; indeed, she prefers America to England because of 'this awful English attachment to defeat and loss and self-negation' (234). She believes that 'California is the future and England is already a thing in a museum, a dying animal in a zoo' (235), and, if she could, Jenny would transform Dan into an American because 'he was born into the wrong culture' (236). Jenny must experience America, and, coping with her abandonment by Dan, she attempts to involve herself fully in its style of life. However, she cannot assimilate her intelligence with American sensuality, especially indiscriminate sexuality, and she rejects the worst of what the California social experience can be. While Jenny is of her generation in accepting the future, she has to continue her own quest for meaning in the new world. Jenny and Dan part, after a final meeting at Kenwood House on Hampstead Heath, both feeling a sense of what might have been without the generational attitudes that separate them. Jenny, like Dan, will eventually find commitment to a 'home', but it is in the future, in America, while Dan must come to terms in the present with his past, with England.

For Dan, Jenny is a major diversion from his quest for self and cultural identity. She represents a significant symptom of the cultural interregnum. Fowles in his essay on 'Starlets' describes the effect of sexuality on his time: 'We live in a typical *entre-deux-guerres* period, one that is bound by history to be rococo and frivolous in its pursuits and loves; and what the painted and carved cherubs and cupids and *putti* were to the age of Boucher and Fragonard, the omnipresent image of the starlet-model-cover-girl is to ours'.[13] Consequently, Jenny, like Calypso, is a kind of goddess of her time, the 'houri-girl' who 'like a true goddess . . . never grows older' and 'appears to make time stand still; and if we manage to make love to her, then it will not matter that time never stands still, so she is both amulet to the blind and consolation to the clearsighted'.[14] For Dan with his sense of 'loss', Jenny is clearly consolation, but their relationship remains above the sheer 'nympholepsy' that Fowles attributes to a 'Western, or at any rate Anglo-American, society' that 'has become girl-besotted, girl-drunk, girl-distorted'.[15] By the time that Dan meets Jenny, he has already experienced this nympholepsy into which he has been introduced by becoming involved in the 'hallucinogenic' (136) world of the commercial cinema. While trying to maintain his marriage to Nell, Dan's infidelities begin with 'the first woman that Dan had met whose reputation was based purely on sexuality' and 'whose motives are no more humane than when Circe asked Ulysses up for a drink' (137). This actress, who he does not name but only recollects as being his 'Circe' (137, 138), is followed by others: Andrea, the production secretary, who as a confident professional colleague turns out to be 'what the French call a *belle laide*; someone whose charm grew very slowly on you' (148); and two sisters, Miriam and Marjory, who both at the same time live with Dan and share his bed. In retrospect, Dan realizes that the sisters, with their 'stunning honesty, and a tact, and an intelligence', were 'the two most civilized feminine creatures I have ever known' (251), and they give him 'a lasting lesson on the limitations of my class, my education and my kind'. He finally classifies them appropriately as 'Clio and Thalia' (252), the muses of history and comedy.

Jenny, as the vigorous intelligence of her 'contributions' to Dan's autobiography shows, is the best of the sexual women in the protagonist's life. Nevertheless, she remains in a sense a 'houri' of the moment, ultimately living up to the original meaning of the word by sardonically describing herself to Dan at their farewell

meeting at Kenwood House as a 'lousy vestal virgin' (626).[16] Her intelligence enhances her sensuality, and she is the type of the legendary mistresses who, as Fowles describes them in his essay on starlets, have 'fascinating minds first and fascinating bodies second; their lovers sought from them an intellectual as well as a merely copulating relationship.'[17] But, as Dan finally tells Jenny, she knows him only passingly 'in cross-section', and he has moved beyond the concern with the momentary to a concern with his history (621). By the end of the novel, Dan is no longer that figure against whom he warns his daughter Caro, what Fowles in his essay describes as the 'older man' for whom 'happiness so often comes to mean an affair or a marriage with a girl young enough to be his daughter'[18]; he has advanced beyond the state of being of his friend, Barney. Jenny shows more promise for the future than most women of her generation, but Dan has come to look beyond the type of the houri for a woman who embodies for him a more ancient and magical power of being female.

Jane is Daniel Martin's White Goddess as well as his Pallas Athena. It is to her that Dan returns to England; it is through her that he recovers his sense of place. As Odyssean epic, the novel could end with Dan united with Jane at Thorncombe – it *is* his Ithaca; but Fowles continues his novel beyond the form prescribed by the Homeric parallel. The final third of the novel, Dan and Jane's trip to Egypt and Syria, extends the experience of coming to terms with being English from the conventions of the *Odyssey* to the world of *Gilgamesh* and ancient rites of fertility and regeneration associated with the mythologies of Osiris and Baal. In the context of this journey to the very origins of civilization, the function and meaning of Jane, elusive as she remains as a fictional character, deepens. Not only does Jane impart wisdom as the Athena guiding Dan's odyssey, but she plays as well the role of Artemis, or Diana, in his life. In serving to bring his promiscuity under control, Jane, as Fowles describes her symbolism in his essay on starlets, acts like the 'goddess of the moon, of chastity, of lust controlled . . . the earliest of man's attempts to turn himself into a moral being'.

In following Kitchener's passage along the Nile River, Dan and Jane achieve enlightenment through their encounter with the artifacts of the ancient world. It is as if the ultimate way to define personal as well as public goals and discover the means to survive meaningfully in the present is to penetrate the overlay of their contemporary world and become immersed

in the past, and each of their stops on the river voyage marks their further maturing and increasing self-knowledge. While Jane guides Dan's intellectual development and inspires his creativity, he is also shaped emotionally, and, spiritually, by encountering the surviving symbols of the aspiration for renewal and continuity of ancient human beings. Dan discovers the importance of the White Goddess to the artist in the very sense suggested by Robert Graves. Dependence on the self alone – what Graves would view as Apollonian self-centredness – has led to his personal wanderings and artistic mediocrity, and from encountering ancient artifacts Dan discovers the mysterious essence of authentic creativity.

For the first time, Dan perceives the inter-relationship of the male and female principles necessary for life and art. In a wall carving in the Temple of Karnak, he sees that only in Osiris and Isis having the closest familial and sexual relations in being 'brother and sister, husband and wife', do they achieve the act of fertilizing the land in pouring the flood waters of the Nile:[19]

> Two divinities, a male and a female, faced each other, holding up tilted flasks from which the water poured into two curved and crossing lines, forming an arch; except that it wasn't water, but chains of the ancient keys-of-life, cascades of little loop-topped crosses. (477)

At Abydos, Dan again sees the importance of the union of male and female powers in the bas-relief of 'Isis massaging up the penis of Osiris at her husband's annual resurrection from the dead', and there he is particularly struck by 'a strangely eager tenderness in the goddess's face as she knelt over her hibernating consort, the echo of the Persephone legend'. Dan jokingly compares the figures to 'D. H. Lawrence and Frieda' (502). Consequently, Dan's love and need for Jane, in a sense his Isis and his 'sister' (after all, she was once his sister-in-law), intensifies until their river trip ends at Aswan. There, they seem on the brink of consummating their relationship; yet, they remain strangely apart, a last experience of the ancient world being needed to unite them, one which will carry them further beyond reality into the realm of the mythical – into the world discovered by Anna with Saul in the Golden Notebook.

This experience occurs when Dan and Jane leave Egypt to travel to Palmyra in Syria to visit the ruins of the Temple of Baal. Their

journey no longer has an ostensible purpose, Syria not being on the Kitchener itinerary. However, in terms of completing his initiation into the rites of the White Goddess, Dan seems inexplicably drawn to experience the ancient powers associated with the strange site. The trip to Palmyra is, as one chapter title describes it, to 'the end of the world' (577). The setting is like the 'edge of a limbo nearest to a hell' (581), and Dan describes it as '"one of the loneliest landscapes in the world"' (587). Dan and Jane have a sense of being in the 'nothingness' of a Beckett play (587) or of being in England amid the aftermath of the destruction of the war. In Palmyra itself, they encounter the 'scattered, veiled debris of a lost civilization' (595), and their hotel is 'isolated in the huge graveyard of the dead city' (584). Yet, it is here in this netherworld of an almost forgotten civilization that Jane accepts Dan's offer of 'Any warmth. In a wasteland' (597), and they finally sleep together again, like Odysseus and Penelope, after twenty years of separation. Dan and Jane had slept with one another for the first time as students at Oxford on the day that while punting on the river they had found the corpse of a woman, their sexual encounters confirming what the ancient Egyptians – and D. H. Lawrence – had known: an encounter with death demands reaffirmation of the life-force. Hence, Dan and Jane find each other and themselves again amid the isolation of the place and the harshness of the accommodations but in close proximity to the ruins of the shrine to the great Sumerian god of fertility; they resurrect in their sexual reunion the lost fecundity of the place.

Baal is the ultimate symbol for that which Dan has been seeking for his life and for his art. Like most of the ancient gods of vitality and life, including Isis and Osiris, Baal is bisexual and androgynous, the female aspect being, as Robert Graves explains, also known as Belili, 'the Sumerian White Goddess . . . who was a goddess of trees as well as a Moon-goddess, Love-goddess and Underworld-goddess'.[20] Athena, too, has a masculine side represented in her first name, Pallas,[21] and, as Graves points out, 'a bi-sexual diety naturally remains chaste'.[22] These mythological resonances explain the quality of chasteness in Dan and Jane's – Odysseus and Athena-Artemis's – re-union which is sexually less than ideal (certainly in comparison to that of Odysseus and Penelope):

It came to him, immediately afterward, when he was still lying half across her, that the failure could have been put in terms of

grammatical person. It had happened in the third, when he had craved the first and second. (599)

In addition, there is a mythic quality of reversal of roles, personal and sexual, in their embrace:

Her dark eyes stared gently into his. There was something in them that was both maternal and unchanged. She was still the girl who had never understood him, or herself; eternally tempted by him, eternally uncertain, almost as if their sexes were reversed, and he Eve, she recalcitrant Adam; but aware now of the pain she caused. He knew finally, he couldn't quite say how, but it was in the eyes, that nothing had changed. (600)

As Dan discovers in committing his future to Jane, the figure of the Triple Goddess remains ever-elusive, and her relationship to the artist is always distant and difficult.

The strange and compelling sense of place which affects Dan at Palmyra haunts his search for self-discovery throughout *Daniel Martin*. As Dan says about Thorncombe, 'my real need for the place came from the depths of my unconscious' (324), and in his wanderings he seeks and finds various places of enlightenment. Each being the realm visited by the White Goddess, they must necessarily be associated with a significant woman in Dan's life, and his experiences of these places anticipate what he finally finds with Jane 'at the end of the world'. They also convey the sense of the harmony of the golden age of an integrated society described by Lukács. With Jenny, he feels hints of the magic among the Indian ruins of Tsankawi in New Mexico:

In some way, the mesa transcended all place and frontier; it had the haunting and mysterious personal familiarity I mentioned just now, but a simpler human familiarity as well, belonging not just to some obscure and forgotten Indian tribe, but to all similar moments of supreme harmony in human culture; to certain buildings, paintings, musics, passages of great poetry. It validated, that was it; it was enough to explain all the rest, the blindness of evolution, its appalling wastage, indifference, cruelty, futility. There was a sense in which it was a secret place, a literal retreat, an analogue of what had always obsessed my mind; but it also stood in triumphant opposition, and this was

what finally, for me, distinguished Tsankawi from the other sites: in them there was a sadness, the vanished past, the cultural loss; but Tsankawi defeated time, all deaths. Its deserted silence was like a sustained high note, unconquerable. (325)

Jenny, in turn, is sexually aroused by the place, desiring to take off her clothes and 'be had' (327). Similarly, Kitchener's island in the Nile at Aswan is for Dan 'one of the loveliest and most civilized few acres in his knowledge of this world, a tropical *bonne vaux*' (536), and Jane, anticipating her response in Palmyra, finds it 'like a Douanier Rousseau version of the Garden of Eden' (536).

But, the ultimate green world for Dan must be, of course, Thorncombe, his Ithaca. There, as a young man, he experienced a kind of Eden – a golden world – where innocence, nature, and passion coalesced in an achievement of ecstasy that haunts his memory and motivates his wanderings. In terms of the novel, Thorncombe is literally the pivotal setting for Dan's quest, the halfway place described at the centre of the narrative where he first considers writing seriously again and where he is strangely moved to ask Jane to accompany him to Egypt. The power of Thorncombe is explained in the chapter preceding these decisions, titled 'Phillida', which as reminiscence defines Dan's conscious and unconscious need, both personally and artistically, for such a place. He recalls his adolescent initiation in love with the farm girl Nancy Reed who with her family (and twin sister) lived at Thorncombe. During their summer idyll together, Nancy leads Dan to her 'real secret place' (363) high above the valley, and there he for the first time experiences sexual passion. Dan's idyll with his 'Phillida' imparts to him a pastoral ideal of a bower of bliss that subsequently haunts him in his earthly wanderings and comes to constitute the gist of his understanding of what it is to be English.

Dan associates Thorncombe with his desire to write a script about Robin Hood. He finds the story to be 'too profoundly about being English', it being the 'archetypal national myth, perhaps the only one, outside the Christ story, that literally every English person carries in his mind all through his life'. Moreover, Dan associates this 'myth based on hiding' with the artist's 'desire to create imaginary worlds other than the world that is the case'. Dan goes on:

This desire, or need, has always been strongly linked, at least in my own experience, with the notion of retreat, in both

the religious and the military sense; of the secret place that is also a redoubt. And for me it is here that the Robin Hood – or greenwood – myth changes from merely symbolizing folk-aspiration in social terms to enshrining a dominant mental characteristic, an essential behavior, an archetypal *movement* . . . of the English imagination. (271–72)

Hence for Daniel Martin to be English must be to enact the myth of Robin Hood, to retreat to a safe, secret place with the feminine muse who inspires his art. Hence, the hero comes home – finally – to know the essence of himself, his art, and his country.

For John Fowles to be English is to enact the same myth; he literally practices what his protagonist preaches. In his essay of 1964, 'On Being English But Not British', his own words anticipate those of his 1977 hero. Fowles begins by differentiating the 'Red-white-blue Britain', which is the legacy of the Victorian world of Kitchener and which ultimately ended with World War II, from the 'green England'. For the green England of today, the appropriate state of mind is 'that very primitive yet potent archetypal concept – the Just Outlaw' which is expressed in the Robin Hood myth. In words anticipating those of his hero Dan, Fowles explains: 'this legend is the only national one of which it can be said that it has been known to every English man and woman since at least the year 1400. There is in fact only one other so ubiquitously well known – the Christ story'.[23] The novelist's definition of its significant values further parallels that of his protagonist: 'Robinhoodism is essentially *critical opposition that is not content not to act. . . . The essence of Hood is that he is in revolt; not in power'*. This attitude has been espoused by great English artists from William Hogarth to Francis Bacon and requires not just the mental and emotional 'ingrained habit of withdrawal',[24] but, in its protest and nonconformity, a radical style of life: 'In contemporary psychological fact the Green-Englishness shows itself in our preoccupation with seclusion, with practising the emotions, the desires, the lusts, the excesses, the ecstasies, in private, behind walls, behind locked doors, behind the current code or codes of "correct" public behavior'.[25] Therefore, the attitude must be linked to a certain kind of place: 'The Green England is green literally, in our landscapes. . . . England is green, is water, is fertility, is inexperience, is spring more than summer'.[26]

For John Fowles the green place where he can practice his literary Robinhoodism is his own retreat at Lyme Regis; for Daniel Martin

it is his Thorncombe. Consequently, the shaping strategy for this novel is that of a creative Just Outlaw hiding among the leaves of a fictional forest projecting his ideas and values into an epic. *Daniel Martin*, as John Fowles said in an interview, is 'about what one twentieth-century man feels about his century and generation in one particular country',[27] and, while the author is not necessarily narrating his own life in the novel he is creating a kind of fictional *ka* for his own values and attitudes and for the self-consciousness which dominates literary thinking in his time. Perhaps, that is why the novel concludes with revelations of reflexivity both in its content and its style.

As content, reflexivity is revealed in Dan's encounter with the famous self-portrait of Rembrandt in Kenwood House. Having just bid farewell to Jenny who has told him he will never finish his novel Dan feels 'dwarfed, in his century, his personal being, his own art' (628), but he finds 'consolation' in the eyes of Rembrandt, the painter in his own self-portrait illuminating the predicament of himself and all future artists. Then Dan goes home to Jane to acknowledge the truth of Jenny's prophecy about 'Simon Wolfe'. But, while Daniel Martin can never make a novel of his own life, John Fowles can, and the result concludes in a revelation of reflexive stylistic virtuosity which epitomizes the whole of the literary and intellectual effort. The novel ends with Dan and Jane – ironic artist and all-knowing muse and goddess – together:

> Dan told her with a suitable irony that at least he had found a last sentence for the novel he was never going to write. She laughed at such flagrant Irishry; which is perhaps why, in the end, and in the knowledge that Dan's novel can never be read, lies eternally in the future, his ill-concealed ghost has made that impossible last his own impossible first. (629)

The ending acknowledges the relationship of fiction and auto-biography in Fowles's form as the door between art and life remains open in his Contemporary expression. Therefore, what Terry Eagleton has said about the epic of Wordsworth can be said as well about the novel of Fowles:

> *The Prelude* is a poem about the poet's preparation to write an epic which turns out to be *The Prelude*. . . . *The Prelude* is creased and haunted by the aesthetic and ideological ambiguities of

the moment. It is haunted by certain spiritual and historical possibilities, by the ghost of certain powers and values which its formal ideology is forced to censor; and it is in the rifts created by this radical lack of unity with itself that its play of meanings becomes most fertile.[28]

So, too, *Daniel Martin*. The novel is difficult to understand because the reader must look hard for John Fowles hiding among the leaves of his epic. By means of artistic Robinhoodism, author and hero merge in their seclusion in Devonshire and emerge to celebrate Green England and being English in our time.

Afterword

A tranquillizing spirit presses now
On my corporeal frame, so wide appears
The vacancy between me and those days,
Which yet have such self-presence in my mind
That sometimes when I think of them I seem
Two consciousnesses – conscious of myself,
And of some other being.

William Wordsworth, *The Prelude* (1805)

In Earl's Court, London: Asian flower sellers and newsagents; Malaysian, Italian, Indian restaurants and 'take away'; down a narrow lane almost a Calcutta bazaar with shops stocking bags of basmati rice and rows of jars of pickles and curries; a wine bar at one corner, a Victorian pub at another; Lebanese pastry; foreign tourists; McDonald's; streets leading to fashionable squares and renovated Victorian blocks of flats; Barclay's and Westminster banks; Islamic 'halel' meat shops as well as English butchers; foreign exchange kiosks; a post office; voices from all continents – the confluence of the peoples of an empire lost in a contemporary international city. This, too, is the country that Daniel Martin must acknowledge and accept along with the green England.

There can be no hiding out from it; it has been emerging since the war. The narrator of V. S. Naipaul's *The Enigma of Arrival* (1987), who lives in Earl's Court when he first arrives in England from Trinidad, saw this future – and this subject – forming long ago:

Because in 1950 in London I was at the beginning of that great movement of peoples that was to take place in the second half of the twentieth century – a movement and cultural mixing greater than the peopling of the United States, which was essentially a movement of Europeans to the New World. This was a movement between all the continents. . . . Cities like London were to change. They were to cease being more or less national cities; they were to become cities of the world, modern-day Romes, establishing the pattern of what great cities should be, in the eyes of islanders like myself and people even more remote in language and culture. They were to be cities visited for learning

194

and elegant goods and manners and freedom by all the barbarian peoples of the globe, people of forest and desert, Arabs, Africans, Malays. . . . I had found, if only I had had the eyes to see, a great subject. (141–42)[1]

The narrator is the witness to the author's experience of the new culture, but, by now, a decade after Fowles and two after Lessing, the door between fiction and autobiography can easily be left open.[2]

Near the end of *The Enigma of Arrival*, the consciousnesses of narrator and author self-consciously and literally merge:

I had thought for years about a book like *The Enigma of Arrival*. . . . The story had become more personal: my journal, the writer's journey, the writer defined by his writing discoveries, his ways of seeing, rather than by his personal adventures, writer and man separating at the beginning of the journey and coming together again in a second life just before the end. (343–44)

Emerging out of this discovery of artistic form and personal identity is finally a new understanding of history and the sacred place within that gives it meaning:

Men need history; it helps them to have an idea of who they are. But history, like sanctity, can reside in the heart; it is enough that there is something there. (353)

Naipaul, in the late twentieth century, has found meaning where Conrad, in the late nineteenth, found 'darkness'.[3]

Preserving the light of idealism and hope at the heart of things is the greatest human need, as Conrad well knew in letting his narrator Marlow tell his 'civilized' lie. Ironically, one source for *Heart of Darkness* would have been Victor Hugo's *Les Misérables* (1862)[4] with its compelling plot of the pursuit of the convict Jean Valjean by the policeman Javert through the darkness of post-Napoleonic France. Like Marlow and Kurtz in the jungle, Valjean and Javert in the Paris sewers know the Underworld and confront the nightmare lurking beneath the dream of the civilized. Just a short Underground ride from Earl's Court, their struggle is enacted every night in the West End. Its presentation is in the new form of the spectacle of the English pop-opera, in this instance the Royal Shakespeare Company's appropriation of *Les Misérables*, and

new form of the spectacle of the English pop-opera, in this instance the Royal Shakespeare Company's appropriation of *Les Misérables*, and the production epitomizes Naipaul's vision of London as a city of the world: an English musical based on a French novel with an international cast. Yet, still it poses, as does the culture that supports it, the human issue. At the beginning of the musical, the doomed Fantin defines the desperate condition,

> I had a dream my life would be
> So different from this hell I'm living
> So different now from what it seemed
> Now life has killed
> The dream I dreamed,

and at the end civilized aspiration is affirmed by the chorus,

> Is there a world you long to see?
> Do you hear the people sing?
> Say, do you hear the distant drums?
> It is the future that they bring
> When tomorrow comes . . .
> Tomorrow comes.[5]

Out of the babel of voices in the West End, in Daniel Martin's beloved Devon, in Anna Wulf's notebooks, in Robert Graves's myths, in Raymond Williams' 'country' and 'city', Contemporary form merges with Contemporary subject to mark a more worldly and less traditional way for 'English' culture.

In Earl's Court, the browsing visitor to the bookstore inspects that epic novel born of late twentieth-century London and burned at Bradford. He recalls the flames and hears echoes from the heart of darkness: "'The modern city . . . is the locus classicus of incompatible realities".'[6] But, in the contemporary city outside the open door of the bookstore, he sees another England.

Notes

FOREWORD

1. Critics have used the term 'post-Modern' indiscriminately to label creative work of the post-war period. I use the term solely to identify those works created after the Second World War that still express the pessimistic values of the world-view of the Modernist movement before the war. In my view, the term that should be used for post-war works that are innovative in form and theme is 'Contemporary', and I label the period in English culture since the war the 'Contemporary' period.
2. For a literary history of the period, consult the three volumes by Robert Hewison published by Oxford University Press (New York and Oxford): *Under Siege: Literary Life in London 1939–45* (1977); *British Culture in the Cold War 1945–60* (1981); *Too Much: Art and Society in the Sixties 1960–75* (1987).

CHAPTER 1: VICTORIAN SHADES

1. This account of the incident is based primarily on Philip Magnus, *Kitchener: Portrait of an Imperialist* (New York: E. P. Dutton and Company, 1959), pp. 133–37.
2. Quoted by Stephen Jay Gould, *The Mismeasure of Man* (New York and London: W. W. Norton, 1981), pp. 97–98.
3. Julian Symons, *England's Pride: The Story of the Gordon Relief Expedition* (London: Hamish Hamilton, 1965), p. 236.
4. George Bernard Shaw, *Agitations: Letters to the Press 1875–1950*, ed. Dan H. Laurence and James Rambeau (New York: Frederick Ungar, 1985), pp. 49–51.
5. Ernest W. Bennett, 'After Omdurman', *The Contemporary Review*, 75 (1899), 29; 31.
6. Winston S. Churchill to Lady Randolph on 26 January 1899, in *Winston S. Churchill*, ed. Randolph S. Churchill, I, Part 2 (Boston: Houghton Mifflin, 1967), 1004–1005.
7. *The Times*, 25 February 1899, p. 11.
8. Quoted by Frederick R. Karl, *Joseph Conrad: The Three Lives* (New York: Farrar, Straus and Giroux, 1979), p. 440.
9. Short references are to Joseph Conrad, *Heart of Darkness*, ed. Robert Kimbrough (New York: W. W. Norton, 1971). Kimbrough, p. 81, notes an interesting 'error' in the 1921 text that Conrad considered

the final one: 'Kirtz' for 'Kurtz'. Conrad probably had other models for the figure of Kurtz in mind; Norman Sherry in *Conrad's Western World* (Cambridge: Cambridge University Press, 1971), pp. 92–118, argues for Arthur Eugene Constant Hodister, a commercial agent and explorer in the African ivory country, about whom Conrad might have heard anecdotes during his visit to the Congo in 1890.

10. Magnus, pp. 141–42.

11. Conrad was probably influenced in his description of the skulls as well as the mysterious savage rites of the Inner Station by an account of human sacrifice in Sir James Frazer's *Golden Bough*, first published in England in 1890. In *The New Golden Bough*, ed. Dr. Theodor H. Gaster (New York: New American Library, 1959), pp. 507–508, the passage reads: 'The skulls are at first exposed on the branches of two or three dead trees which stand in an open space at every village surrounded by large stones which serve as seats. The people then dance round them and feast and get drunk. When the flesh has decayed from the head, the man who cut it off takes it home and preserves it as a relic, while his companions do the same with the hands and the feet.'

12. Max Nordau, *The Conventional Lies of Our Civilization*, trans. Louis Schick (Chicago: Laird and Lee, 1895), p. 1.

13. Karl, p. 626, asserts the possible influence of *Degeneration* on Conrad and describes Mann's debt to Conrad's 'vision of breakdown'. Also, see the account of the rise of pessimism in Paul Johnson, *Modern Times: The World from the Twenties to the Eighties* (New York: Harper and Row, 1983), pp. 10–14.

14. Sigmund Freud, *Civilization and Its Discontents*, trans. James Strachey (New York: W. W. Norton, 1962), p. 91.

15. Quoted by Magnus, pp. 134–35. Philip Warner in *Kitchener: The Man Behind the Legend* (New York: Atheneum, 1986), p. 100, reports that Sir Reginald Wingate was 'more discreet' about the skull of the leader of the Dervishes, the Khalifa, and that 'he was said to have drunk champagne out of it for the rest of his life on each anniversary of the battle of Omdurman'.

16. Magnus, p. 134, quotes Sir Evelyn Baring, 1st Earl of Cromer: 'Kitchener is himself responsible for the rather unwise course of sending the skull to the College of Surgeons'.

17. Quoted by Magnus, p. 135.

18. Short references are to *W. B. Yeats: The Poems, A New Edition*, ed. Richard J. Finneran (New York: Macmillan, 1983).

19. Short references are to *The Collected Plays of W. B. Yeats: New Edition* (New York: Macmillan, 1952).

20. Samuel Beckett, *Endgame* (New York: Grove Press, 1958), p. 33. Hamm, 'very perturbed' that Clov might have a flea, says, 'But

humanity might start from there all over again! Catch him, for the love of God!'

21. Short references are to W. H. Auden, *Collected Poems*, ed. Edward Mendelson (New York: Random House, 1976).
22. Short references are to T. S. Eliot, *The Complete Poems and Plays, 1909–1950* (New York: Harcourt, Brace, 1952).
23. Short references are to Virginia Woolf, *Between the Acts* (New York: Harcourt, Brace, 1969).
24. Jacque Lassaigne, 'The Genius of Henry Moore', in *Homage to Henry Moore: Special Issue of the XX Siècle Review*, ed. G. di San Lazzaro; trans. Wade Stevenson (New York: Tudor, 1972), p. 6.
25. *Henry Moore on Sculpture*, ed. Philip James (New York: Viking Press, 1971), p. 105.
26. Alan G. Wilkinson in *The Drawings of Henry Moore* (London and Toronto: The Tate Gallery in collaboration with the Art Gallery of Toronto, 1977), p. 103, describes the origin of the drawing and provides a parallel but different interpretation of its figures: 'On 3 September, the day war was declared, the Moores were bathing off the Shakespeare Cliffs at Dover. He remembers hearing an air raid siren, an ominous prelude to the day and night warnings in London a year later during the Blitz. In this recreated scene of bathers with the cliffs in the background, the strange heads of the figures, evoking the world of science fiction, were probably suggested by the familiar form of gas masks. Standing chest high in the water, these forbidding women, alert and watchful, look across the Channel towards the French coast.'
27. Described in *Henry Moore on Sculpture*, p. 14.

CHAPTER 2: ORWELL'S WAR

1. Laura Knight, *Oil Paint and Grease Paint: Autobiography of Laura Knight* (New York: Macmillan, 1936) and *The Magic of a Line: The Autobiography of Laura Knight* (London: William Kimper, 1965). Short references are to *The Magic of a Line*.
2. A sketch in the possession of the author pictures the emblem.
3. Short references are to *The Collected Essays, Journalism and Letters of George Orwell*, eds. Sonia Orwell and Ian Angus (London: Secker and Warburg, 1968), 4 vols.
4. See John Coleman, 'The Critic of Popular Culture', in *The World of George Orwell*, ed. Miriam Gross (New York: Simon and Schuster, 1973), pp. 101–115.
5. See Chapters VII and VIII for further discussion of this Contemporary literary element.
6. See, for example, Miller's description of America in *Tropic of Cancer* (1934) and account of the 'Cosmodemonic Telegraph Company of North America' in *Tropic of Capricorn* (1939).

7. Short references are to George Orwell, *Coming Up for Air* (Harmondsworth: Penguin Books, 1962).
8. Short references are to George Orwell, *Nineteen Eighty-Four*, ed. Bernard Crick (Oxford: Clarendon Press, 1984).
9. *1985* (Boston: Little Brown, 1978), pp. 12–13.
10. Cf. Albert Camus's *The Plague* (1947).
11. Pop art was already stirring in the late 1940s in collages created by Eduardo Paolozzi; see discussion of the movement in Chapter V.
12. 'King Zog' was Ahmed Zoga, King of Albania, who was driven into exile when his country was invaded by Italy on 7 April 1939. The references to his wedding of 1938 would have seemed ironic to contemporary readers of *Coming Up for Air* when the novel was published on 12 June 1939, *after* the invasion of Albania.
13. George Steiner in 'Killing Time', *The New Yorker*, 12 December 1983, p. 182, finds 'a strain of sadistic kitsch of precisely the kind Orwell had tracked down in his studies of pulp fiction' in the scenes of Winston's torture.
14. *George Orwell: The Critical Heritage*, ed. Jeffrey Meyers (London and Boston: Routledge and Kegan Paul, 1975), p. 199.
15. Quoted by Coleman, p. 110.

CHAPTER 3: PRISONERS OF WAR

1. John Russell, *Francis Bacon* (London: Thames and Hudson, 1979), p. 55.
2. David Sylvester, *Interviews with Francis Bacon, 1962–1979* (London: Thames and Hudson, 1980), p. 81.
3. For biography, consult *The Oxford Companion to Twentieth-Century Art*, ed. Harold Osborne (Oxford: Oxford University Press, 1981), pp. 37–38.
4. Sylvester, p. 152.
5. Russell, pp. 151–152.
6. John Rothenstein and Ronald Alley, *Francis Bacon* (New York: Viking Press, 1964), p. 11.
7. Rothenstein and Alley, p. 146.
8. Rothenstein and Alley, p. 11.
9. See Orwell's review published 4 January 1946, in *The Collected Essays, Journalism and Letters of George Orwell*, ed. Sonia Orwell and Ian Angus (London: Secker and Warburg, 1968), IV, 72–75.
10. Sylvester, p. 22.
11. Sylvester, p. 87.
12. In Sylvester, p. 30, Bacon describes his interest in Muybridge's photographs.
13. Sylvester, p. 46.
14. Sylvester, p. 28.
15. Sylvester, pp. 32–34.

16. Russell, p. 86.
17. Russell, p. 100.
18. Russell, p. 90.
19. In Sylvester, p. 32, Bacon describes the influence on his style of a book on x-ray.
20. Sylvester, p. 78.
21. Rothenstein and Alley, p. 20.
22. Rothenstein and Alley, pp. 15–16.
23. Jeff Nuttall, *Bomb Culture: Pop, Protest, Arts, Sick, The Underground* (London: MacGibbon and Kee, 1968), p. 20.
24. Nigel Dennis, *Cards of Identity* (Harmondsworth: Penguin Books, 1955), p. 100.
25. R. D. Laing, *The Divided Self: An Existential Study in Sanity and Madness* (Harmondsworth: Penguin Books, 1960), p. 37.
26. Laing, p. 42.
27. Laing, pp. 41–42.
28. Laing, pp. 100; 95.
29. E. M. Forster, 'What I Believe', in *Two Cheers for Democracy* (New York: Harcourt, Brace, 1951), p. 70.
30. Forster, pp. 68–69.
31. Forster, p. 73.
32. Rebecca West, *The New Meaning of Treason* (New York: Viking Press, 1964), p. 140.
33. For accounts of the conspiracy, see Bruce Page, David Leitch, Philip Knightley, *The Philby Conspiracy* (New York: Doubleday, 1968); Barry Penrose and Simon Freeman, *Conspiracy of Silence: The Secret Life of Anthony Blunt* (New York: Farrar, Straus, and Giroux, 1987); and Andrew Sinclair, *The Red and the Blue: Cambridge, Treason and Intelligence* (Boston: Little, Brown, 1986).
34. John Halperin, 'Between Two Worlds: The Novels of John le Carré', *The South Atlantic Quarterly*, 79 (1980), 18.
35. Quoted by Halperin, p. 22.
36. Graham Greene, *Ways of Escape* (New York: Simon and Schuster, 1980), p. 309.
37. Graham Greene, 'Kim Philby: An Introduction by Graham Greene', in Kim Philby, *My Silent War* (New York: Grove Press, 1968), p. 11.
38. Connor Cruise O'Brien, 'Greene's Castle', *New York Review of Books*, 1 June 1978, p. 4. He adds, 'There seems indeed to be a kind of inversion or diversion of Kafka, perhaps a Christianization: not just people in quest of the inaccessible Castle, but the Castle itself engaged in a quest: man seeking Christ, and Christ seeking man'.
39. Short references are to Graham Greene, *The Human Factor* (New York: Simon and Schuster, 1978).
40. Eleanor Philby in *Kim Philby: The Spy I Married* (New York:

Ballantine Books, 1967), p. 144, quotes a letter from her spy-hus-
band: 'It was a relief to read a somewhat sophisticated spy story
[le Carré's *The Spy Who Came In From the Cold*] after all that James
Bond idiocy'.

41. Kim Philby, who defected in 1963, was preceded into exile by
 Guy Burgess and Donald Maclean who fled to Moscow in 1951.
 Burgess died there in 1963. Eleanor Philby, p. 71, describes her
 husband's Moscow flat: 'As I walked round the flat on that first
 night . . . I noticed piles of books stacked high against the walls in
 every room. There were more than four thousand volumes which
 Burgess had left to Kim'.

42. Anthony Burgess, 'Good Morning! It's 1984: Are We Free?' *Miami
 Herald*, 1 January 1984, p. 6E.

43. Short references are to Alan Sillitoe, *Saturday Night and Sunday
 Morning* (New York: New American Library, 1958).

44. Richard Wollheim, *Socialism and Culture*, Fabian Tract, No. 331
 (London: Fabian Society, 1961), pp. 8–9.

45. Short references are to John Osborne, *Look Back in Anger*
 (Harmondsworth: Penguin Books, 1957).

46. John Raymond, 'A Look Back at Mr. Osborne', *The New Statesman
 and Nation*, 19 January 1957, p. 67.

47. Harold Pinter, 'Writing for the Theatre', in *Complete Works: One*
 (New York: Grove Press, 1976), p. 13.

48. Peter Hall, 'A Director's Approach: An Interview with Peter Hall',
 in *A Casebook on Harold Pinter's 'The Homecoming'*, ed. John Lahr
 (New York: Grove Press, 1971), p. 9.

49. Pinter, 'Writing for the Theatre', p. 13.

50. Pinter, 'Writing for the Theatre', p. 11.

51. Irving Wardle, 'The Territorial Struggle', in *Casebook*, pp. 38; 41.

52. René Girard, *Violence and the Sacred*, trans. Patrick Gregory (Bal-
 timore and London: The Johns Hopkins University Press, 1977),
 pp. 57–58.

53. Short references are to Harold Pinter, *Old Times* (New York: Grove
 Press, 1971).

54. Short references are to Harold Pinter, *Betrayal* (New York: Grove
 Press, 1978).

55. Wardle, p. 44.

56. Bernard F. Dukore, 'A Woman's Place', in *Casebook*, p. 116.

CHAPTER 4: DEBATING 'CULTURE'

1. T. S. Eliot, *Notes towards the Definition of Culture* (London: Faber
 and Faber, 1948), p. 5.

2. Eliot, p. 34.

3. Eliot, pp. 40; 48.

4. Eliot, p. 62.

5. R. H. S. Crossman, *Socialism and the New Despotism*, Fabian Tract, No. 298 (London: Fabian Society, 1956), pp. 231–232.
6. *The Letters of Lewis Mumford and Frederic J. Osborn*, ed. Michael E. Hughes (Bath: Adams and Dart, 1971), pp. 56–57.
7. *The Letters of Lewis Mumford and Frederic J. Osborn*, p. 368.
8. F. R. Leavis, *The Great Tradition* (New York: New York University Press, 1969), p. 25.
9. C. P. Snow, *The Two Cultures and the Scientific Revolution* (New York: Cambridge University Press, 1959), pp. 8–9.
10. Snow, p. 12.
11. Snow, p. 7.
12. Snow, p. 12.
13. F. R. Leavis, 'The Significance of C. P. Snow', *The Spectator*, 9 March 1962, p. 303.
14. Bernard Bergonzi, *The Situation of the Novel* (Pittsburgh: University of Pittsburgh Press, 1970), p. 182, speculates that Burgess is commenting on the 'current dominance of Americanisms in colloquial English speech', but I think that Burgess, following Orwell, is playing on the paranoia of the Cold War to invent a language for a despotic future. He may have been inspired also by Colin McInnes's 'teenage epic' in slang, *Absolute Beginners* (1959).
15. Short references are to Anthony Burgess, *A Clockwork Orange* (New York: Ballantine Books, 1988).
16. This final chapter, Part III, Chapter 7, was omitted from the American edition of the novel until 1988.
17. Short references are to John Fowles, *The Collector* (Boston: Little, Brown, 1963).
18. Short references are to John Fowles, *The Aristos* (New York: New American Library, 1975).
19. Rebecca West, *The New Meaning of Treason* (New York: Viking Press, 1964), p. 141.
20. George Steiner, 'F. R. Leavis', in *Language and Silence* (New York: Atheneum, 1967), p. 233n.
21. Raymond Williams, *Politics and Letters: Interviews with New Left Review* (London: NLB, 1979), pp. 97–98.
22. Patrick Parrinder, 'The Accents of Raymond Williams', *Critical Quarterly*, 26 (1984), 50.
23. Williams, *Politics and Letters*, pp. 309; 312.
24. Raymond Williams, *The Country and the City* (New York: Oxford University Press, 1973), p. 231. Williams emphasizes the importance of the passage in *Politics and Letters*, pp. 321–322.
25. Williams, *The Country and the City*, p. 305.
26. Peter Conrad; 'Two Traditions', *New Statesman*, 4 May 1973, p. 664.
27. Terry Eagleton, *Criticism and Ideology* (London: Verso, 1976), p. 23.
28. Williams, *The Country and the City*, pp. 2–3.

INTERLUDE

1. George Martin with Jeremy Hornsby, *All You Need Is Ears* (New York: St. Martin's Press, 1979), p. 200. My account of the history of the recordings is based on Martin as well as Philip Norman, *SHOUT! The Beatles in Their Generation* (New York: Simon and Schuster, 1981), Bob Cepican and Waleed Ali, *Yesterday . . . Came Suddenly* (New York: Arbor House, 1985), George Melly, *Revolt Into Style: The Pop Arts* (Garden City, N.Y.: Anchor Books, 1971), pp. 125–128, and Wilfred Mellers, *Twilight of the Gods: The Music of the Beatles* (New York: Viking Press, 1973), pp. 69–104.
2. Melly discusses the technique of musical collage, p. 126.
3. Lyrics quoted from *The Compleat Beatles: Volume II, 1966–1970*, ed. Milton Okum (Toronto and New York: Bantam Books, 1981), pp. 122–126. Lyrics printed on album covers differ.
4. The contemporary scene is well-described by Nicholas Schaffer, *The Beatles Forever* (Harrisburg, Pennsylvania: Cameron House, 1977), pp. 71–84.
5. Martin, p. 202.
6. *The Compleat Beatles*, pp. 180–185.
7. Cepican and Ali, p. 217.
8. Cepican and Ali, p. 218.
9. Norman, p. 292.

CHAPTER 5: THE CITY:
POP ART AND BRUTAL ARCHITECTURE

1. Quoted by Asa Briggs, *Victorian People* (Chicago: University of Chicago Press, 1955), p. 16.
2. Arthur Bryant, 'Our Notebook', *Illustrated London News*, 12 May 1951, p. 736.
3. Briggs, pp. 37, 41.
4. Adrian Forty, 'Festival Politics', in *A Tonic to the Nation: The Festival of Britain 1951*, ed. Mary Banham and Bevis Hillier (London: Thames and Hudson, 1976), p. 27.
5. Michael Frayn, 'Festival', in *Age of Austerity*, ed. Michael Sissons and Philip French (London: Hodder and Stoughton, 1963), p. 319.
6. Forty, pp. 35, 36.
7. Arthur Bryant, 'Our Notebook', *Illustrated London News*, 26 May 1951, p. 838.
8. Quoted by Frayn, p. 322.
9. For a full description of the movement, see *A Paradise Lost: The Neo-Romantic Imagination in Britain 1935–55*, ed. David Mellor (London: Lund Humphries in association with the Barbican Art Gallery, 1987).
10. Quoted by Reyner Banham, *The New Brutalism: Ethic or Aesthetic?* (London: The Architectural Press, 1966), p. 75.

11. Elizabeth Wilson, *Only Halfway to Paradise: Women in Postwar Britain: 1945–1968* (London and New York: Tavistock Publications, 1980), p.10.

12. Jasia Reichardt, 'Pop Art and After', *Art International*, 7 (1963), 43.

13. For an account of the history of the Independent Group, see Lawrence Alloway, 'The Development of British Pop', in *Pop Art*, ed. Lucy R. Lippard (London: Thames and Hudson, 1966), pp. 27–68.

14. Alison and Peter Smithson, *Without Rhetoric: An Architectural Aesthetic 1955–1972* (London: Latimer New Dimensions, 1973), pp. 1, 2.

15. Alloway, p. 28.

16. These exhibitions, and others, are described by Alloway, pp. 29–40.

17. Quoted by Christopher Finch, *Image as Language: Aspects of British Art 1950–1968* (Harmondsworth: Penguin Books, 1969), p. 24.

18. The design of the exhibition is described by Alloway, pp. 38–40.

19. Smithson, *Without Rhetoric*, p. 12.

20. Quoted by Reichardt, p. 43.

21. Richard Hamilton, 'An Exposition of $he', *Architectural Design*, October, 1962, p. 73.

22. Hamilton, p. 73.

23. Hamilton, p. 76.

24. Robert Melville, 'The Durable Expendables of Peter Blake', *Motif: A Journal of the Visual Arts*, 10 (1962–63), 22, 29.

25. Quoted in 'Peter Blake: Pop Art for Admass', *Studio*, 161 (1963), 184.

26. Quoted in 'Peter Blake: Pop Art for Admass', 187.

27. George Melly, *Revolt Into Style: The Pop Arts* (Garden City, N.Y.: Anchor Books, 1971), p. 128.

28. See Ebenezer Howard, *Garden Cities of To-Morrow: a Peaceful Path to Real Reform*, ed. F. J. Osborn (London: Faber and Faber, 1945).

29. Lionel Esher, *A Broken Wave: The Rebuilding of England 1940–1980* (London: Allen Lane, 1981), pp. 96, 98, uses the phrase 'thought in "rings"' to describe Patrick Abercrombie's planning for London.

30. See Donald L. Foley, *Controlling London's Growth: Planning the Great Wen 1940–1960* (Berkeley and Los Angeles: University of California Press, 1963), chap. 2.

31. Graeme Shankland, 'Dead Centre: The Crisis of Planning and the Future of Our Cities I', in *Architecture Association Journal*, 72 (1957), 149–59.

32. Banham, p. 11.

33. David Wilcox with David Richards, *London* (London: Thames, 1977), p. 11.

34. *'Why is British Architecture So Lousy?'*, ed. Nathan Silver and Jos Boys (London: Newman, 1980). This symposium grew out of Silver raising the topic in a radio talk on 8 September 1979.
35. Graeme Shankland, 'Dead Centre: The Crisis of Planning and the Future of Our Cities II', *Architecture Association Journal*, 72 (1957), 196.
36. James Stirling, 'Regionalism and Modern Architecture', in *Architects' Year Book 8*, ed. Trevor Dannatt (London: Paul Elek, 1957), pp. 62–63.
37. Quoted by Robert Maxwell, 'The Pursuit of the Art of Architecture', in *James Stirling: Architectural Design Profiles* (London and New York: Academic Editions/St. Martin's Press, 1982), p. 5.
38. Alison and Peter Smithson, *The Heroic Period of Modern Architecture* (London: Thames and Hudson, 1981), p. 9.
39. Alison and Peter Smithson, 'The Aesthetics of Change', in *Architects' Year Book 8*, p. 22.
40. Stirling, 'Regionalism and Modern Architecture', p. 63.
41. Smithson, *The Heroic Period of Modern Architecture*, p. 9.
42. Smithson, *Without Rhetoric*, p. 14.
43. Smithson, *Without Rhetoric*, pp. 60, 63.
44. Stirling, 'Regionalism and Modern Architecture', p. 68.
45. Quoted by Banham, pp. 71, 72, 73.
46. Banham, p. 19.
47. Banham, p. 130.
48. Ian Nairn, quoted in *James Stirling*, ed. Peter Arnell and Ted Bickford (New York: Rizzoli, 1984), p. 51.
49. Smithson, *Without Rhetoric*, p. 85.
50. James Stirling, *Exhibition – Royal Institute of Architects, 24 April-21 June, 1974* (London: RIBA Publications, 1974), p. 54.
51. Smithson, *Without Rhetoric*, p. 92.
52. The article appeared in *Architectural Review*, 118 (1955); the book was published London: The Architectural Press, 1966.
53. Quoted by Banham, p. 41.
54. Banham, p. 13.

CHAPTER 6: THE COUNTRY: THE WHITE GODDESS

1. For a succinct history of speculation about Stonehenge, see John Fowles and Barry Brukoff, *The Enigma of Stonehenge* (London: Jonathan Cape, 1980), pp. 88–112. Romantic speculation began with William Stukeley's *Stonehenge, A Temple Restor'd to the British Druids* (1740), but the idea of sacrifice in wicker cages derived from an engraving of a giant wicker figure in Aylett Sammes's *Britannia Antiqua Illustrata* (1676) based on a comment in Caesar's *Commentaries* that the Druids 'make hollow images of vast magnitude, with twiggs wreathed about together, whose members they

fill up with living men'.

2. William Wordsworth, *Poetical Works*, ed. Thomas Hutchinson and Ernest de Selincourt (London: Oxford University Press, 1966), pp. 20–21.

3. Short references by plate and line numbers are to *The Complete Poetry and Prose of William Blake: Newly Revised Edition*, ed. David V. Erdman (New York: Doubleday, 1982).

4. Short references are to Robert Graves, *The White Goddess: A Historical Grammar of Poetic Myth*, Amended and Enlarged Edition (New York: Farrar, Straus and Giroux, 1966).

5. Short references are to *On Poetry: Collected Talks and Essays* (New York: Doubleday, 1969). Graves is characterizing Randall Jarrell's view of the book.

6. Martin Seymour-Smith, *Robert Graves: His Life and Work* (New York: Holt, Rinehart and Winston, 1983), p. 403.

7. Wordsworth, p. 737.

8. 'The Fate of Pleasure: Wordsworth to Dostoyevsky', in *Romanticism Reconsidered*, ed. Northrop Frye (New York: Columbia University Press, 1963), p. 77.

9. Robert Graves, 'Jungian Psychology', *Hudson Review*, 5 (1952), 251.

10. Graves, 'Jungian Psychology', 257.

11. Short references are to Apuleius, *The Golden Ass*, trans. Robert Graves (New York: Farrar, Straus and Giroux, 1951).

12. Short references are to Evelyn Waugh, *Brideshead Revisited* (New York: Dell, 1944).

13. Joseph Conrad, *Heart of Darkness*, ed. Robert Kimbrough (New York: W. W. Norton, 1971), p. 66.

14. Short references are to Ted Hughes, *Gaudete* (New York: Harper and Row, 1977).

15. Keith Sagar, *The Art of Ted Hughes*, Second Edition (Cambridge: Cambridge University Press, 1978), pp. 186–187, discusses the origins of the poem.

16. Leonard M. Scigaj, *The Poetry of Ted Hughes: Form and Imagination* (Iowa City: University of Iowa Press, 1986), p. 168.

17. Wordsworth, p. 735: 'For a multitude of causes, unknown to former times, are now acting with a combined force to blunt the discriminating powers of the mind, and, unfitting it for all voluntary exertion, to reduce it to a state of almost savage torture'.

18. Short references are to Lucy R. Lippard, *Overlay: Contemporary Art and the Art of Prehistory* (New York: Pantheon Books, 1983).

19. Quoted by Guiseppe Marchion, 'Henry Moore's Themes', in *Homage to Henry Moore: Special Issue of the XX Siècle Review*, ed. G. di San Lazarro; trans. Wade Stevenson (New York: Tudor, 1972), p. 73.

20. Quoted in *Henry Moore on Sculpture*, ed. Philip James (New York: Viking Press, 1971), pp. 71, 88, 96.
21. *Henry Moore on Sculpture*, pp. 51–52.
22. *Henry Moore on Sculpture*, p. 208.
23. Will Grohmann, *The Art of Henry Moore* (London: Thames and Hudson, 1960), p. 43.
24. *Henry Moore on Sculpture*, p. 100.
25. *Henry Moore on Sculpture*, p. 82.
26. *Henry Moore on Sculpture*, p. 248.
27. *Henry Moore on Sculpture*, p. 270.
28. *Henry Moore on Sculpture*, p. 274.
29. T. S. Eliot, *Notes towards the Definition of Culture* (London: Faber and Faber, 1948), p. 34.
30. The transition in Blake's career and the history of the Brotherhood is described by Nicholas Usherwood, *The Brotherhood of Ruralists* (London: Lund Humphries, 1981).
31. Usherwood, p. 6.
32. Usherwood, p. 23.
33. Quoted by Usherwood, p. 61.
34. Usherwood, p. 61.
35. An eighteenth-century source for Blake's portrayal of Titania may be Sir Thomas Lawrence's portrait of young Sarah Moulton-Barrett, the famous painting popularly known by the sitter's nickname, 'Pinkie' (1795). Robert Rosenblum in *19th Century Art* (New York: Abrams, 1984), p. 63, relates Lawrence's figure to Henry Fuseli's *Titania and Bottom*, c. 1790: 'we may register the almost Fuselian fantasy of this fairy-tale figure, a modern Titania, who, with the imperious gaze of an enchantress, stands in wild nature, her dress and pink ribbons swept by the wind'.
36. Reproduced in *Peter Blake: Retrospektive*, ed. Michael Compton, Nicholas Usherwood, and Carl Haenlein (Hannover: Kestner-Gesellschaft, 1983), pl. 66.
37. Martin Seymour-Smith, p. 409, describes how Graves's depiction of the White Goddess differs from the women to whom he was closest in his life: 'Graves's mother had black hair. Nancy was dark. Riding was hebraically dark – and her skin could not be described as white. Beryl is dark'.

CHAPTER 7: AN ENGLISH EPIC: LESSING

1. R. P. Blackmur, 'Prefatory Note', *Eleven Essays in the European Novel* (New York: Harcourt, Brace, 1964), p. vii.
2. R. P. Blackmur, 'The Dialectic of Incarnation: Tolstoi's *Anna Karenina*', *Eleven Essays*, p. 10.
3. Doris Lessing, *A Small Personal Voice: Essays, Reviews, Interviews*, ed. Paul Schlueter (New York: Alfred Knopf, 1974), p. 5.

4. Lessing, *A Small Personal Voice*, p. 11.
5. Lessing, *A Small Personal Voice*, p. 15.
6. Lessing, *A Small Personal Voice*, p. 4.
7. Georg Lukács, *The Theory of the Novel*, trans. Anna Bostock (Cambridge: The M.I.T. Press, 1971), p. 11.
8. Lukács, *The Theory of the Novel*, p. 33.
9. Lukács, *The Theory of the Novel*, p. 56.
10. Lukács, *The Theory of the Novel*, p. 60.
11. Lukács, *The Theory of the Novel*, p. 80.
12. Georg Lukács, *The Historical Novel*, trans. Hannah and Stanley Mitchell (London: Merlin Press, 1962), p. 34.
13. Lukács, *The Historical Novel*, p. 36.
14. Lukács, *The Historical Novel*, p. 300.
15. Lukács, *The Historical Novel*, p. 304.
16. Lukács, *The Historical Novel*, p. 306.
17. Lukács, *The Historical Novel*, p. 312.
18. Lukács, *The Historical Novel*, p. 313.
19. Lukács, *The Historical Novel*, p. 315.
20. Lukács, *The Historical Novel*, p. 350.
21. George Steiner, 'The Pythagorean Genre', in *Language and Silence* (New York: Atheneum, 1967), pp. 85–86.
22. Short references are to Doris Lessing, *The Golden Notebook* With a new Introduction by the author (New York: Bantam Books Windstone Edition, 1981).
23. George Steiner, 'Literature and Post-History', in *Language and Silence*, p. 389.
24. Lukács, *The Historical Novel*, p. 142.
25. Doris Lessing, *In Pursuit of the English* (New York: Simon and Schuster, 1961), p. 15.
26. Nicola Chiaromonte, *The Paradox of History: Stendhal, Tolstoy, Pasternak, and Others* (Philadelphia: University of Pennsylvania Press, 1985), p. 19.
27. Quoted by Chiarmonte, p. 42.
28. Chiarmonte, pp. 42–43.
29. Malcolm Bradbury in *The Social Context of Modern British Literature* (Oxford: Blackwell, 1971), pp. 122–123, comments: 'For us, as observers, it would be appropriate to note that 'alienation' is in fact as much an expression of liberal society as a protest against that society. As such, it can, of course, be taken as a symptom of that degeneration that Max Nordau saw in the decadence of the 1890s, in which the arts were – Nordau suggests in an illusory way – gesturing towards hope while manifesting a good deal of the decay. That sort of view is interestingly echoed by the Marxist critic Georg Lukács, who has seen 'modernist anti-realism' as a manifestation of bourgeois culture, alienated from true consciousness, ridden with an exaggerated devotion to a static

and sensational view of the world, a solitary and individualistic version of the human condition, and a flight from outward reality into psycho-pathology'.

30. See Marion Vlastos, 'Doris Lessing and R. D. Laing: Psychopolitics and Prophecy', *PMLA*, 91 (1976), 245–58. While perhaps overstating Laing's influence, at least on *The Golden Notebook*, Vlastos in a note, p. 257, does call attention to Lessing's statement in a talk in 1973 that 'All educated [sic] look for a key authority figure who will then act as a law giver. Laing became that figure'.

31. My interpretation of Lessing's achievement as a Contemporary novelist differs radically with those who read *The Golden Notebook* with the bias of Modernism; they tend to read the whole of Lessing's novel according to limitations of Anna's *Free Women*. Frederick R. Karl, for example, in 'Doris Lessing in the Sixties: The New Anatomy of Melancholy', *Contemporary Review*, 13 (Winter, 1972), 15–33, frames Lessing within the tradition of Modernism by describing her as 'heir to a development in literature that has become insistent in the last fifty to sixty years . . . a literature of enclosure', and he emphasizes the Kafkaesque paralysis of Anna, blocked as a writer: 'she must always return to her room – like Gregor Samsa's, her room is a fierce refuge against harsh men and events – and in her room she dreams endlessly. They are terrible things, her nightmares, which are most comparable to Gregor's metamorphosis into a bug'. Such a view ignores the creativity that Anna achieves through her notebooks and particularly her liberating vision in the Golden Notebook.

32. Leo Tolstoy, *Anna Karenina*, ed. George Gibian (New York: W. W. Norton: 1970), p. 695.

33. In spite of Lessing's explicit rejection of Camus in *A Small Personal Voice*, p. 11, compare his wartime *Le Mythe de Sisyphe* (1942; trans. 1955). Anna is a fictional character, after all, and we should not confuse a philosophy that gives her comfort and inspiration with Lessing's own philosophical views. As a character living in the 1950s, Anna is very much of her time and her place in her thinking; but her ideas are on the same level of sophistication as her writing.

34. Tolstoy, pp. 738–40.

CHAPTER 8: ENGLISH EPIC: FOWLES

1. George Orwell, 'Inside the Whale', in *Collected Essays, Journalism and Letters of George Orwell*, ed. Sonia Orwell and Ian Angus (London: Secker and Warburg, 1968), I, 527.
2. Orwell, 'Inside the Whale', p. 493.

3. Jeremy Treglown, 'Generation Game', *New Statesman*, 7 October, 1977, p. 482.
4. George Steiner, 'Literature and Post-History', in *Language and Silence* (New York: Atheneum, 1967), p. 389.
5. John Fowles, 'Notes on Writing a Novel', *Harper's Magazine*, July 1968, pp. 89–90.
6. Terry Eagleton, *Marxism and Literary Criticism* (Berkeley and Los Angeles: University of California Press, 1976), p. 29.
7. For discussion of the traditional metaphors for the relation of art to life, see M. H. Abrams, *The Mirror and the Lamp: Romantic Theory and the Critical Tradition* (New York: Oxford University Press, 1953).
8. John Fowles, 'On Being English But Not British', *The Texas Quarterly*, VII (1964), 154.
9. Short references are to John Fowles, *Daniel Martin* (Boston: Little, Brown, 1977).
10. Appropriately, the messenger of the gods was for years the emblem of the American Telephone and Telegraph Company.
11. The ancient concept of *ka* is associated in Egyptian mythology with a cult center called a '*ka* house'. Eberhard Otto in *Ancient Egyptian Art: The Cults of Osiris and Amon* (New York: Abrams, 1967), p. 18, defines such a place as follows: 'This would mean that the occupant of the house was not the person of the king concerned but rather the spiritual power of personality called the *ka* which is not identical with the bodily appearance, but surpasses it in influence and permanence'.
12. John Fowles, 'The Trouble with Starlets', *Holiday*, June 1966, p. 18.
13. Fowles, 'The Trouble with Starlets', p. 18.
14. Fowles, 'The Trouble with Starlets', p. 20.
15. Fowles, 'The Trouble with Starlets', p. 17.
16. 'Houri' literally means 'beautiful virgin'.
17. Fowles, 'The Trouble with Starlets', p. 15.
18. Fowles, 'The Trouble with Starlets', p. 20.
19. Eberhard Otto, pp. 22–30, describes how Osiris embodies the experience of the power of chthonic fertility in his relationship to his female counterpart, Isis.
20. Robert Graves, *The White Goddess* (New York: Farrar, Straus and Giroux, 1982), pp. 360-361; 58.
21. Graves, p. 351.
22. Graves, p. 361.
23. Fowles, 'On Being English But Not British', pp. 156–57.
24. Fowles, 'On Being English But Not British', p. 158.
25. Fowles, 'On Being English But Not British', p. 160.
26. Fowles, 'On Being English But Not British', p. 161.
27. Quoted by Kerry McSweeney in *Four Contemporary Novelists:*

Angus Wilson, Brian Moore, John Fowles, V. S. Naipaul (Kingston and Montreal: McGill-Queen's University Press, 1983), p. 103.

28. Terry Eagleton, *Criticism and Ideology* (London: Verso, 1976), p. 187.

AFTERWORD

1. Short references are to V. S. Naipaul, *The Enigma of Arrival* (New York: Knopf, 1987).

2. Peter Kemp, reviewing Naipaul's book in *The Times Literary Supplement*, 7 August 1987, p. 838, states: 'Naipaul has produced both fiction and non-fiction for more than a quarter of a century now. The links between them have been close. . . . Further weakening the boundaries between fiction and non-fiction, many of Naipaul's novels appear heavily autobiographical. Habitually, they focus on restless, rootless colonials, often with a pen in their hand, who act as surrogates for the author'.

3. Kemp, p. 839, states: 'The notion of a journey being simultaneously real and metaphorical recalls *Heart of Darkness*'.

4. Frederick R. Karl, *Joseph Conrad: The Three Lives* (New York: Farrar, Straus and Giroux, 1979), emphasizes the influence of the French novelist on Conrad, quoting him, p. 68: 'At ten years of age I had read much of Victor Hugo and other romantics'.

5. Alain Boublil and Claude-Michel Schonberg; Lyrics by Herbert Kretzmer, *Les Misérables* (London: The Palace Theatre, 1985).

6. Salman Rushdie, *The Satanic Verses* (New York: Viking Press, 1988), p. 314.

Index

Note: Works cited will be found under the artist's name.